American Women Painters
of the 1930s and 1940s

American Women Painters of the 1930s and 1940s

The Lives and Work of Ten Artists

by
Robert Henkes

McFarland & Company, Inc., Publishers
Jefferson, North Carolina, and London

British Library Cataloguing-in-Publication data are available

Library of Congress Cataloguing-in-Publication Data

Henkes, Robert.
 American women painters of the 1930s and 1940s : the lives and
work of ten artists / by Robert Henkes.
 p. cm.
 Includes bibliographical references and index.
 ISBN 0-89950-474-4 (lib. bdg. : 70# alk. paper) ∞
 1. Women painters—United States—Biography. 2. Painting,
American. 3. Painting, Modern—20th century—United States.
I. Title.
ND212.H46 1991
759.13'082—dc20 90-53708
 CIP

Manufactured in the United States of America

McFarland & Company, Inc., Publishers
 Box 611, Jefferson, North Carolina 28640

To the American women artists
of the Depression
and World War II years

Table of Contents

Introduction

A common thread weaving throughout the lives of these American women painters was the zest for life and their neglect of major American tragedies. There are others who qualify. Yet those discussed in the following chapters were unique in that each approached life differently and with different subject matter. Each lived through the Great Depression and World War II. There were always personal challenges which resided within the artists themselves. None were swayed by current trends, each adhering to personal beliefs, and all reached a peak of artistic achievement at an early age.

Andrée Ruellan's interest in the commonplace generating the unexpected is similar to MacIver's artistic outlook except that Ruellan's unexpected discoveries focused upon the human element. It was not that MacIver disfavored the human condition as witnessed in the intimate portraits of clowns, Emmett Kelly and Jimmy Savo, but they allowed her the freedom to pursue a diversity of stimuli.

Gladys Rockmore Davis was a figurative painter of the classical style. She avoided the street people, preferring to portray, almost glorify, the female form. Her portrayals of children were conceived and executed in the grand French style of Renoir and the American Cassatt, while her depictions of nudes relished the thoughts of Rubens.

Each possessed a selfishness, a personal responsibility to oneself rather than to society as a whole, except for Ruellan who, having been blessed, sensed the need to return those blessings. Her paintings, however, were not expressions of protest as one would imagine of one adhering to a social calling. Ruellan's works recorded the time and place of particular cultures. Thus her approach also possessed a touch of personal endeavor, a somewhat selfish outlook. Although objective in appearance, her paintings project a lingering personality, an intimate awareness of her subject matter. The human figure and environment are blessed with a profound sense of belonging.

It was Davis' later works that revealed her humanitarian concerns with such great works as *The Kiss, Man's Inhumanity to Man* and *The Paris of 1945 Series.* Forced to respond quickly to events which were momentary in nature, Davis ignored the usual prearrangements and

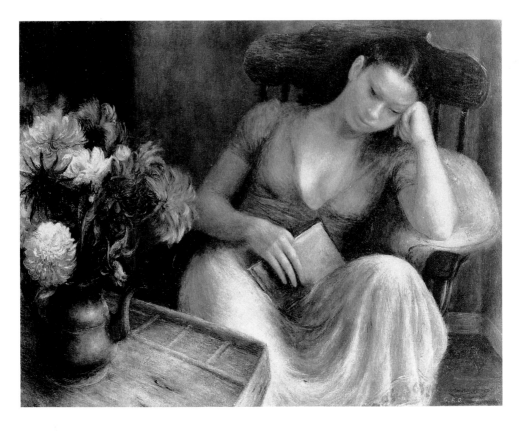

Gladys Rockmore Davis. *August Afternoon.* **Oil on canvas, 30″ × 40″, 1939. The Metropolitan Museum of Art. George A. Hearn Fund, 1940. (40.47.1)**

captured the fleeting moment, so to speak, much like MacIver's obsession with raindrops and flickering vigil lights.

Davis' classical style gave way to the emotional brushwork of an Abstract Expressionist. The mother and child theme was not preconceived as separate humans but as a single life, an irresistible urge toward total attachment. *The Kiss* was such an example. So too were her depictions of Paris of 1945.

Although Mabel Dwight was initially a painter, her fame stemmed from her prints of New York City. Her influence reached such American masters as Reginald Marsh, the Soyer brothers and Paul Cadmus. Her bitter irony was more than superficially rendered, and there was a unique mysticism not unlike that of MacIver who dealt not with people but with life's smallest miracles. Her famous lithograph, *Ferry Boat,* would have blistered with anger the nunnery of the forties.

Dwight's thoughts coincide with those of Loren MacIver regarding the beauty which resides in various forms. While MacIver saw beauty in a battered sidewalk or a rotten apple thrown in a garbage can, Dwight would visualize beauty in the ugly, in the sick, because it would be the spirit that would rise above the flesh.

While Mabel Dwight relished the satirical and ironic, Marion

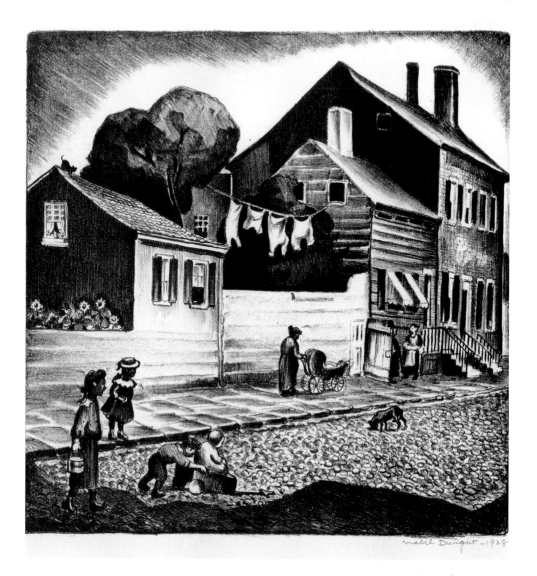

Mabel Dwight. *Old Greenwich Village.* **Lithograph, 9½″ × 9½″ (image) 16″ × 11⅝″ (sheet), 1928. The Whitney Museum of American Art. Gift of Gertrude Vanderbilt Whitney. (31.723)**

Greenwood exploited the ravages of war, especially in the far-off countries of India and China. She also favored the impoverished peoples of Mexico, which incidentally provided the breath and depth of Doris Rosenthal's work as well.

Most of the ten artists discussed in this volume painted murals, but none with the heralded success of

Marion Greenwood. Both the Mexican and the American governments considered her accomplishments worthy, and she received praise also from such Mexican masters as Diego Rivera and José Orozco.

Doris Lee possessed a wit and charm that enveloped her paintings, so innocent and direct that some critics dismissed them as immature and

unworthy of comment. But her naïveté grew into sophistication.

Loren MacIver's forms of life were non-figurative, but possessed a magic that enchanted mankind. Daily occurrences often overlooked by the common passerby blossomed into delightful mysteries. Aside from a few portraits, MacIver purposely avoided the expression of the figurative aspect of nature, perhaps because it lacked the imaginative possibilities inherent in the unexpected. The puddle, pebble, crack in the sidewalk, twig, leaf or the candle flickering in the darkness—all afford countless variations of expression. This personal style of art made MacIver a nearly unique and in any case highly successful American painter.

Doris Rosenthal seldom avoided the human form in her work, except she favored the Mexican culture to the American. Hers was a compassionate display of the joys and sorrows of a humble and disciplined people.

Similarities exist between the works of Lauren Ford and Doris Lee. Both consciously chose their styles to yield the atmosphere of their subject matter, and it is this conscious choice that disqualifies their work from receiving the label of primitivism which some critics have tried to apply. Art sophisticate Lauren Ford, like Doris Lee, had used a quasi-primitive idiom in most of her compositions which embrace both religious and rural subject matter. Ford's *The Country Doctor* and Lee's *Winter in the Catskills* show a similarity. Both paintings are panoramic. Both employ a composite of themes. The focal point in Lee's *Winter in the Catskills* is the couple skating in the foreground, while in Ford's *The*

Country Doctor, the horse and buggy in which the doctor drove to the isolated farmhouse becomes the central theme.

Edna Reindel's still life paintings relate to the magical charm of a Loren MacIver, her landscapes to the peace and loneliness of an Edward Hopper and her *Women at War* series to the forthrightness of a Doris Lee. While others bypassed World War II themes, Reindel was commissioned to paint the war effort. Her resulting paintings possessed tinges of surrealism but were unlike her still lifes. Her success, like others discussed in this book, reached its peak shortly after World War II.

Reindel's change of style during the late forties came to resemble the drawing technique of the famed British sculptor Henry Moore, in such works as *Dancing to the Harp* and *Praying Mothers.* Her technical change suited her previous versatility in style as she moved closer to being a major contributive force in American painting.

When Helen Sawyer was not lured by the New England landscape, the circus became her motivation. The nostalgia of both themes were pronounced in quiet, yet convincing manner. She believed in the singularity of expression, that is, the total use of the canvas for a totally subjective experience, not a series of individual objective notations. It was this diminishment of visual perspective of an objective nature that distinguished the works of Sawyer.

Not unlike other artists of the Depression era whose works focused on the pleasantries of life rather than the tragedies of the Depression itself and the ensuing World War II, Sawyer preferred to concentrate on the American landscape and the familiar

Loren MacIver. *Violet Hour.* **Oil on canvas, 1943. The Los Angeles County Museum of Art, Mira T. Hershey Memorial Collection.**

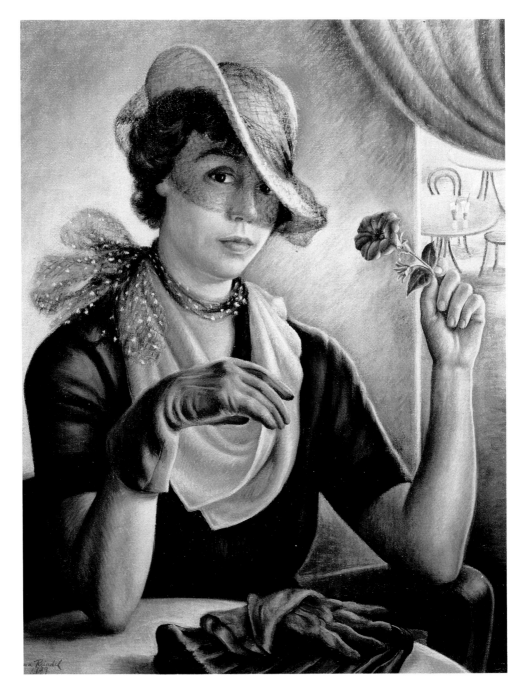

Edna Reindel. *Cafe Girl.* **Oil on canvas. The Canajoharie Library and Art Gallery, Cana-joharie, New York.**

circus scenes of the thirties and forties.

Several others ranked among the nation's best women artists of the period, and could have been included, but the selection of the ten was deliberate even as the cutoff was difficult. It seemed to this author that the choices were based upon accessibility and partly upon personal favoritism. Except for Mabel Dwight, all were born of the same generation, and according to this author, all were great but are now largely forgotten.

Critic Donald Bear summed it up with his appraisal of Doris Rosenthal. His remarks could well apply to all of the artists discussed in this volume. He spoke of Rosenthal as "an artist who cannot be included in any group-ing because of her personal devotion to highly specialized subject matter and who has developed her own honest sense of humor. Her paintings are vigorously fresh and as personal as a letter."

In a sense, all artists adhere to the above philosophy, but for the sake of discussion, one might consider it especially relevant to the artists representing the decade of the Great Depression.

Others considered for inclusion were Ann Brockman, Lily Harmon, Georgina Klitgaard and Loren Barton. Those omitted from the text because of established popularity included Georgia O'Keeffe, Isabel Bishop, among others.

Doris Lee

Doris Lee was acknowledged as a recorder of rural life. Her obsession with detail made alive those aspects of nature that other painters ignored, and her ability to weave throughout a single canvas a multitude of ideas has made her a prominent painter of the American scene. Noted for her primitive appearing expressions of landscapes, particularly the countryside of farms and orchards in which she piled dozens of inner compositions within a single arrangement, she occasionally diverted her talents into such devastating works as *The Catastrophe,*[1] a nightmare of disaster.

Born in 1904 in Aledo, Illinois, Doris Lee studied at Rockford College, the Kansas City Art Institute and the California School of Fine Arts under the noted painter Arnold Blanch. She became firmly enshrined within the lists of American painters when she won top prize in the exhibition called "Painting in the United States 1944." Prior to this award she captured high honors from such prestigious institutions as the Worcester Art Museum, the Cincinnati Art Museum and the Pennsylvania Academy of Fine Arts.

Artists are concerned about the turmoil of their country may go through. Yet artists like Lee have been accused of avoiding cries for assistance from her compatriots. In fact, Doris Lee assisted greatly in the alleviation of their pain and sorrow by refocussing their minds on the simple and significant facets of life. Arbor Day, seemingly a lost holiday of the American scene, springs to life whenever one witnesses Doris Lee's famous painting *Arbor Day.*[2] In it one travels backward to years of peace and quietude. The American flag waving proudly in the sky, the old schoolhouse reflecting the springlike chill through the quiet puffs of smoke easing from the chimney, the children decked out in their Sunday best, the bicycle slumped against the tree—all lend to the atmosphere, as does the anticipated gesture of the schoolmarm readying for the planting of a tree which will grow strong in the years ahead to remind one of the potential of this great nation. Lee's ability to impart the mood of this event is witnessed even in the birds hovering in the distance. The horses to the right of the painting look anxiously for the proceedings to begin. The timid lamb to the left does likewise. The young girl with the butterfly net, the boy with the bat and ball, the

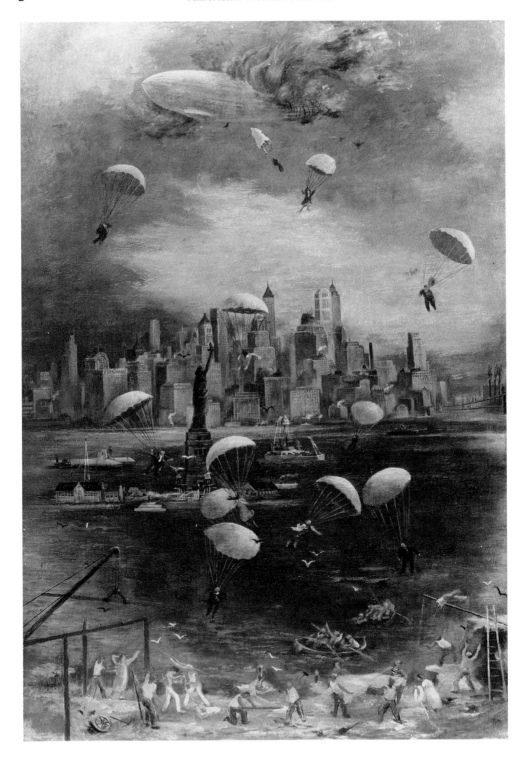

Doris Lee. *The Catastrophe [The Disaster].* **Oil on canvas, 40″ × 28″. The Metropolitan Museum of Art. George A. Hearn Fund, 1937.**

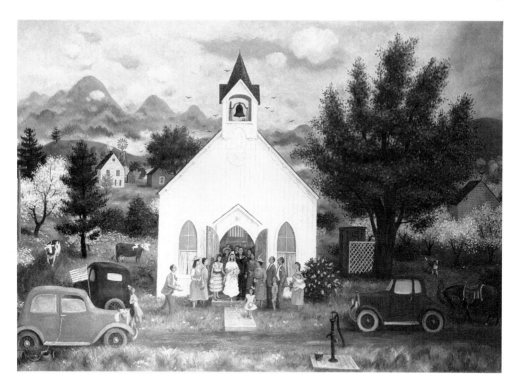

Doris Lee. *Country Wedding*. Oil on canvas, 30″ × 44½″, 1942. Albright-Knox Art Gallery, Buffalo, New York. Room of Contemporary Art Fund, 1943.

twin girls hurrying so as not to be late—all lend to the dignity and simple excitement of the event.

Noted for her scenes of rural America, Lee has sustained a unique position in the annals of American painting. Over the years her work has remained unpoisoned by traditional trends, gimmicks, tutorship and cries of "be concerned." Doris Lee has painted the American scene in magnificent charm unlike any other American artist. Her continuous emphasis on the simplicity of living has never been more evident than in *Arbor Day*.

Lee packs her paintings with excitement, and her sheer joy of painting is evidenced in the painstaking manner of paint application. She is as unhurried in her painting as she is in

life, and has enjoyed romping through wooded areas and picking flowers as she sketched. She was one of those unique persons capable of cherishing the most minute aspects of nature.

A case in point is *Illinois River Town* in which the river of a small community is seized with activity while small businesses nestle in the distant landscape. Portrayed in a strict objective fashion, the characters remain alien to the viewer as if Lee preferred to generalize personalities. The artist has painted a panoramic view of a small town, but presents the illusion of total and complete participation of an entire community to a seemingly mundane experience ... fishing. There is glee and frivolity, and there is joy in the doing. The

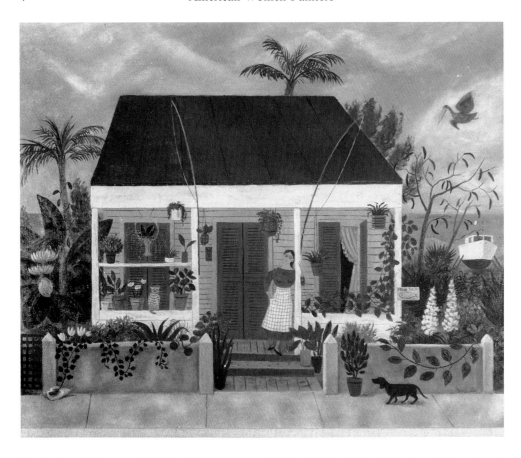

Doris Lee. *Fisherman's Wife.* **Oil on canvas, 22½″ × 28½″, 1945. Collection of Cranbrook Academy of Art Museum. Gift of Cranbrook Foundation. (1945.27)**

artist reflects a personal love of life into each and every gesture, and she invites the viewer to participate.

Horizontally, Lee has structured four planes, each complementing the other. The forefront blossoms with activity in contrast to the comparative quiet of the river plane in which a lone fisherman occupies the vast waterway. The activity is renewed within the third plane in which factories and stores parade in articular order, and finally, the fourth plane again echoes the river plane as Lee presents a quiet but compatible sky which seems to enjoy the proceedings below.[3]

Doris Lee studied under those in-structors who painted the times, but remained undisturbed by those whose ideas and manner of painting were contrary to hers. This insistence on personal freedom is again reflected in her painting titled *Country Wedding.* All of life seems engendered within the single country church. In fact, the building seems the same as the school house witnessed in her painting, *Arbor Day*. It is indeed a glorious occasion ... the wedding of a serviceman and the appropriate items of patriotism. One is almost saddened at the fact that the wedding had already taken place, and that the viewer had missed it. It looks as if it were a delightful ceremony. Lee's focal point

of interest again resides in the center of the canvas, but in no way does it afford less travel in other segments of the canvas. Lee's ability to incorporate numerous compositions within a single picture makes for an intriguing atmosphere of charm and whimsy. She invites the whole world, so to speak, to participate in her events. The birds, cows, horses, dogs, and newborn babies seem pleased to be part of the ceremony. Even the windmill in the distance proudly whirls the wind about in joy.

A muralist and illustrator as well as a painter, Lee gained fame as one of the top contemporary painters by virtue of a Carnegie Institute Award.[4] Since then, her stature continues to grow so that her work now appears in permanent collections of the major American museums and galleries. She also gained stature as a printmaker during the forties and fifties executing several lithographs. These will be discussed later in this chapter.

Lee's obsession with the minute and varied aspects of nature is brought into close scrutiny as one inspects *Holiday,* a close-up view of a family of four. Instead of a panoramic view of a landscape, the viewer is treated to an intimate study of a single aspect of that landscape. There is little room to wander. A compact unit of four tightly overlapped figures, presumably of a single family, greet the viewer. The mother, grasping a rolled-up newspaper, looks bewildered while comforting her youngest sibling, who wears high knee socks with black garters. The young girl clutches the mother's dress, causing several folds of overlapped material. The oldest daughter, tucked partially behind her mother, gazes wonderingly at a closed door reading,

"Boat Ride." A third offspring is partially hidden by her older sister as she stands erect with legs crossed, waiting patiently.

Lee tells a story of disappointment. The characters of *Holiday* are endearing indeed, rendered in delicate and sensitive brushstrokes. One believes and understands, and even in despair, Lee translates the sense of belonging.

The subjective execution of the quartet in *Holiday* is contrary to that of *April Storm.*[5] The quartet would be misplaced and possibly lost in the array of figures objectively arrayed across the surface of *April Storm.* One is overwhelmed by the fusion of life. Lee allows only enough space between activities to ward off congestion. The scene describes the prominent Washington Square area amid downtown Manhattan during April of 1932. Such a scene typified the Great Depression when free activities were not only possible but essential.

Even a spacious sky is infested with birds, and if that were not enough, naked tree branches pierce the April sky overlapping the distant skyscrapers and the famous Washington Square Arch. This New York monument became the trademark of several of Lee's predecessors and contemporaries—Reginald Marsh, John Sloan, Philip Evergood, Isabel Bishop, Raphael Soyer and others. No space is left untouched as Lee pays homage to the old and young, the good and evil, the robust and the shy. *April Storm* is a celebration of life.

Even though the New York scene was not her favorite locale, Doris Lee's superbly rendered canvases titled *Hudson River Excursion* and *The Catastrophe* met with critical acclaim. Her

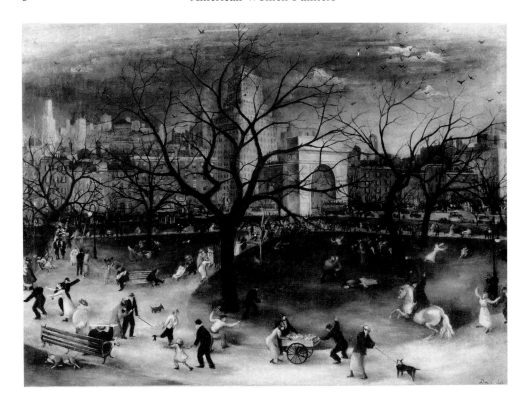

Doris Lee. *April Storm, Washington Square, New York City.* **Oil on canvas, 26″ × 36″, 1932. Museum of Art, Rhode Island School of Design. Gift of Mrs. Murray S. Danforth.**

ability to activate an objective portrayal as in *Catastrophe,* and then express a single subjective unit in a personal yet objective fashion as in *Hudson River Excursion,* enabled her to maintain personal spontaneity.

In *The Catastrophe* (see page 2), Lee has established four horizontal planes, each with appropriate activity: survivors line the shoreline; riverboats sail the Hudson; skyscrapers nestle on the opposite shore; and a flaming dirigible (zeppelin) explodes in the sky. All these events in a single painting provide a remarkably complete expression, but Lee introduces another dimension, parachutists, whose descent overlaps the remaining three horizontal planes in the process. It is this zest for life, whether tragic or joyous,

that Lee insists must be included in her work. And in the midst of it all dwells the Statue of Liberty, acting as a symbol of welcome for those both fortunate and unfortunate.

In *Hudson River Excursion,* Lee again consumes the working surface with numerous figures and objects, and delights the viewer with continuous excitement which is not contained to the riverboat itself. It overflows onto the water below and to the sky above. The frivolous clouds ride above the riverboat while whimsical waves anchor the sightseeing vehicle. Lee has jammed the riverboat with people while exercising the same technique to its surroundings.

In spite of success with painting New York city life, Doris Lee was

more at ease with the simplicity of rural life. In her painting titled *Noon,* she relates the human diversion of picnicking. A boy and a girl are nestled in a haystack while male workers nap under the hot sun. In this farm scene that departs from the drudgery underlining the business of farming, Lee sees the joyful activities that make life worthwhile in spite of the hardships that prevail. Lee's points of interest seem to lie directly in front of the viewer. The artist wants you to enjoy her paintings as much as she enjoys doing them.

The Heifer[6] portrays a country girl guiding a cow through a hay field while being escorted by the family dog. A mundane subject perhaps, but with vivid color and an avid love of nature, Lee uncovers a simplicity and charm that are frequently ignored. The knobs of hay which occupy the foreground recede into the distant landscape, delighting the viewer with glints of sunlight and shadow. The large oak tree acts as a haven for the charming trio while casting a shadow onto the surrounding grassland. The farmhouse, barn and silo in the distance add to the charm. Lee had enlarged the oak tree to symbolically protect the threesome and to establish a perspective between the advancing and receding objects.

Quite different is the composition titled *Maytime* (see page 16), in which the viewer is confronted with the charming country girl picking cherry blossoms. The foreground is smothered with cherry trees, fence posts, rocks and clumps of tall grass, while farmhouses blend into the distant background. An almost cloudless sky is pierced only by four birds flying in the distance.

The beauty of nature is exemplified by the direct statement of visual truth. However, the major difference between Doris Lee and other artists who portray similar scenes is the zeal for things as they are and not for things as one wishes them to be. Lee seems to waver between the simple arrangement of nature as seen in *The Heifer* to complex compositions as seen in *The Farm in the Spring.* Lee executed several preliminary drawings, and established a location on the canvas for each. For example, the farmer plowing his land is inappropriate in terms of location, and yet it was essential to the artist that a spot in the painting be reserved for him.

Lee loaded her canvases with love—in this case, love for the young child by the well, for the old lady and her grandson, for the farmer and his horse, for the milkmaid, for the animals hidden in the barns and grazing in the fields. And on center stage is a swing built for two couples in love. Thus, the viewer is treated to an intimate journey through a Midwestern farmland.

Doris Lee frequently selected a single activity as a focal point and repeated similar compositional techniques to sustain the whole. In *The Widow,* a strong country girl strains to tame two ferocious horses. The dramatic composition formed by the tension created between the outstretched arms of the girl and the stubborn headstrong horses is repeated in skeletal tree forms and the subtle maneuvering of the clouds. Determination is the key to understanding this dramatic event, and yet Lee presents the activity as a casual, perhaps daily affair.

There is a vast difference between

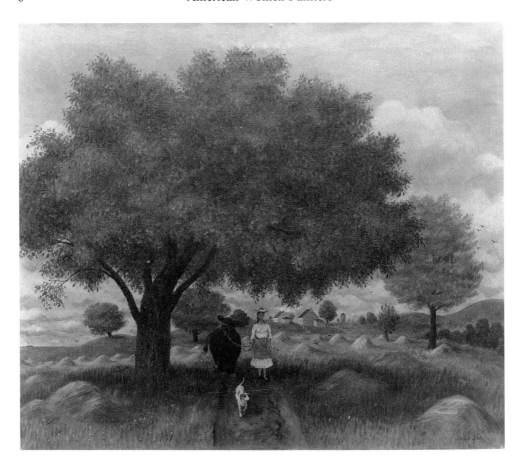

Doris Lee. *The Heifer*. Oil on canvas, 24⅞″ × 30″, 1943. Collection Nebraska Art Association.

Lee's works of the twenties and the thirties. Her earlier works, including *The Sleigh,* either hinge on primitivism or on the reality of appearance. A charm of innocence prevails. The stark, naked trees barricade the natural spaciousness of the outdoors and separate the activities into stagnant events. The farmhouse, barn and outhouse are shaped into simple geometric forms. The fir trees scattered throughout the countryside resemble simple childlike cutouts. The stillness of the scene is interrupted by the two horses prancing in the snow. The sleigh to the left of the painting leads the viewer into a typically pastoral environment. Although plain in appearance *The Sleigh*[7] is blessed with insignificant details which Lee considered important because visually they were to be made accountable.

Images of people generally flourish throughout Lee's paintings. However, in *Landscape with Hunter* the artist has placed at opposite ends of the canvas the two stimuli which activate the viewer. Within the space between the two role players, Lee has established a wooded area which lessens an immediate reaction. One is enhanced by the lush foliage almost to the point of losing the prey. *Landscape with Hunter* becomes a single

Doris Lee. *Strawberry Pickers.* **Lithograph, 7″ × 7⅞″, 1938. Palmer Museum of Art, Pennsylvania State University. Gift of Mrs. Francis E. Hyslop, Jr. from her husband's collection and given in his memory.**

environment in which two aspects of nature compete for attention. Because of the insignificant size and location of the dog and hunter, significance is actually heightened by the unusual appearance of each. Without the two role players, the intrigue would disappear. Her portrayal of trees, both nude and full blossomed, would escape as a total and complete expression in and of itself. She still manages to include a few birds which had become a peculiar trademark.

Doris Lee was fond of trailways, walking lanes, roads, sidewalks and bridle paths which led the viewer in and out of her paintings. In *The Well* the artist leads the viewer from left to right and while enroute, the viewer is treated to women and children gathering buckets of water for daily chores. The farmer rests from his horse and plow to satisfy his thirst, while the impatient dog waits his turn.

The Great Depression was an inspirational incentive for the artist. Although gloom and despair, poverty and starvation, crime and politics were often the criteria from which she acted, Doris Lee painted the serene, the quiet, the daily activities and moments of thanksgiving. The ideal example is her now famous *Thanksgiving Dinner (Day)*[8] which resides in the Chicago Art Institute's permanent collection. Movement, action, anticipation, preparation and anxiety describe *Thanksgiving Dinner.* The

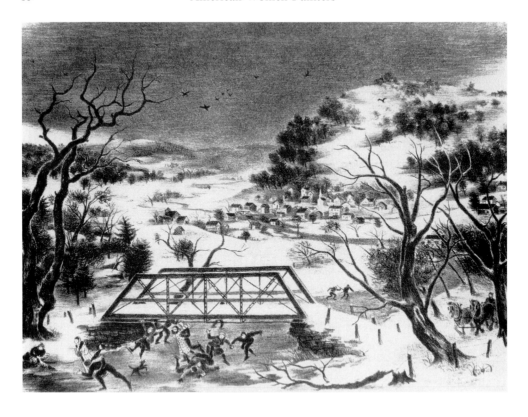

Doris Lee. *Winter in the Catskills.* **Lithograph, 1936. Collection of Madison Art Center, Madison, Wisconsin. Photograph by Wenzel Kust.**

locale is a country kitchen. The role players are mother, grandma, daughters and grandchildren all of which are assigned or unassigned to particular chores. The cat with the familiar ball of yarn, the faithful dog warming his weary bones under the wood-burning stove, the rolling pin moving roughly over the floury dough, the child feeding the family pet, the favorite aunt bustling about the checkerboard floor and the mother tending to the turkey make *Thanksgiving Dinner* an artistic treat. Unlike other bustling productions in which several unrelated activities are recorded, *Thanksgiving Dinner* presents events which corral a single purpose.

A complete compositional reversal from *Thanksgiving Dinner* is *End of Summer.* Passengers wait patiently while the oncoming train steams toward the depot. Lee's fondness for detail was never more evident. Her use of a roadway, path or trail to move the viewer across the canvas is well noted. In *End of Summer,* the railroad serves the purpose. It echoes welcomes and farewells, and during the thirties and forties was the bloodline for communities throughout the nation. And yet, Lee does not allow a single aspect of nature to dominate the scene. Even the railway is interrupted several times to lessen the anticipated speed of the oncoming train — a symbolic move to diminish the sorrow of ending the season. There are moments of glad tidings as

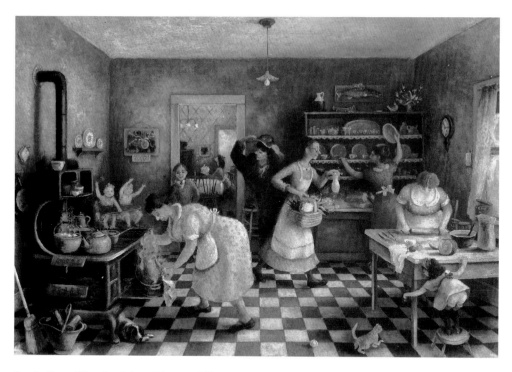

Doris Lee. *Thanksgiving Dinner.* **Oil on canvas, 71.4 cm. × 101.6 cm., 1935. Mr. and Mrs. Frank G. Logan Purchase Prize, 1935.313...**

friends and relatives exchange past experiences and anticipate new adventures. Lee's use of vertical lines creates a counterbalance to the natural horizontal planes of land and sky. This highly objective portrayal lacks intimate communication while sustaining a warm and friendly relationship. The tall telephone poles, the station depot and the waiting passengers assist in the compositional unity of *End of Summer.*

Occasionally Doris Lee would imagine pictures into existence. Rather than record the presence of daily activities and natural stimuli, she recalled from memory her favorite aspects of nature as in *Orchard,* in which cherry blossoms sparkle and cows graze in the tall grasses, not as they exist in nature, but as the artist envisions them. Each aspect

has its own identity embedded within its natural habitat, and yet each seems to float upon the canvas, although anchored sufficiently to permit reality to be recorded.

Orchard has three visible planes distinguished from each other only by color. Lee has utilized circular shapes throughout. Even the cloud pattern is echoed in the two-tone hides of the cows. And she again finds it necessary to include five birds hovering in the distant skies.

In further poetic fashion, Lee had produced a fanciful work titled *Siesta,* in which a brass bed covered with a checkerboard quilt and lace pillow sets in elegant repose a fully clad female form. Lining the bedside are remnants of pre-siesta indulgences, which were chosen from Lee's countless miniature sketches.

Lee constantly shifted from group activity to a single event. In *Runaway,*[9] the artist's style is altered to coincide with the theme. The speed of the runaway horse is transfused throughout the painting by brushstrokes which move horizontally across the surface. The galloping horse tends to move off the canvas surface, but the movement is reversed by the placement of a small wooden bridge to the right of the picture.

Although Lee painted during the Great Depression and World War II, her works reflected the gladness of life, family ties and the spirit of freedom and thanksgiving. She was never consciously influenced by her contemporaries, although there appeared traces of Thomas Hart Benton, Philip Evergood, Leon Kroll, Ben Shahn, John Carrol and Edward Hopper. She considered herself a recorder of life, but it was her love of people and nature that raised her art above simple recordings. The viewer identified with Lee's characters, whom she knew well. Her zest for life and for painting caused them to conjoin, thus strengthening her beliefs and attitudes about world crises. It was the immediate that counted, the now, but those immediate experiences became timeless. Her paintings and lithographs not only recorded a part of history, but life anew.

While the farmer works the field, his wife and family run the vegetable stand. This is the scene in *Farmer's Wife.* Again, a daily occurrence becomes a delight for Lee. It is this commonplace event which has no profound effects upon humanity that excites Lee and, in direct contact with real-

ity, she does nothing to alter the situation. Inconsistent influences filter into individual expressions in which a change of style transpires within a single work. In *Farmer's Wife,* Cézanne's influence is apparent, although Lee's study tours in Europe had influenced her work only slightly. It was Arnold Blanch who persuaded her to ignore European trends.

Lee claimed that she preferred to paint shapes rather than ideas. In her work titled *The Cemetery,* she did paint shapes — strange shapes — shapes that had individual meanings. Free to exploit the hundreds of detailed drawings of intimate objects, she designed her own personal cemetery. Set upon a single horizontal plane, a variety of shapes are indeed evident, but each is decorated and positioned for full view. Each gravestone is delicately expressed and given a spacious environment, allowing for a freedom of acknowledgment without interruption. The combination of the linear and textural brushstrokes resemble a Shahn landscape.

Lee's love of life is obvious in her portrayals of daily experiences, but it was never transferred to her objective still life paintings. Dealing now with inanimate or artificial objects, Lee objectively arranged commonplace items in such paintings as *Pink Mirror, Jewel Box, Sewing Box* and *Fishing Tackle.* These academic works were initiated by European influence, and eventually led to semi-abstract works.

All artists experience trends and challenges. For Doris Lee, still lifes were a dead end, and after the usual

Opposite: **Doris Lee.** ***The Cowboy's Ranch.*** **Oil on canvas, 24¼″ × 44½″, c.1939. The Carnegie Museum of Art, Pittsburgh. Bequest of Charles J. Rosenbloom, 1974.**

experimentation and frustrations, she once again returned to the nature she loved and lived. In *High Tide,* a title suggesting a dramatic event, Lee presents a delightful country girl wading ankle-deep through water covering a country road. The fluid expression has the usual perspective techniques; yet, the artist includes the horse grazing in the tall grass and ducks enjoying the flooded water.

Less fluid in execution is the work *Fisherman's Wife*[10] (see page 4), which articulates in formal balance an immediate and detailed homestead. Each item is conceived and carefully situated to form a display of plants and flowers. The simply dressed wife stands proudly on the porch of the simple but decorative home. Fishing poles, braced onto the vertical pillars of the front porch, extend upward to overlap and interrupt the staid rooftop. Palm trees in the background identify the general locale. The highly decorative painting is a delight to behold. Simple horizontal and vertical lines are discreetly applied but are frequently overlapped by climbing vines and winding ivy.

Two paintings of similar styles are *Rendezvous* and *The Inlet.* In *Rendezvous* the viewer is drawn into the painting and follows the fisherwoman and her horseback companion. Amid a similar environment is *The Inlet,* which offers a simple depiction of a woman in a rowboat holding a fishing pole. A similar depiction shows a man fishing. Both figures face opposite directions, causing an activated space between the two. To insure a compatible composition, Lee introduced aspects of nature outside the circular shape in which the two boats appear.

Rodeo[11] introduces a modified

baseline onto which the major characters are anchored. Spectators line the fence, and to avoid a monotonous horizontal plane, Lee had unhooked a fence section and opened it slightly. Although the action occupies the center of *Rodeo,* the viewer is occupied with those watching the action. The major audience occupies the upper righthand corner of the painting. Lee had established four horizontal planes, each connected with the vertical figures in the foreground and the animals situated in the center plane.

Shore Leave[12] is unusual because it departs drastically from what is usually associated with sailors on leave. Lee's contemporaries such as Paul Cadmus, Philip Evergood, Reginald Marsh and others whose paintings generally focus on the urban locale, have gained notoriety for their efforts. Lee has established a coastline for a single sailor playing a guitar and serenading his girl while several ships sit in the ocean awaiting his return. The painting itself is cluttered with shoreline plant life and a circular marble table loaded with fish and other edibles. The ocean, occupying the middle plane, is saturated with ships and boats anchored at various depths. And the upper plane (sky) is flooded with birds. *Shore Leave* presents a bit of fantasy by the sailor, by the girl, or perhaps by the artist herself.

Her painting titled *The Beachcomber* reflects a "shore leave" more than the painting given that title. It depicts two sailors walking down Main Street while being eyed by a girl in a nearby apartment building. The door is open as an invitation to their entry. Why are the sailors walking on the street instead of the sidewalk? It is strictly a compositional technique

on the part of the artist to join together three of the four horizontal planes. The spacing of the sailors from the girl is significant. The distance between the two factions becomes activated as the sailors move toward the invitation. It is this anticipation of an event that enthralled Doris Lee, and yet at times such an expression seems routine.

Occasionally Lee had enlarged her characters so that the viewer became intimately involved. Similar to *Holiday* in which a family is closely scrutinized, *August Afternoon* pictures a mother and child engaged in dialogue. Playing the leading roles, they are positioned near the center of the painting, flanked to the left by the edge of a cornfield and to the right by towering vineyards.

Lee was at her delightful best with her panoramic, fun-filled, objectively portrayed events of everyday America. At a distance, Lee recorded whimsical, zestful lives, people dedicated to the joy of living. At close range, she tended to strait-jacket her characters. Even in *August Afternoon,* the free-flowing exuberant sky is cemented in place by the stalwart figures of the mother and child. There is a seriousness, a tautness, almost as if the characters were aware of the artist's intention.

In *Timmy,* a neatly dressed woman decked out in a flowery hat, lacey blouse, printed skirt and coordinated handbag, poses for viewer approval. A gold-plated necklace splits the blouse's monotony. *Timmy* is a strong painting, yet it lacks the freshness of her candid landscapes. It reflects a change of pace, a form of discipline imposed in order to remind artist and viewer of structural anatomy and the security it affords. The

background is flatly executed, which amplifies the objectivity and serious intent.

In the painting, *Marie,* however, Lee succeeded in expressing a genuine tenderness, and the background sustains a technique similar to the portrait itself. An endearing child gazes wistfully into space, almost a mute plea to the viewer for a friendly smile or amiable gesture.

In a dual portrait titled *Pastoral,* Lee again reveals her love of nature. A country girl dressed in a printed blouse and skirt holds a flowered hat with one hand and feeds wild flowers to a friendly goat with the other. A fishing pole lies in the tall grass while her left foot shares the cool waters of a stream with a frolicking fish. *Pastoral* resembles one segment of some panoramic landscape by Lee.

Because of her love for nature, Doris Lee accepted a commission to do a series of paintings for the state of Michigan[13] along with other contemporary painters, notably such artists as Aaron Bohrod, Zoltan Sepeshy, Charles Lopez, Arnold Blanch, Joe Jones, Adolf Dehn, John S. DeMartelly and David Fredenthal. This was in 1946, and one of the first paintings in this series was titled *Spring in the Fruit Country* (also called *Michigan Cherry Countryside*)[14]; in it she delighted in sharing with her viewers acres of trees of cherry blossoms spotted throughout the countryside. Sort of in a patchwork quilt effect, Lee sprinkles the cherry blossoms amid the typical rural homes, windmills, barns and livestock, and in spite of the small segment of blue sky lining the top of the canvas, Lee insists upon the inclusion of birds flying in the distance as if to omit them would be to

Doris Lee. *Maytime.* **Pastel, 22″ × 27″, 1936. The Butler Institute of American Art, Youngstown, Ohio.**

exclude an aspect of nature deemed significant.

The focal point of interest is less obvious than in her other works. Because of their significance, the cherry trees tower into the sky, allowing the buildings to remain secondary in importance. Yet, it seems every farmer had grown cherry trees since a plot of trees lies adjacent to every farmhouse. Her handling of recessive characteristics is unique. As aspects of nature recede into the distance, color remains intense. Only the objects become smaller, which creates an optical effect that is strangely acceptable. Doris Lee's charm is evident throughout the painting, and it is this charm that had become Lee's trademark.

While many art critics might dismiss as childishness her depiction and placement of objects, the fact remains that within these childlike expressions is a sophisticated delicacy called intimacy. It is because of the innocent touch that her work typifies the child's unaffected charm. It is being a child that makes the child charming. It is Doris Lee's intensive delight with life and nature that adds the sophistication which differentiates it from that of the child. In her painting titled *The Little Red Schoolhouse*,[15] Lee adheres to no artistic criteria, no instructional motivation. It is refreshing to ignore the intellectual philosophies, abstract concepts and scientific research, and simply inhale

the aroma and visual beauty of Lee's landscapes. The little red schoolhouse has served various purposes in Lee's work. The same basic structure has been used as a church, a farmhouse, a schoolhouse, a garage, a barn, a service station and a log cabin in the wilderness.

It is interesting that Lee portrays nature as significantly larger than humans themselves. A case in point is Lee's painting *Michigan Cornfield,*[16] in which she diminishes the size of the hunter in order to play up the importance of the towering corn stalks. The activities of the hunter, dog and prey serve as an added attraction to the corn which monopolizes the center portion of the painting. Predominant in the center of a triangular composition is the typical fence which prohibits trespassers.

As with most artists, a change of pace is often noted in Lee's work. She gives us a close-up view of nature in two paintings, titled *Early Spring Flowers* and *Michigan Treetop.*[17] In the former, the artist concentrates on a variety of wild flowers neatly tucked into vases, the whole composition resembling a line-up at a county fair. She forsakes the spontaneity normally to be seen in her colorful landscapes for a tight exact composition of flowers. The pattern of vases is balanced by the strong legs of a table upon which the vases and flowers are anchored.

In the case of *Michigan Treetop,* Lee focused on the delicate tips of branches holding superb apples in all their splendor. In each of these paintings the surrounding space seems an underlay of color for the more positive aspects of nature. The background is divided between the ground and the sky and overlayed are the leaves, stems and apples of the Michigan landscape. Again, taking part in the picture rather than being the main source of motivation is a lusciously colored bird poised as if to join in the fun.

Doris Lee has clung to much of the baseline theory evident in her early childlike attempts to anchor herself to her environment. In her painting, *Little House,*[18] which is a typical one-sided view, Lee anchors the house in perspective but refuses to do likewise with the sidewalk leading to the side door of the house. It is in a sense this inconsistency that promotes the charm of Lee's pictures. The focal point of the painting is the little house, which actually looms large on the canvas flanked by colorfully formalized trees.

As mentioned earlier, Lee has consistently overcome the numerous stereotypes of a childlike approach to art with an abundance of lush color and a charming primitiveness. In many of her works she consistently ran sidewalks off the painting, roads into nowhere, and employed other elements of cuteness. Brushed upon the canvas by any other artist, such stereotypes would be inadmissable, but under the sophisticated vision of Doris Lee they became masterful images appropriately functioning.

Over the years Lee's work varied little. Yet it hinged on a realistic approach to life, not only as a visual recording, but as an emotional reaction to the joys of life. Hers is the type of painting that will be cherished in times when joy and delight become as essential as the clown's laughter and antics in times of sorrow.

Weekend Cabin[19] possesses a primitive charm, a quietude that ideally describes the peace of the locale. The gentle, smooth lake

surface sustains the stillness of the oarsman's aura, and there is a particular intensity that prevails between the boat's occupant and the pier, which extends into the water, and which leads to the cabin inland. This anticipation or wonderment remains a mystery. The small rectangular shape of the lake cottage became the trademark of Lee's buildings. The innocent approach is evident with the occupant in the boat and the direction it has taken. One senses a surreal atmosphere at the placement of the three horizontal planes. Instead of receding, one sees an upward trend. Furthermore, the extension of the dock into the water and the trees into the sky are the only means of union between the three planes.

Michigan Farmyard[20] is a typical Doris Lee farmyard. The roadway splitting the individual farm is interrupted by an obvious compositional technique. A grain cart, although positioned on farmland adjacent to the roadway, overlaps the roadway thus lessening the visual speed of the viewer looking at the painting. Visual perspective is evidenced in the diminishing roadway and in the receding of telephone poles and buildings. The main focus is on the farmer feeding his livestock. The red barn with white trim illustrates the prosperity and general neatness of the Michigan farm.

The *Michigan on Canvas* series proved an essential segment of her artistic career. Of the commission, Lee stated, "I guess it is because of Michigan's rich woodlands that I found the prettiest wildflowers in rare abundance. It was like a dream driving through the blossoming orchardy country."

Among other commissions was

Life's in 1944 for Lee to paint four canvases from scenes of the musical comedy hit, *Oklahoma.* The scene, *Out of My Dreams,* pictures three dancing girls in frolicking gestures, while located to the left are the bride and groom and other role players about to take their turns on center stage. Lee's painting reveals the real participants on stage and the backdrop scenery which serves as the environment.

Train Arrives in Sandrock differs from *Out of My Dreams.* It reveals the entire cast as the train arrives at the depot. It is a panoramic view of the outdoor sets and the cameramen in action. It is more than a Hollywood version of an episode in Western American history. It becomes a segment of American society of the forties. Aside from the commissioned series, Lee expressed the landscape of Hollywood in other works. Particularly noteworthy is the portrayal of a Hollywood home. It is a typical mansion surrounded by towering palm trees. A beautiful fountain graces a circular lawn which is surrounded by an immaculate sidewalk. Enclosing the entire property is a cement wall adorned with an intricate wrought-iron gate leading the viewer onto the scene.

Off Laguna Beach, Lee expressed perhaps her most whimsical and fanciful portrayal of nature. Titled *Bird Rocks,* the painting reveals various types of birds roosting on triangularly shaped rocks along the shoreline. Applied over an underwash of color are flocks of birds in varying degrees of action freely drawn to reflect the precious freedom of life.

A follow-up is *Prospector's Home* in which Lee lines the waterway with birds. There is a linear technique found in both *Bird Rocks* and

Prospector's Home, a technique which seems to reflect an afterthought. Doris Lee had occasionally sketched in new ideas onto a painting after it had been completed. *Prospector's Home* is a vertical painting divided by a river flowing back into the distance and into the mountains beyond. Miners' shacks line the river front as a sign identifies the site as "Phantom Gulch." To reflect Lee's flair for the whimsical, two birds are perched upon a high boulder nestled in the waterway in the forefront of the painting. Scribbles resembling animals, birds and people occupy the creek shoreline.[21]

The unusual painting *Haunted House,* in which 14 windows prevent a pattern of monotony, does not identify its source of motivation. The ancient house occupies the center of the painting and is flanked by partially clothed trees lacking foliage enough to favor its dramatic structure. Each window is slightly altered in appearance to avoid repetition. In an upper story window is a screeching woman whose destiny is left to the viewer to determine. The lengthy front porch is barely supported by timber rotting through age and neglect. There is an exciting distribution of light and dark forming eerie movements of shadows. The simplicity of composition is offset by the dramatic application of paint and the effective use of overlapping segments.

Artists generally work in a single style while producing several similar works before discovering a new approach. Lee has shifted to and fro from realism to a childlike primitivism throughout her career. Paintings such as *Landscape with Fisherman, Landscape with Hunter* and *Strawberry Pickers* sustain a consistent

technical approach and color scheme as well as a compositional technique of activating space between the two role players. In *Strawberry Pickers* (see page 9), Lee placed a small tree between the two female pickers which did little to interrupt the tension between the two. The several trees surrounding the figures become subordinate to the activity itself.

Landscape with Fisherman presents a similar relationship between the fisherman and fish. An added attraction is a series of winged tree branches aping the arched shape of fishing rod and line of the fisherman. A bit of contrast results from the addition of a pair of cows grazing peacefully and the action of the fisherman. The major characteristic of all three paintings—the characters themselves—are overpowered in size by the dramatic structure of the surrounding trees, but it is precisely this contrast in size that creates the significance attached to the role players.

Winter in the Catskills (see page 10) is one of Lee's popular paintings, very similar to *The Catastrophe* and *April Storm* in its panoramic view of seemingly endless activity. Packed with energy and enthusiasm, its central theme is flanked by gnarled trees in what seems to be an attempt to hem in the excitement. Yet, Lee's spontaneity overflows into the background and into the distant mountains. The ever-present birds fly relentlessly high above the excitement, but close enough to be part of the celebration.

Sunbath is one of the those dreamlike paintings which hinges on fantasy. A nude female figure lies leisurely in a rowboat in the company of a pelican who gawks wonderingly at the rather cumbersome body of flesh.

Doris Lee. *Girl Sewing.* **Oil on canvas. Courtesy of Terry Dintenfass Gallery, New York, New York.**

The unattractive form, with elbow resting on what appears to be a pillow, stares into the sky. Her left foot dangles into the fluffy waves of the water current. Tall swamp reeds act as a backdrop while soft billowy clouds run parallel to the tamed ripples of water anchoring the boat. *Sunbath* is similar in theory to Lee's painting *Siesta,* in which she combines pleasures of the indoors with those of the outdoors.

Such single portrayals are rare and Lee seems more successful with panoramic landscapes such as *Pastoral,* a Midwestern farm scene at dusk in which several objects compete for attention. Horses graze in the fields, a tractor rests in a shed, a farm girl feeds a hungry goat and buildings dot the landscape. *Pastoral* is a study of darks and lights. The darkened sky

is relieved by white clouds receding into the distance. Light and shadow roam the foreground as a solemn glow of peace resides throughout.

Similar in composition is *Evening,* in which a woman ropes her rowboat to the dock after a peaceful tour of the lake. Two young passengers sit obediently awaiting the cue to disembark from the boat. The basic composition of four horizontal planes is topped and anchored by object-free areas. The two central planes consume the brunt of the activity. A projecting dock pierces the center of the painting; two rowboats are moored to it. The three people are also a part of the dock area. In the distance are doll-like buildings suggesting a lake village. A lighthouse, hotel and several homes dot the shoreline. Lee has touched off

her painting with the inclusion of several birds appropriately perched atop dock posts, adding to the joy of the scene.

Throughout her career, Doris Lee expressed a love for life. She saw in others the beauty of life, a freedom from frustration, a freedom from tyranny, from despair. She refused to remind us of the sorrow, failures and death of the human condition. In so doing, she lifted our hearts and our minds to a better world. She did this with entire social communities and with single portraits.

Several of her lithographs were inspired by her paintings, such as *Country Wedding* and *Thanksgiving Dinner.*

Other lithographs include *Helicopter* and *Girl with Dove.* In *Helicopter,* the strange machine that hovers over the Midwestern farmland stuns the onlookers. The farmer and his farmhands, along with the family goat and geese, stand in amazement gawking at this weird whirling machine. And standing obediently are the immaculate rows of well-groomed vegetables—the tall, healthy cornstalks towering over the farmer's wife and daughter as the helicopter guards the entire proceedings.

Compositionally, *Helicopter* is a typically compact arrangement of farmland essentials. Even the textural forefront is balanced by the cloudy skyline. The textural environment is interrupted by the plain, wooded farmhouse and barn, Lee's habit of sketching single objects and then spotting them throughout her paintings is evident in *Helicopter.*

In *Girl with Dove,*[22] Lee presents a rare closeup of a young girl wearing a lacy white dress complete with petticoat. A fancy flowered hat tops off the ensemble. The two vertical ropes attached to the crossbar of the swing avoid a run-off as a tree branch crosses behind them to form the upper horizontal plane of the rectangular composition. The black figure forms an intense contrast with the lacy white dress as the girl gapes at the white dove. The viewer is first drawn to the startled look of the young girl and then to the dove. The distance between the two is called "activated space." It is the space between two objects or figures that appears inactive but which becomes active because of the anticipation of a possible happening.

It seems logical that the paintings of these subjects were done before the lithographs, because the printed images were reversed from those of the paintings. Of all the printed media, the lithograph is ideal for the open and free expression that Doris Lee is noted for. Since color is eliminated (except of course for black and white), her lithographs take on a dramatic effect that is sometimes lost with the addition of color.

As an illustrator of books, particularly that titled *The St. Johns,* Lee excelled as a linear graphic artist. The same details witnessed in her paintings are evident in her various line drawings ranging from single portraits to group figure compositions and panoramic war scenes. There appears that usual wit and humor which is ever present. It is a subtle humor which is of a personal nature, and because of her exuberance, it flows into the mainstream of viewers.

Her illustrations were both deliberate and reluctant, and yet they were honest. Her capacity for life was reflected in her drawings related to the "melting pot" of America. She left no

doubt in the viewer's mind, or in the minds and hearts of immigrants, of the abundance of America's resources. The soon to be established American citizens are treated to rich farmland, grazing land, ideal climate—a heaven on earth to people used to European frustrations. It is this optimism that permeates her life and her work.

In another illustration in *The St. Johns,* however, dealing with a scene of horror, Doris Lee fails to portray convincingly the extent and intensity of the tragedy, referred to as the river of blood. Hundreds of slaughtered Lutherans lie to rot, appearing more like sunworshipers than slain believers. This indifference toward death is in tune with her zest for life. Such a self-assignment seems alien to her sense of optimism.

She was at ease with such themes as are depicted in the chapter titled "The River of May," which described the Indians' greeting to the French explorers. The friendly, humble Indians were peaceful in nature and lived life with little notion of power or greed.

A family portrait, so to speak, in which the several major characters are portrayed, is revealed in a detailed contour fashion illustrating special traits of each.

Mare with Mule Colts brings into focus a segment of a Lee panoramic. Lee's love of animals is reflected in the joyful antics of the baby colts and the pride of the mare. The artist had positioned them within an apple orchard free to roam and eat at leisure. A pond is available for their thirst. Thus, Lee had presented a lovable trio enjoying life as it was meant to be.

Scenes such as *Spillway* and *The Bath* might occur to some viewers as being frustrating and troublesome,

but to Lee they are delightful. She accepted life as it was and revealed life as it was.

Perhaps Doris Lee best sums up her philosophy with the following statement: "I enjoy enormously the variety of things in America and like nothing better than a leisurely sketching trip through the Midwest, to make small, rough sketches of what I see and then return to my Woodstock studio to paint pictures these sketches suggest. The pictures probably lack accurate documentation, but what one remembers is far more important, isn't it?"[23]

However, her travels have taken her beyond the Midwest. Doris Lee's deliberate disregard for visual exactitude continued with her paintings of Mexico and Cuba. Her painting titled *The Overseas Highway* is cut in two by the image of the highway itself and flanked by flatly painted figures with fishing poles dangling over the rail. The ever-present pelicans circle the skies overhead while fishing boats, yachts and sailboats dot the waters.

The primitive approach succeeds because of the sophistication of the artist. Lee is well trained and convincingly positions her characters throughout the painting. This is not happenstance. It is finalized from several preliminary drawings of intuitive responses to elements encountered on her travels.

Almost identical but with a change of environment is the painting titled *Spring on the Highway,* which depicts Lee's description of the Mexican section of the Pan-American Highway. Cactus and yucca plants line the highway. The driving is slow, however, as Lee observed, because of animal obstacles. "A sheep or cow may wander across the road at any

time."[24] The ever-present birds fly freely above the animal-packed highway.

Doris Lee's charm and elegance is shared with her husband, who joins her in a twilight ride "in one of many sightseeing carriages parked in the center of Monterrey." "The flowers," she said, "especially the roses, overwhelm us." [25] In her painting *Twilight Ride,* Lee focused upon the carriage and its passengers and Saddle Mountain in the distance. There is a tremendous pride in the Mexican tourist trade and Doris Lee colorfully and elegantly portrays this Mexican enterprise.

In a painting titled *Chapultepec Park,* Doris Lee described the park thusly: "It is in Mexico City and is easily the most beautiful park I have ever seen. Horsemen and women ride by in fancy costumes. Strange characters sell ice cream, balloons and fortunes selected by trained canaries in a cage. Children are dressed up. Wonderful trees, foliage and flowers ... and monkey shows."[26] It is like a Sunday School picnic—elegant dress and innocent fun. Lee's figures look like cutouts, but their elegant charm surpasses the primitive nature of her characters. Lee had been labeled a sophisticated primitive, or primitive sophisticate. Her distortions are deliberate to suit the mood of her work. There is a daintiness, a careful primping of her figures which characterizes a certain restraint.

At times Lee will ignore the recessive elements of a picture. In *Chapultepec Park,* the Mexicans on horseback who are placed in the background appear larger than those figures in the forefront. This deliberate ignorance of the visual appearance of things is Lee's option and seems to deal with the importance of things from the point of view of a child.

Thieves Market, the title of one of Lee's paintings, exhibits another element of her travels. The two vendors of stolen goods show their wares to the open public. As Lee indicated: "Here you can ponder over fascinating things such as nails, keys, old purses, parts of electrical equipment."[27] Each item is carefully displayed to afford the buyer an ample view of all options. Again, the design gives way to the artist's personal sense of interior space.

Lee's placement of figures, particularly onto or into an object or animal, is forever a joy to behold. In her painting titled *After the Market,* mother and child sit atop a mule. The flatness of her figures defies the physical possibility of maintaining their positions astride the animal. It is the convincing manner in which she replaced the obvious requirements of physical reality with her own peculiar juxtaposition of figures that charms the viewer. The presence of birds, which frequently adds very little to the composition, adds to the personal pleasure of the artist.

Charm and beauty are also evident in her painting *Mexican Farmhouse,* in which a family of plants, pigs, chickens and children live in a garden of paradise. Lush color reigns throughout the unbelievable landscape. The house is all but overcome by the overflowing plants and flowers. The lineup of cut flowers carefully placed in vases and pots is a frequent image and indicates her own love of earthly things.

In order to give a full view and appreciate the total image, Lee seldom overlapped her figures or animals. *Mexican Farmhouse* was a

prime example. So too is the painting *Park at Oaxaca.* Even though figures recede and advance in space, each is carefully positioned to avoid an overlap which would hide a segment of each figure. Lee enjoyed her subjects, and her pride is revealed in the full range of dress design, facial expressions and body gestures of her subject matter. The park at Oaxaca is a place where people love to walk and talk. Lee had stated that "every Mexican city and village is built around a park with a bandstand, a center of social activity."[28]

Doris Lee frequently sacrificed perspective elements in favor of a fuller view of the scene. Such a painting is *Social Centers,* which illustrates a meeting place for women in Mexican villages for washing purposes. Lee has shifted the focal point (washing pool) from a front view to a top view, thus allowing the viewer to witness the action. Furthermore, the shift diminished the threat of figure overlapping which would have happened if the more natural front view had been established. The social center is similar to the current American laundromat which acts as a meeting place for news gathering and relaxation.

The primitive style of Lee matches the primitive practice of public bathing as witnessed in her painting, *Women Bathers.* Small village houses line the river bank as mothers bathe and wash clothes to the dismay of tourists. The river flow is interrupted suddenly by the female nude appearing unashamedly and peering at the viewer as if the intrusion was unwarranted. A fisherman naps on the dis-

tant river's edge while his dangling line affords the fish some discomfort.

The river in Mexico serves other purposes. In her painting *Sunday at Xochimilco,* the river becomes a canal for social boating. As the artist stated: "People often bring their lunches, sing and enjoy the flowers. Small boats with cameramen, flower girls, refreshments and musicians float by selling their wares."[29] The seemingly happy gathering is hampered by the crowded boat conditions, but nonetheless, endures the occasion. Lee's compositions are unpredictable. The inclusion of figures relies not always on compositional needs, but rather on personal or sympathetic choices. The jamming of figures onto the canal boat lessens the degree of enjoyment for the viewer as well as the occupants. Enjoyable occasions need not always be enjoyed.

Her trip also included Cuba, and her paintings of this country were quite similar in theme and composition to those of the Mexican landscape. The painting *Siesta* illustrates her primitive technique and the custom of the Latin Americans, an afternoon nap and escape from the midday sun. The balcony forms an optical illusion against the exterior wall, and the "delightful colored tile floor,"[30] as Lee described it, lacked the three-dimensional depth. However, the relaxed atmosphere is recorded, and typified the attitudes of the Cuban people. Such balcony engagements are status symbols which most Cubans could ill afford.

During the peak of her career, Lee had been enlisted as an artist

Opposite: **Doris Lee. WPA Mural. National Archives of American Art Washington, D.C.**

correspondent for *Life*. Thus, her assignments did not end with her travels in Mexico and Cuba. An extended stay in Hollywood proved enlightening. According to *Life's* staff, Doris Lee was ideally suited to record Hollywood's obvious contradictions, its peculiar exuberance and its splendid extroversions of color.

Typical of Hollywood's grandeur is her rendition of a sunlit mansion, which is surrounded by palm trees and fronted by an outdoor sculptural garden and pool. Lush flowers and foliage inhabit the environment. The locked-in mansion serves both thematic and compositional needs. The diminutive form bathing in the pool is well protected from unwelcome tourists. Giant palm trees, perhaps exaggerated, resemble clawing octopuses and thus recall some earlier portrayals of Lee's whimsy and fancy.

Grauman's Chinese Theater, as depicted by Lee, did not need to adhere to her whimsical expressions since it already displayed elements of fantasy. Lee again avoided the overlapping of figures. The sidewalk sweepers, the statues, the posters, the Chinese animalistic symbols are displayed as singular entities, each supplying its own message. Except for the positioning of one of the sanitation caretakers, Lee has presented a formally balanced architectural design.

The artist was also excited about painting *Schwab's Pharmacy,* a corner drugstore for Hollywood's somebodies and nobodies. Lee's Pharmacy is a delicate, charming, cardboard-like facade joined by an equally one-sided fruit market. Each figure is cautiously located so that each can be evaluated singularly. Lee has utilized the familiar baseline technique of children

even though the four figures are anchored slightly below the baseline edge. This is one of her few paintings to utilize an advertisement even though its use was spurred by the owner's popularity and the nature of the stimulus. The female figure to the far left adds to the feel of a comic strip with continuous episodes. Lee has recorded a popular landmark, but added charm and sophistication to an otherwise commonplace subject.

Still in Hollywood, Lee matched the landscape of the California mountain range in *Back to Nature* to that of her Woodstock environment. Eliminate the picturesque palm trees and Lee has portrayed the farmlands of the Midwest. Actually, what Lee had recorded so charmingly was the San Fernando Valley. Small sheds resembling farm outhouses are stalwart structures surrounded by lush flowery foliage. A young starlet muses amid the company of ducks, chicks, hens and a cowboy who trots upon a white charger. It is a delight to see Lee's ever-present birds soaring in the bright skies above.

Periodically, Lee has reverted to previously designed compositions such as *Costume Design,* which is a fallback to her lineup of spring flowers or rows of cornstalks. The painting resembles a fashion show minus the models or a Marshall Field's window display. Lee's delicate touch is reflected in the lacy, elegant designs within each costume.

An inner panoramic view is seen in her painting titled *State Fair,* and since Lee refused to overlap her figures, the participants maintain their individualities. The painting shows an excited director, and cameramen who are tediously studying the action. Large

floodlights focus on the anticipated crowd pleaser. Individual gestures were recorded of people in the bleachers. The circular composition enables the viewer to enjoy individual state fair enthusiasts from several angles. Patriotic flags and banners hang in appropriate locations.

Lee's Hollywood "period" entourage included the "sittings" of such popular screen stars as Edward G. Robinson, Lena Horne, Elsa Lanchester and Vincent Price, each attired appropriately for forthcoming films. Lena Horne's gown, designed for the film, *Ziegfeld Follies,* resembles a five-tier wedding cake topped with the beautiful ebony face of the star herself.

A similar pose sets filmstar Elsa Lanchester in the limelight as she fingers a delicate flower and fancy parasol. Also in character is handsome, pleasant Vincent Price for his role in *Dragonwyck.* The "checkerboard" vest was a delight for Doris Lee to paint. In all three portraits, Lee muted the backgrounds to afford the viewer personal insights.

A Hollywood sidelight of a nonfigurative nature is the artist's recording of Laguna Beach, a favorite weekend spot for celebrities and pelicans. Artist and bird colonies coexist and, according to Lee, the birds are "more impressive than the artists."[31] The scene allows Lee to escape from the rigors of set agendas and dictated stimuli. The result was a series of intuitive responses to scores of unshackled pelicans whose antics were as varied as the sea itself. The sheer delight of recording the gestured lines and shapes made for a symbolic life of freedom—uncontrolled, yet controlled by instinctive needs for survival. Color and shape wrestle with

each other, yet fuse into a compatible union of rock and sea.

Lee's success as *Life*'s artist correspondent continued throughout the forties including a final stint with a Hollywood production of *The Harvey Girls.* The painting titled *Heading West* depicts the baggage car of the Santa Fe railroad. It resembles a first class envelope with seven postage stamps glued in perfect harmony, another example of Lee's interesting lineup of images. Other paintings included portraits of John Hodiak, Angela Lansbury and Judy Garland in their respective roles in the movie, *The Harvey Girls.*

In a painting using the theme of Christmas, Lee has depicted a king and a courtier enroute to the scene of the birth of Christ. The king, in a richly colored velvety robe and laden with gifts for the newborn, seems to float over the land. If this were so, then the seemingly disproportionate castle is accurately recorded. Stereotyped pine trees dot the snow-covered landscape. A distant cabin awaits the king's arrival while the night owl glistens under a full moon. When visual perspective is ignored to suit the artist's impulses, new concepts are formed during the creative process. Lee was a master of the interchange of fantasy and realism.

As late as the early fifties, Doris Lee was commissioned to research the Arab world for *Life.* According to Lee, Morocco seemed "like the Arabian nights" and Tunisia was "straight from the Old Testament."[32] In her paintings, Lee pictured the stately camel caravans, the lonely shepherds with their flocks along the fringes of the desert and the domed tombs marking the burial places of holy men.

The exotic practice of Bedouins setting up their own kitchens is seen in her painting *Oasis,* which shows an outdoor restaurant. Lee's primitive style is evident throughout as the artist had employed several childlike features. The deliberate positioning of figures disregards visual perspective as seen in *Carthage Garden.* The beautifully textured stone walk — anchoring the Arab boy, with his wheelbarrow of newly excavated Roman fragments, and the missionary — extends not into the picture plane, but upward, intersecting the middle plane. Small feet continue to characterize Lee's human subjects, but add to the sophisticated charm.

Her *Tunisian Market* is a classic example of front/top views of items. Visual perspective is rearranged to suit a creditable marketing of the objects. Items are displayed from angles which most favorably enrich their qualities. Lee has become a master at spreading charm.

Doris Lee consistently painted lineup pictures. With each excursion came an appropriate concatenation of figures or objects. Her Arabian tour incorporated water bearers, musicians, nomads and veiled Moslem ladies. There is a precious deliberate appeal for attention. Lee shows off her characters. Her simple, proper designs affixed to similarly simple, proper people seem naïve, but a sophistication permeates the entire picture plane.

This same lineup is presented in her painting *Snake Charmer,* in which three Arabian musicians face the viewer with their traditional instruments hoping to claim for the snake charmer a few coins for his efforts. Lee was careful to individualize each figure with different costumes. The traditional small feet anchor the cardboard style role players. Her deliberate primitivism continues to charm her viewers.

Notes

1. The painting titled *The Catastrophe* is also known as *The Disaster* and is in the permanent collection of the Museum of Modern Art in New York City.

2. The painting titled *Arbor Day* is in the collection of the Encyclopaedia Britannica.

3. The painting titled *Illinois River Town* is in the collection of the Phillips Collection, Washington, D.C.

4. Doris Lee won the Carnegie Institute Award for her painting titled *Siesta* in the exhibition, "Painting in the United States 1944."

5. *April Storm* (Washington Square) was painted in 1932 and is now owned by the Rhode Island School of Design.

6. *Heifer* is a painting registered in the permanent collection of the Nebraska Art Association.

7. *The Sleigh* was commissioned by the Abbott Laboratories of Chicago and now resides in their permanent collection.

8. The painting *Thanksgiving Dinner,* also called *Thanksgiving Day,* won the honorable

Opposite: **Doris Lee. *Dress Rehearsal for Show Boat.* Oil on canvas, 27¾″ × 41″. University Art Collections, Arizona State University. Mrs. Clare Booth Luce, on extended loan May, 1968, given September, 1968, accessioned October 10, 1968.**

Logan Award. According to the artist winner, Doris Lee, "the repercussions in criticism that followed interested me, but when the huffy Mrs. Logan picked up her big guns and shot out such cannon balls as 'atrocious,' 'insanity,' etc., the situation for me became one of merriment. My innocent little canvas had started the pompous 'Sanity in Art Movement,' and through this fluke many people learned of my painting, who probably never would have normally. The Chicago Art Institute acted with courage and integrity, in spite of the protests of their influential patron, Mrs. Logan." The painting is owned by the Chicago Art Institute.

9. Doris Lee's painting *Runaway* is in the permanent collection of the University of Arizona.

10. *Fisherman's Wife,* a painting, is owned by the Cranbrook Academy of Art, Bloomfield Hills, Michigan.

11. From the Hollywood series commissioned by *Life,* the painting *Rodeo* is owned by the Fort Worth Art Association.

12. *Shore Leave* is a painting which won for Lee the Jerry Sesnan Prize from the Philadelphia Academy of Fine Arts.

13. Titled *Michigan on Canvas,* the series of paintings was commissioned by the J.L. Hudson Company of Detroit. The paintings are now owned by the Michigan Historical Society and are in the permanent collection of the Detroit Public Library.

14. Of the painting *Spring in the Fruit Country,* Florence Davies, Art Editor of the *Detroit News,* wrote in the catalogue, "Michigan on Canvas": "A three day Cherry Festival, which brings crowds of visitors from all over the State, is held each year in Traverse City, heart of Michigan's cherry-growing country, to celebrate the fact that Michigan produces more cherries than any other state in the Union." Page 12 of "Michigan on Canvas."

15. Florence Davies wrote of *The Little Red Schoolhouse:* "As in many sections of the country, the little red schoolhouse is still a part of the State's educational system." Page 19 of "Michigan on Canvas."

16. *Michigan Cornfield* is described by Florence Davies as follows: "An amusing sub-title to this artist's tribute to the small game season in Michigan might well be, *The Dog, the Bird, the Man.* This lone hunter carries one of 600,000 small game licenses issued in Michigan annually [this was in 1947]." Page 18 of "Michigan on Canvas."

17. Of *Michigan Treetop,* Davies has written: "Whimsey and humor play a large part in the reports of artist Doris Lee, who sees Michigan's apple crop in terms of fruit laden branches, which she has made into a border-like design." Page 27 of "Michigan on Canvas."

18. Florence Davies described *Little House* as follows: "Many little sturdy houses as this one, gaily trimmed with painstaking embroidery of the jig-saw artist, so popular in the seventies and eighties, dot the Michigan countryside. The well kept tulip bed, cherry tree and tall spruce are all typical of the central or farming section of the state, while the fan shaped rose trellis adds a touch of elegance, dear to the hearts of the country or small town families who take pride in their well kept grounds." Page 34 of "Michigan on Canvas."

19. *Weekend Cabin* is described by Davies as follows: "Such cottages as these, built in the deep shade of fragrant pines and hemlocks, each with its own little dock jutting out into the water, are familiar sights along the state's shorelines and inland waterways." Page 47 of "Michigan on Canvas."

20. *Michigan Farmyard,* painting on page 57 of "Michigan on Canvas," described as follows by Florence Davies: "The red barn and storybook horse are symbols of the prosperous Michigan farms. A typical country church is seen beside the road."

21. The paintings, *Out of My Dreams, Train Arrives at Sandrock, Hollywood House, Bird Rocks* and *Prospector's Home,* all are reproduced in the small book titled *Doris Lee,* published in 1946 by the American Artists Group, Inc., of New York.

22. The lithographs *Country Wedding* and *Girl with Dove* are in the permanent collection of the Library of Congress.

23. This quote is taken from the remarks made by Doris Lee related to her painting *Arbor Day,* which is in the permanent collection of the Encyclopaedia Britannica.

24. Quote is taken from the article titled "She Paints a Gay Record of Cuba and Mexico," which appeared in a 1947 issue of *Life.*

25. *Ibid.*
26. *Ibid.*
27. *Ibid.*
28. *Ibid.*
29. *Ibid.*
30. *Ibid.*
31. The quoted phrase was taken from the article, "A Painter's Portfolio of Impressions of Movie City," which appeared in *Life,* December 3, 1945.
32. "Like the Arabian nights" and "straight from the Old Testament" are quotes from the article titled "An Artist in Africa" which appeared in *Life,* 1947.

Bibliography

Advertisements for Abbott Laboratories. *Graphis.* 4 no. 21:28, 1948, and *Graphis.* 4 no. 34:27, 1951.

"An Artist in Africa." *The Britannica Encyclopaedia of American Art.* New York: Simon & Schuster.

_____. *Life.* December, 1947.

"August Afternoon." *Art News.* March 1, 1944.

Baigell, Matthew. *The American Scene.* New York: Praeger, 1974.

Cabell, John. *St. John's River.* New York: Harper & Row, 1953.

"Cemetery." *Art News.* October 1, 1943.

Comini, Alessandra, ed. *National Museum of Women in the Arts.* New York: Harry N. Abrams, 1987.

"Country Christmas." *Design Magazine.* December, 1948.

"Country Wedding." *Art Digest.* May 15, 1943, and *Art News,* May 15, 1943.

"Curio Cabinet" (textile design). *Time.* January 7, 1952.

Fern, Alan. *American Prints in the Library of Congress.* Baltimore & London: Johns Hopkins University Press, 1970.

Gruskin, Alan. *Painting in the U.S.A.* New York: Doubleday, 1946.

Henkes, Robert. *Eight American Women Painters.* New York: Gordon, 1980.

"Landscape with Fisherman." *Parnassus.* April, 1936.

Lee, Doris. *Doris Lee.* New York: Associated American Artists Group, 1945.

_____. "Michigan on Canvas." Detroit: Hudson's Department Store, 1945.

_____, and Arnold Blanch. *Painting for Enjoyment.* New York: Tudor, 1946.

"Maytime." *London Studio.* January, 1937.

"Noon." *Art News.* January 29, 1938.

"A Painter's Impressions of Movie Cities." *Life.* December 3, 1945.

Phillips, Duncan. *The Phillips Collection.* New York and London: Thames & Hudson, 1952.

Rubinstein, Charlotte Streifer. *American Women Artists: From Early Indian Times to the Present.* Boston: G.K. Hall, 1982.

"Rural Landscape." *American Magazine of American Art.* February, 1936.

"Sea Island Rendezvous." *Art News.* October 26, 1940.

"She Paints a Gay Record of Cuba and Mexico." *Life.* November, 1943.

"Showboat." *Art News.* April 20, 1940.

"Strawberry Pickers." *Art News.* May 21, 1938, and *London Studio.* August, 1938.

"Thanksgiving." *Art Digest.* November 1, 1935.

_____. *Art Digest.* November 15, 1939.

"Washington Square." *American Magazine of Art.* January, 1934.

"Winter in the Catskills." *American Magazine of Art.* October, 1934.

_____. *London Studio.* September, 1937.

"Woman Sewing." *American Magazine of Art.* November, 1935.

Loren MacIver

Among the growing number of women who rank very high among American artists of all time is Loren MacIver. Since childhood she has painted poetry of a tender nature. Her discovery of beauty in the most unexpected places — raindrops being swept off a taxi windshield, hopscotch chalk marks on a dirty sidewalk, the flickering monotony of vigil lights, the design of a mud puddle — has delighted the art world for many decades, and assuredly will continue to do so in the years to come.

Born in 1909, MacIver never succumbed to the typical teenage conformity of pictorially sophisticated art. She was always herself, and yet her encounter with high school art instructors must have been somewhat antagonistic, or the teachers were compassionately aware of her unique abilities and allowed them to develop. (Her career as one of the outstanding artists of America grew from a distinct love of painting. She avoided philosophical theory and artistic commitment. She simply never recognized the need, or was ignorant of any intellectual pursuit.)

Her love for life found haven in her tremendous interest in the theatre of music, drama and comedy as they relate to the simple things of life.

Her famous painting titled *Votive Lights,* commonly referred to in the Catholic church as *Vigil Lights,* characterizes the simplicity of faith of those penitents who push pennies and nickels through the slot in order to receive favors from saints of their choice. Yet, in order to transform the seemingly monotonous tiers of burning lights into an expression of vibrancy and urgency, MacIver has compartmentalized the lights in order to give each its own life symbolizing the individuality of its donors. Yet, within the compartments, the candles burn at varying heights indicating the length of time remaining for one's prayer to be granted. It has been said that a penitent's prayer is answered according to the degree of financial sacrifice rather than the amount of the donation.

Each of MacIver's several versions of a single theme was touched with intuitive magic. Highly acclaimed by critics, her "Votive Lights" series[1] eluded the common error of duplication. Each version is an experiment with color and movement. The constantly flickering lights, each contained within its own space, create a

Loren MacIver. *Red Votive Lights.* **Oil on canvas, 20″ × 25⅝″, 1943. Collection, The Museum of Modern Art, New York. James Thrall Soby Fund. Photograph by Rudolph Burckhardt.**

contemplative spirit which tends to die when the flame expires and resurrects with the drop of a coin. The simple faith which is symbolized by the flickering flame never dies, for there is a communion of prayers which absorbs not a single flame but the entire compartment of lights.

Frank Getlein referred to her votive lights as a cultural monument.[2] For whom is the monument established? Indeed, it is a unique Catholic worship. Votive lights are vehicles of faith, objects of spiritual transfusion.

MacIver carefully placed compositional areas where the eyes could "rest" in order to avoid monotony and congestion. In her version owned by the Pierre Matisse Gallery of New York, thirteen vigil lights occupy each of five horizontal tiers. Shadows and reflections caused differing effects in each of the 165 candlelit glass containers. Each votive light sustained a spirituality, a gift of faith, an answer to a prayer.

MacIver's compositional challenge while maintaining a consistent magical appearance was indeed the mark of a highly acclaimed talent. The composition technique is similar to that used in *The City.* However, in *Votive Lights,* MacIver extended the light beyond each singular geometric shape

in order to vary the petitioned responses. It is this religious tone, this spiritual, eerie sense of need to identify with someone greater than oneself that informed many of her paintings.

MacIver was not a painter of religious themes, but she was a religious painter. Her thoughts were of the universe, perhaps devoted to the forgotten aspects of nature. Hers was a world of wonderment.

Noted for her spiritual poetry, MacIver delighted in the discovery of nature's mysteries, which she expressed with delicacy and sensitivity. Hers is a tame art, if sophisticated. Remote aspects of nature become delightful expressions in the hands of Mac-Iver.

Her painting of the Crucifixion titled *Calvaire,*[3] painted in 1965, reflects the curious inquisitive nature evident in her previous works. Mac-Iver has established an altar slab typical of the early childhood baseline upon which she placed the cruciform. However, in spite of the fact the painting is named after the hill upon which Christ was crucified, the artist refused to include the main character. Again, the artist succeeded in imparting a sense of the inquisitive and suggestive. The cross becomes a dual exposure of forms, one representing the traditional crossbar, the other, the outstretched arms of Christ raised in a hopeful plea for reconciliation. Spots of splattered "flowers" scatter throughout the painting a sense of Easter Sunday.

The artist is seldom serious. Drama of tumultuous proportions seems to elude MacIver, who prefers subject matter of a childlike nature. Yet, a deep religious conviction seems clear. As MacIver explores nature, her mind functions beyond in the

world of wonderment and faith. The unusual becomes the springboard for intimate expression. In earlier work, MacIver would pit single aspects of nature against each other utilizing restful and activated spatial relationships to fortify her theme. In *Calvaire,* the artist's refusal of such relationships forces one to participate directly with the theme expressed. One envisions Christ on the cross, but one also envisions the universe surrounding and interpenetrating the figure of Christ, strongly suggesting His everpresence.

In a somewhat similar painting of the same theme titled *Bretagne* and also executed in 1965, the image of Christ is muted in color, shielding us from the agony of Good Friday. Instead, one witnesses Christ remotely visible shrouded by free-floating, flower-like specks of color. Her image of Christ stands alone on the canvas, which advances and recedes with equal mobility. The open eye of the Savior resolves both the compositional and symbolic purposes. *Bretagne* is an experimentation in color. Its poetic charm stems from intuitive forces which seem to flow freely from MacIver's brush.

This poetic charm was evident as early as 1935 as illustrated in her painting titled *Strunsky House,* and in her now famous painting titled *Hopscotch.* In *Strunsky House,* MacIver utilized a childlike theory of interpenetration, or x-ray picture as some art educators prefer to call it. *Hopscotch* was painted in 1940, and even though it would easily pass as a photograph of a single aspect of nature viewed as an enlargement of a physical detail, there remains an added dimension—that poetic charm that could only emerge from the

Loren MacIver. *Hopscotch.* **Oil on canvas, 27″ × 35⅞″, 1940. Collection, The Museum of Modern Art, New York. Purchase.**

intuitive insights of a MacIver. The design may uncover various interpretations as a suggestive image as well as reveal a statement of social decay and unrest, or mere physical neglect or simply a stimulus for action. What makes it art was MacIver's technical arrangement and unique approach.

Hopscotch reflects a mature sophistication on a childlike theme. Similar to the realist school of photography and the painting of Ben Shahn, the artist expands the commonplace beyond realism in terms of ideas, composition and technique. The title is misleading since the painting incorporates various aspects of childhood. Aside from the image of the game of hopscotch, MacIver portrays sidewalk scribbling and social community as reflected in the texture, age and general condition of the sidewalk.

MacIver's work symbolizes the everlasting. *Hopscotch,* for example, relates an image of continuous existence. The theme is as old as the artist and will continue to exist. It is as if creative images grew out of the cracks in the sidewalk and enveloped the surrounding space, jabbing at idea possibilities along the way. The emergence of a "little old lady," a distorted face with old-fashioned eyeglasses, a science-fiction monster activates the area of canvas adjacent to the hopscotch numbers.

This is an unusual statement, one of poetic charm and appeal which

captures the hearts of all youngsters who have utilized the neighborhood sidewalk as a surface of expression, and oldsters who prefer to reminisce about the "good old days."

Loren MacIver had that intuitive response to a theme. She practiced no particular style, but remained flexible throughout her career. To be able to respond to stimuli in a manner suitable to its nature and simultaneously render it with a mysterious charm is remarkable. MacIver possessed an inquisitive nature, a curiosity that defied the academic and intellectual schools of thought. There was always a ghostly, eerie appearance to her work, and it was this mystery that captured her viewers. She was unpredictable, spontaneous and almost oblivious of the world surrounding her, and yet, she became an integral part of it.

Sometimes the subject matter characterizes the artist. In *The Window Shade,* the artist reflects her own humility by her choice of stimulus, a simple window shade, which emerges as a masterpiece of symbolism and composition. MacIver has split her painting into three segments, each relying on its own focal point to sustain interest while blending into a total expression. The degree of interest would change according to the degree of change in the segments. Why is the window shade positioned at a precise spot? Is the reason to exhibit the shade, or to hide something? Or does it really matter? It becomes a mystery. MacIver's choice of stimuli reflected subtleties which are magical in nature and which challenge the intellect and soothe one's emotions.

Over the years MacIver dwelled on the cityscape as her principal theme, but has avoided futuristic abstraction and objective realism. Her expressions are realistic tidbits of life. Rarely has she painted a full and complete segment or composition except in such cases as *Venice* and *Portrait of Jimmy Savo.* In spite of an objective composition, her rendering of *Venice* is pure subjectivity. The majesty of *Venice* penetrates the vast ocean surrounding the city. The bright lights of the city mirror poetic mysteries of the deep as a whimsical sailboat glides leisurely through the blue Mediterranean. The vast ocean is activated by subtle nuances of reflections spiralling into the water from Venice's colorful cityscape. Again, MacIver succeeds in transforming an amateur photographer's familiar view of a skyline into a charming electrifying masterpiece.

In *Venice* the vast sea is activated in a textural fashion similar to a Ben Shahn landscape. The distant cathedrals whose spires pierce the stillness of the azure sky sparkle with zest and vibrancy. The beauty of *Venice* rests in the nuances of color which cast the viewer into a state of reverie. It matters not if objects are identified or exist as abstractions, for there prevails a mysterious charm of which MacIver was a master.

Eight years before the painting of *Venice,* MacIver finished *The City,* in which scores of New Yorkers plod through their daily lives. This panoramic view again relates to an early childhood characteristic of placing one layer upon another with complete disregard for visual perspective. This orderly congestion fits the hustle of New York City. Shoppers, transients, mothers holding babies, mothers wheeling babies, horses hauling their daily merchandise, workers, pushcarts, visitors—all vie for breathing space. MacIver created a three-

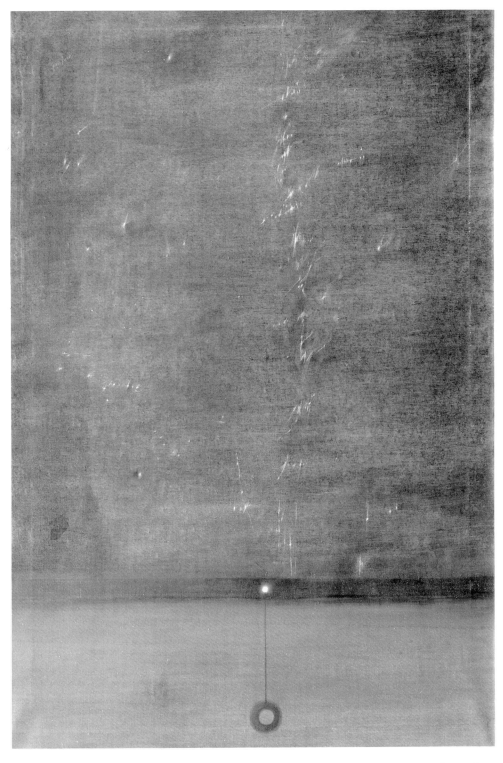

Loren MacIver. *The Window Shade.* **Oil on canvas, 43″ × 29″, 1948. The Phillips Collection. Washington, D.C. Acquired 1951.**

dimensional tension by nuancing colors and creating dark and light areas without losing the illusion of three-dimensional figures.

Painted during the same year as *Venice* was the unusual painting titled *Paris.* Even though MacIver purposely avoided artistic trends, influences of her contemporaries became evident. In the case of *Paris,* the cubicles stacked in recessive style is typical of earlier abstract techniques. The elusive approach in which contours are slightly obliterated create an eerie sense of abandonment. Even though visual perspective is applied, MacIver deliberately blurs the contours of definitive buildings and defines those which recede into the distance. This amazing panoramic view of a great European city is a testament to MacIver's diversity and flexibility. *Paris* becomes a lonesome city, a community of strangers, and yet sustains the MacIver charm.

Nowhere in the historical record of this amazing woman is there a representative or academic expression of life. MacIver's art transcends nature. Divine design succumbs to her artistic touch, but more significant is the transcendence of man-made objects of ugliness to beauty.

MacIver has retained images which find refuge in her work regardless of the year of execution. For example, her *Oil Splatters and Leaves* reappears again in her painting, *Calvaire,* painted 15 years later. Her reappearing symbolism represents her "falling in love" with the insignificant aspects of life. Her consistent repeat performances are a technique of recalling those things dear to her. And, of course, being in love enables the cultural world to further enjoy her boundless wonderment of life. *Oil*

Splatters and Leaves is less poetic than other works, yet it sustains a certain aromatic substance characterizing an inner strength of faith in humanity. MacIver was less noted for her flower paintings because they represented a universal theme. It is the unique theme — the rain on the windshield, the windowshade, cracks in the sidewalk, scribbles on walls, carving of names into the bark of trees — that MacIver made universal.

It was during the thirties that MacIver's view of the child became evident. In one of her earliest works titled *Winter Dunes,* executed in 1932 at the early age of 23, her inquisitive innocence was unveiled. The baseline, stick-figure, comic strip version of composition, objects tipping upward instead of receding into the distance and triangular-shaded houses are all seen in *Winter Dunes.* Her positive assertion and innocent approach create the charm and poetic illusion.

In *The Shack,*[4] executed two years later in 1934, MacIver again reverts to the childlike x-ray picture in which the interior rooms are analyzed from above. The shack is questionable, but it is her inquisitive nature that causes the viewer to react in a questionable fashion. The portrayal of childlike characteristics is natural for MacIver who uses them in a somewhat intuitive manner.

MacIver's inquisitive nature never faltered, perhaps because her imagination and artistic interest were never considered a combination. The duality simply occurred whenever paint was put to brush. MacIver had the tremendous capacity of fulfilling a vast area of emptiness with excitement and interest weaving through the entire composition. Not only is her painting

Loren MacIver. *Taxi.* **Oil on canvas, 48^{1}/$_{16}$″ × 28″, Wadsworth Atheneum, Hartford. The Ella Gallup Sumner and Mary Catlin Sumner Collection.**

titled *Taxi* proof of this ability, but this same painting provokes and promotes a social commentary typical of the city. The angle from which she depicted a taxicab is indeed unique. The observer is positioned in the back seat of the cab. Cigarette smoke figuratively filters through the painting. The viewer participates as MacIver would wish him to do.

With ideas similar to those in the works of Ben Shahn—in that the expression of a seemingly vast empty space is made into a close-up intimate revelation of life—MacIver eludes the precise three-dimensional qualities exhibited in Shahn's work, but manages in an even more difficult way to absorb the viewer's interest in an empty area by mysteriously and poetically displaying apparent excitement. *Taxi* focuses one's attention to the upper portion of the painting occupied by the rain-spattered windows. The subtlety of color, however, provokes excitement throughout the painting. The artist sensitively paralleled the ringlets of cigarette smoke to coincide with the direction of the windshield wipers. The common occurrence of everyday traffic becomes in the mind and hands of MacIver a masterpiece of universality. Throughout her long artistic career, MacIver gloried in the commonplace in order to give to the world a sense of belonging.

Although Loren MacIver's career spanned the two most devastating decades in American history, her artistic production ignored the Great Depression and World War II. While other artists gained fame depicting these two great themes, MacIver preferred the commonplace and its small miracles. Her painting simply titled *Puddle*[5] is such an example. It is

an extension of the childhood schema of viewing from above and at close range. *Puddle* and its counterparts of little miracles occur daily. MacIver maintained her blurry technique except for the fallen twig whose articulate image coincides with a similar image represented by cracks in the sidewalk. MacIver's *Puddle* is an example of a single aspect of nature residing within its own habitat, and to avoid monotony within this surrounding environment, she diligently positioned four small leaves at appropriate distances. Her magical charm emerges through the nuances of color and the delicate brushwork which unites the three natural portions of the painting.

In the same year, 1945, MacIver painted *Tree,* a single aspect of nature consuming the entire canvas surface. Thorny geometric shapes overlap and interpenetrate to form a naked tree extending upward. Its weblike claws are both foreboding and dramatic. There is a midnight, haunting sense of peril lurking in the misty background. A waxy finish or appearance creates a moonlit sky which is partially shrouded by the leafless branches.

Two years later and before her trip to Europe, MacIver painted *Emmett Kelly,* a remarkable portrayal of pathos. In a mysterious fashion, *Emmett Kelly* resides between sorrow and despair. MacIver's is not an anatomical study, but rather a study of make-up which eludes the facial structure. A provocative image of sorrow and tragedy dwells in the partially closed eyes and mouth. Wisdom is hushed and reality deterred as a pensive mood prevails. One seldom sees the clown outside the role of clowning. So precious are those artistic moments when the clown and the artist become one.

Kelly was a satirist, and Mac-Iver's intimate knowledge of his methods and personality enabled her to relate his life in a distinctive manner. Her subject sustains the look of frustration and profound sensitivity to the commonplace that marked his fame. For centuries the clown image has been a symbol of loneliness. The artist is similarly lonely. The union of the two make for an extraordinary expression.

The full face of Kelly thrusts the viewer into submission as his sorrow faces the viewer and forces him to come to grips with the life of the clown. MacIver deliberately avoids the precise detail that would normally be evident in a close-up view. Instead, she retains an emotional gesture-like appearance which sustains both the emotional and the intellectual makeup of the clown. The duality of the clown's existence never falters. This is the trademark of the clown and directly challenges the integrity of the artist. To execute both within a single expression is the mark of a unique individual.

This duality is echoed in her work titled *Portrait of Jimmy Savo*[6] in which alien aspects of the subject's personality were removed. Again, MacIver relies on the simplicity of the image, in this case, the clown. This simplicity of composition generally offers difficulties, but MacIver utilized simple gestures within the image. The repeated circular movements witnessed in the subject's round eyes, arched eyebrows, the turned-up mouth as well as the tilted hat band, the circular collar and the curvature of the cuffed hands, sustain the subject's personality.

It was this fusion of talent — an identification of artist to artist — and a sensitivity toward Savo's own feelings about the human condition that resulted in a truly artistic expression.

In *Circus,* MacIver abolished her close-up technique and positioned the clown image (Kelly) in a subordinate site. Without her poetic imagery, *Circus* could have easily become an objective portrayal with the presence of several aspects of the circus environment.

Not unlike Doris Lee (born also in 1909), MacIver was commissioned for several commercial projects which included magazine illustrations, book jackets, posters, greeting cards and murals. After success in several commercial ventures and one-man shows during the years 1940–1948, MacIver spent a few months in Europe, but in spite of her travels she was still at her best with American themes and natural stimuli. *Fratellini,* for example, although refreshingly different and reminiscent of Paul Klee and Joan Miró, remains less poetic than such works as *Votive Lights* and *Taxi.* In fact, such works as *Dublin and Environs, Naples Aquarium, Oil Spatters and Leaves* and *Early,* influenced by her European tour, lack the sensitivity of her earlier works.

Several paintings executed during the year 1952 shifted from magical realism, as witnessed in *Taxi,* to eerie, free-flowing abstractions as seen in *Les Baux* and *New York.* One cannot deny the poetic sense, the luminosity and the technical skill of *New York.* Yet, the anchoring of a single idea seems essential for full appreciation of MacIver's talents. In spite of her refusal to accept the influence of her contemporaries, infiltration of Rodin, Klee, Miró and others has lessened the magical charm of her work. Others may disagree.

Loren MacIver. *New York.* **Oil on canvas, 45″ × 74″, 1952. The Phillips Collection, Washington, D.C. Acquired 1953.**

MacIver has been a recorder of the simple things in life. During the midst of her success in 1946, she was quoted in the exhibition catalogue, "Fourteen Americans," as follows:

> Quite simple things can lead to discovery. ...My wish is to make something permanent out of the transitory, by means at once colloquial and dramatic. Certain moments have the gift of revealing the past and foretelling the future. It is these moments that I hope to catch.[7]

Ashcan, executed in 1944, is a mosaic design of geometric shapes. According to MacIver, "An ashcan suggests the phoenix; its relics begin a new life, like a tree in spring." MacIver has followed her own advice by transforming an ugly ashcan into a glowing geometric painting of exciting shapes and forms. The background is space, almost a floating arena on which abstract shapes vie for attention. The childlike technique of a front-top view of a single object relates to MacIver's option of choice according to individual subject matter. This viewer would have preferred a display of reality; that is, an exhibit of actual contents residing within the ashcan rather than an abstract version of the same.

A year later in 1945, MacIver presented an allover pattern of flowers. Titled *Mountain Laurel,* it is a top view of flowers in full bloom, varying slightly in size and shape and spaced in varying degrees of background freedom. There is a bit of looseness, an exuberance, and a sort of abandonment which prevails. Echoing throughout the painting are shadows and reflections which act as

Loren MacIver. *Les Baux*. Oil on canvas, 121.3 cm. × 101.7 cm., 1952. Gift of the Claire and Albert Arenberg Fund, 1953.465...

contrasting elements to the whole. The environment on which the flowers reside sustains a degree of irregularity and is defined by its outer perimeter. It is this informality which identifies the outer pattern that sustains the delightful theme. Flowers seem to float in space, and yet individually sustain their own identity.

Executed during the same year as her famous *Hopscotch* was a simplistic portrayal of a pair of shoes. Titled

Jimmy Savo's Shoes,[8] it is more than a simple recording of a banal theme, but rather an expression of the personality of a renowned clown. One relates to the possessor of the stimulus rather than the form itself. MacIver again uses the front-top view in order to best display all angles. There is a certain rigidity prevailing relating to the general routine of clowning, but there also exists a bit of looseness or flexibility allowing for a change of routine or intuitive ad-libbing. A dependency occurs, a form of security, an anchor, so to speak, which serves both as a safeguard and as an intuitive springboard.

Painted in 1953, *Fisher's Island* is an uncanny, unreal depiction of a mountainous isle. Composed of a simple horizontal division of four planes, an iridescent glow permeates the entire surface of the painting. Each of three mountainous humps bedecked in jeweled leis occupies the central plane while anchored by sprays of oceanic waves. The fore-plane resembles a pebbled beach similarly displayed in later works such as *Bretagne,* executed in 1965.

Even though *Fisher's Island* is a blend of magic and realism, there exists the need to return to the magical approach to realism as seen in *Taxi.* This ability to switch techniques in midstream, so to speak, is unique to MacIver's approach to life. This 1952 version of a daily occurrence and essential mode of transportation anchored MacIver to reality. It was essential for her to relate reality alongside the surreality of dreams. There exists the need to balance the two opposites either within a single expression or amid several paintings.

One identifies readily with *Taxi,* in spite of its unusual composition, and yet *New York* seems less acceptable. A blend of the real and unreal in New York seemed more unreal. There appear remnants of the real world with the night lights, tall buildings and the darkened luminosity of the city, but they are subdued, almost eliminated by the blurry overtones. Without the title, the painting would fall into disputable interpretations.

Even though MacIver's artistic growth was determined by such titles as *Fratellini, Early, Naples Aquarium* and *New York,* her fame stemmed from her magical commonplace themes like votive lights, sidewalk, taxi and hopscotch. There is a definite permanency in both the commonplace stimuli and in the subsequent paintings, while other themes record permanently those fleeting moments of life deemed worthy of expression by MacIver. However, MacIver saw no distinction between the two approaches.

In 1956, MacIver painted *The Street,*[9] a recollection of an earlier visit to Paris. This dreamlike creation hinges on a reality which seems hidden from view and a dream which emerges from a prior experience. *The Street* seems nestled in limbo, to come alive if only the mist were swept away. Her blurry, suggestive technique hides the reality of the street almost as if to preserve its charm. Its mysterious sense of untouchability creates an intimate, personal relationship with the subject. Because of its subjective nature, one who aspires to her strange sense of reality sustains a greater sense of fulfillment.

MacIver claimed that "you can't call the street by any one name, and you can't look for it." In other words, a street is a street is a street—and it is illusive, and MacIver made it so. *The*

Street is left indefinite, unidentifiable. Although initially conceptualized as singular frontages, each individual facade blended with another to form a series of buildings. This technical process contrasted with Edward Hopper's definitive technique in which a psychological chain of events combined to form a singular event known as the street.

Hopper revealed a loneliness while MacIver reflected a memory, a recollection of good times. There are no humans occupying MacIver's street. There is only recall. So the viewer communes with his own memories rather than identifying with individual characters.

MacIver's street is suggestive. It puzzles the viewer, who questions the activities behind the scenes. Her street is a mystery, a continuous mystery which starts and ends beyond the canvas, but the artist gives no clue. As one walks along MacIver's street, one may linger before entering certain establishments. There exists a certain delight in anticipation, but for MacIver it is more a reverie. And it is this dream, although fleeting at times, that MacIver wished to cement into one's memories. *The Street* is permanent and it is transient, like memory.

It is difficult at times to identify hidden stimuli that seep into MacIver's work. Her recall is both consistent and persistent. The magical charm of the least warranted object seems to appear even after years of neglect. In *Les Marronniers*[10] MacIver has adhered to the earlier stage of tier building. Horizontal planes were established, each recalling an oft-repeated theme and expressing it in a misty atmosphere of eeriness. There remains the primitive innocence which

is engulfed in a foggy glow of light whose source is seldom identified.

The most simple of objects became mysterious clues to an otherwise unsolvable mystery. *Les Marronniers,* executed during the early fifties, appears fluid amid a basically strong and definite understructure.

Similar in technique is *Naples*[11] which focuses upon a single aspect of nature. The ever-present underlying structure creates a three-dimensional depth, a consistent tension between several vertical planes. The shimmering glow of light dictates an ever-present hope, a form of rebirth. What appears to be intuitive in technique is instead a carefully conceived plan of execution. There is always a unique balance of spatial awareness and linear definition.

Although deemed a fantasist, MacIver nonetheless deals with facts. Her subject matter stems from life often ignored as trivia, but which actually forecasts and sometimes explains the socioeconomic status of life. It is the refuse of human society that determines future activity, and MacIver has been a master at uncovering social stigmas. In her works of the fifties she has broadened that base so that less intimate studies of the neglected aspects of nature are expressed. That neglect of nature by man has caused MacIver to revolt in a sense. She has resurrected the ugly in nature and transformed it into beauty. The charm and beauty witnessed in such works as *Taxi, Sidewalk, Hopscotch* and others are the results of a master artist whose observant eye and sensitive soul is in touch with a greater force than herself.

Au Revoir is a recording of past events. Identification is established by proper nouns of places. Recession of

space is established by the blurring technique while the advancement of objects is expressed in detail. A foggy atmosphere prevails throughout the central section of the painting while a linear focus examines the right and left portions of the work. Bits of memory became a panoramic delight.

MacIver's flexibility and intuitive process is again witnessed in the comparison of her works titled *The Street* (discussed earlier) and *Rue Mouffetard*. The front view of *The Street* is transformed into a top view in *Rue Mouffetard*. The famous boulevard easily curves its way across the canvas from bottom to top. Strung along either side of the boulevard are recollections of earlier works—sidewalk markings, flowers, marine life, textures—alongside lettered definitions of famous locales and sites. These markings emerge from the earth's surface and support the tendency to appear and disappear at will. These are indeed permanent objects made temporary, and yet, they are fleeting moments made permanent. The hypnotic trance which may evolve from meandering along *Rue Mouffetard* is a delightful experience.

Another comparison which indicates MacIver's versatility is *Irish Landscape* and *Hellenic Landscape*. There is a similarity in the eerie nature of the two scenes. Both exist amid misty atmospheres of uncertainty, although *Irish Landscape* is less definitive. There seems no rhyme or reason for the choice of technique for particular stimuli.

When MacIver's personal inner thoughts absorb her work, it is indeed difficult to fully understand the mystical even though a title tends to alleviate the task. In *Clochard* MacIver pictures what appears to be a cumbersome figure wrapped in gunny sack attire hoisted high above the city. The blurry, fuzzy geometric shapes diminishing and disappearing in the distance could represent city dwellings. The abstract mysticism of *Clochard,* executed in 1962, is heightened by a beam of hope positioned to the right of the figure.

Of her European stay during the years 1966 through 1970, MacIver seemed content to cement in place those fleeting moments which disappear in seconds or which linger into ensuing seasons. Her several themes of wind-blown trees and orchards as witnessed in *Vignes en Mistral, Deux Cypres Mistral* and others seem like intuitive responses to commonplace occurrences. Wind-blown orchards were drawn and painted at the scene, à la van Gogh. The viewer longs for her preoccupation with a single item of the commonplace.[12]

In her painting, *First Snow,* which seems to resemble an Easter Sunday rather than an oncoming winter season, MacIver reveals a momentary glimpse of a Parisian landscape. Flower patterns are diffused and blended into adjacent areas as if the definition would erase all magical charm. MacIver keeps the viewer wondering.

Logic evades the brushwork of MacIver. Since subject matter dictates her style, there is no predictability. A case in point is her painting titled *Patisserie.* A simple bit of pastry becomes a magical blend of Realism, Abstractionism and Surrealism. Hers is a personal philosophy not subscribed to by everyone. The making of pastry seems to imitate the evolution of life, a resurrection, the rebirth. Each bit of pastry has its own life, its own personality, and MacIver

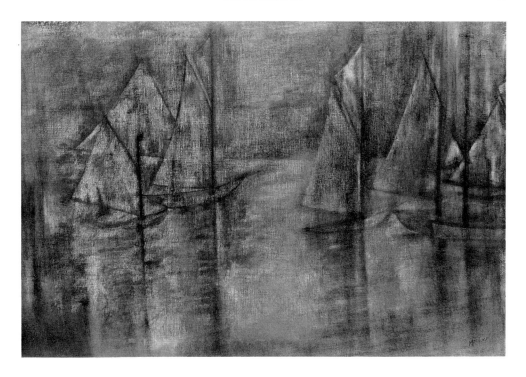

Loren MacIver. *Seascape.* **Oil on canvas, 24″ × 36″, 1939. Collection of the Newark Museum. WPA gift (through The Museum of Modern Art), 1943. Photo by Armen, September, 1969.**

transferred life from one bit of pastry to another.

Just as MacIver meandered through life, so too did her brush roam her canvas allowing instinct to prevail. In *Café en Provence,* although definitive in its composition, it is within each individual shape that meandering occurs. Seventeen diametrically opposed geometric shapes make up the entire painting. Within each shape resides peculiar choices of MacIver. Each depicted object, dreamlike in appearance, is reminiscent of an earlier recall of childhood activities or dreams. Shapes fuse into adjacent shapes. Others sharply define their own boundaries. Yet within each magical shape dwells intimate recollections of MacIver's memories, either of the French experience or of her American childhood.

Similar in appearance is *Annual Closing (Fermeture Annuelle)* which is horizontally divided into three sections representing the wall, baseboard and floor. The inside of the room becomes a flourishing array of colorful geometric shapes which float in space while activating shadows and reflections throughout the painting. MacIver both identified and bled the boundaries of each shape. She incorporated abstract shapes with no apparent logic except for compositional unity. The interior became a mirror of reflections shimmering in both light and dark recesses.

In a different vein is *Regard Fixe (Fixed Glance).* Closely resembling a Paul Klee, its two beady-eyed doorknobs glare at the viewer in some sort of hypnotic spell. The entire painting is a single aspect dwelling within an

eerie atmosphere of nothingness. Unpredictability and unknown environments remained MacIver's magic. *Regard Fixe* depicts a vertical slab resembling a door anchored to a geometrically formed floor mat and attached to a similarly formed wall. The three rectangular shapes are undefined. Instead, blurry borders render each shape unidentifiable, and subsequently blend into a complete and unified composition.

Winter Studio, The Cottage and *Coal Bin* are examples of the commonplace magically transformed into imaginative excursions. MacIver has used the blurry technique to soften the stimulus, and then elaborated on its surroundings so that not only are the titles misleading, but they are cause for the viewer to search for identification. The paintings might well have been titled Abstracts Nos. 1, 2 and 3. MacIver has identified the motivation for each painting, but in fact has transcended the initial idea until it is unrecognizable.

Contrary to the sense of permanency of the three aforementioned paintings, MacIver also thrived on the spontaneous, the non-reflective stimuli of fleeting moments as witnessed in her several versions of the wind-blown orchards or the first snow.

Pavés et Clous pictures pavement quite unlike that of *Sidewalk* or *Hopscotch*. A formally designed surface has gradations of darks and lights which shimmer and glow over an underlying structure of a rugged textural surface. Focal points are abstract in the sense that they are geometric in appearance. There exists an arc-like pattern which is interrupted only slightly by four circular spots not unlike those found in her early works of the forties.

Rainbow in a Room, painted in 1972, exemplifies the theory of interpenetration in which the inside and the outside coexist. It is this unusual stimulus that has raised MacIver to the heights in American painting. The rainbow becomes an ideological image serving a selfish need on the part of the artist. In spite of the intuitive force underlying the composition, *Rainbow in a Room* is intellectually conceived. The vertically shaped environments resemble the negative aspects of an ivy covered fence, two of which remain untouched. It is the middle rectangular environment in which a single aspect of nature (a leaf) enters the environment and eliminates the emptiness. There is an optical illusion caused by the interpenetration of forms, and it is this magical twist which adds another dimension to MacIver's work.

Several different versions of the same theme have found expression in MacIver's work such as *Votive Lights* and *Sidewalk*. In the case of *Fermeture Annuelle* or *Annual Closing,* the 1966 version represented the front view while the 1970 image attacks the composition from above. The 1970 is more abstract and encompasses a greater variety of geometric shapes. Brushwork appears more erratic in places causing a disturbance. Letters and symbols occur appropriately throughout the painting.

The artist's productivity lapsed until 1980, which was a highly rewarding year. One of the most exciting changes was seen in her latest version of votive lights, this one titled *Green Votive Lights,*[13] executed in 1980, some 40 years after her first interpretation. No longer are the vigil lights compartmentalized. Instead, they flourish without boundaries as if

all prayers had been answered, or the opposite, that evil had absorbed the scene. The delicate touch which marked the earlier images has disappeared. MacIver has loosened the flames in an erratic splurge, a final decision. This is a moving painting—no longer the wonder, the melancholy, or the notion of hope. It is now struggling to be free. The eeriness still prevails, but it is no longer calm. It has broken its ties and has thrust upon the viewer an explosion. Each light sustains its original position, but within its confines is disruption and chaos. But it is precisely the unity which exists as a whole incorporating these bits of chaotic events that makes *Green Votive Lights* such a remarkable piece.

A subdued version of this technique is seen in a work of the same year titled *Skylight.* Original geometric sections are slightly disrupted by brushstrokes which diffuse the rectangular shapes. The open-endedness of each shape adds to the looseness and freedom of each compartment. The viewer has several options of interpretation. It is indeed a skylight, but it suggests several earlier memories—the cross in *Bretagne* and *Calvaire,* for example, or the iron fence of *Tree.* It also resembles birds in flight.

Concave and convex images monopolize *Subway Lights.* Because of its personal adaptation, *Subway Lights* could be defined as a showcase for hats, buttons, candies or crystal balls. There is a lingering of the votive light flame registered throughout each of the circular forms. MacIver has created within each form an illusive image which dwells within each selected environment but which beckons the viewer to move outside

each circular form. The unifying force is the similarity of technique which reigns within each positive aspect and its surrounding environment.

The cluster of repeated images is amplified in a series of flower paintings executed during this celebrated year of 1980. *Hyacinth, Daffodils, Bright Spring, Caladium* and *Greenery* exist in various backgrounds, but all adhere to floating environments.

MacIver consistently repeated single themes, each with a peculiar approach. The theme of Paris is no exception. Her *Paris* of 1980 is small in size but momentous in concept and execution. This mystical rendition of a great city resembles a series of cathedrals whose spires reach into the heavens. There is an ethereal sense of searching. Brushstrokes move upward seeking out the spiritual. MacIver has painted religious ideas occasionally but all themes cultivate a spiritual essence. *Paris* is a highly personal rendition, an intuitive response to what is a city of cathedrals which, in turn, inspire greatness from a humane viewpoint.

Another painting of the eighties is *New York Sunset,* an abstract utilizing the forces of earlier works. The reds, oranges and yellows fuse into a stunning display of action highlighting a great city. The overlap of vertical and horizontal planes representing distant skylines and closeup commercial buildings is intercepted by a delicately rendered leaflike branch.

A final series of paintings was exhibited through the year 1987.[14] The more brilliant of these included *Happy Birthday, Dogwood Blossoms, Harlequin, White Flowers in a Broc* and *Skylight Storm. Happy Birthday* is an engaging portrayal of aromatic appeal. Its descriptive cake and burning

Loren MacIver. *Subway Lights.* **Oil on canvas, 50″ × 35″, 1959. Smith College Museum of Art, Northampton, Massachusetts. Purchased with funds given by friends of the artist, 1973.**

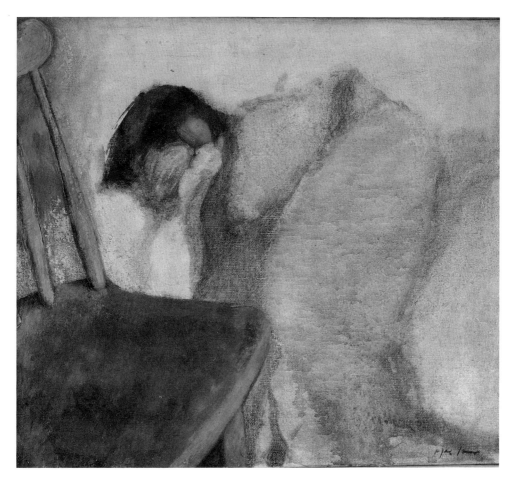

Loren MacIver. *Sleep.* **Oil on canvas, 20¹/₁₆″ × 24¹/₁₆″, 1929. Smith College Museum of Art, Northampton, Massachusetts. Gift of the artist in memory of Lloyd Frankenberg, 1977.**

candles melting into clouds of luminous colors accompany a lackadaisical bouquet of white lilies.

The carefully rendered display of dogwood blossoms in her painting of the same name occupies a full canvas. Her intuitively applied brushstrokes make alive her subject matter. The entire canvas sparkles with excitement.

Harlequin is a disguise both in concept and execution. The masking of one's inner thoughts can only be accomplished with outward signs. MacIver succeeds in fully recording the clowns' features, then proceeding

to eliminate, or at least diminish them with an overlay of paint contrary in color to that originally applied. MacIver's *Harlequin* differs from her clown portraits of Kelly and Savo. By generalizing her subject, she removed personal insights in favor of a socially pertinent approach.

White Flowers in a Broc is a delicate, soft-spoken, serene portrayal of white flowers in a vase. Intuitive blotches of color swell in the forefront and fade into the background. This is a calm painting, one that reflects a lifetime of peace and quietness, one that relates proven artistic

maturity, one that reveals the sense of accomplishment.

In a similar reflection, *Skylight Storm* is not a storm at all, but a peaceful, mellow event which places the storm outside reality. The viewer expresses the peace of shelter and security as the soft colors warm the inner soul. MacIver's *Skylight Storm* breathes joy and contentment. The abstract nature permits the viewer to apply personal interpretation in spite of artistic intent.

In her final years, MacIver has echoed her magical charm in a diversified series of recall. Extracting the spiritual from the natural and attaching to it a personal vision of charm and enchantment has granted Loren MacIver a unique position in the annals of American painting.

Notes

1. MacIver's series of paintings on the theme of votive lights varied only slightly. Five acknowledged renditions are *Votive Lights,* 1942; *Red Votive Lights,* 1943; *Blue Votive Lights,* 1944; *Green Votive Lights,* 1980; *Votive Lights Red and Blue,* 1984.

2. The phrase "cultural monument" is used by Frank Getlein, in his book titled *Christianity in Modern Art.* It appears on page 201. The author contrasts MacIver's "cultural monument" to Tobey and Congdon's cathedral paintings, cultural monument referring to MacIver's series on the theme of the "votive lights."

3. The description of the painting *Calvaire* appeared first in Robert Henkes' book, *The Crucifixion in American Painting.*

4. Loren MacIver's painting *The Shack* was painted in the summer of 1938 on Cape Cod and was bought for The Museum of Modern Art in that same year by Alfred Barr.

5. *Puddle,* painted in 1945, was donated to Wellesley College of Massachusetts by Edgar Kaufmann. It measures 40″ × 29″.

6. On *Portrait of Jimmy Savo,* Emily Genauer wrote in her book *Best of Art,* published in 1948, "Loren MacIver's admiration of Jimmy Savo, master of pantomime, springs from many years of watching him perform, of observing the wonderful eloquent way in which he uses his hands, his great sad eyes, his quizzical lifting of his brows — all the small, seemingly spontaneous yet carefully devised movements which create so winning a picture of pathos. Miss MacIver therefore, had to accomplish within her own medium exactly what Savo did with his; to underscore what is significant by underplaying what is irrelevant."

7. This phrase was quoted from the exhibition "How the Modern Artist Works," as stated by Loren MacIver. The complete quotation follows:

"Quite simple things can lead to discovery. This is what I would like to do with painting; starting with simple things, to lead the eye by various manipulations of colors, objects and tensions toward a transformation and a reward. An ashcan suggests a phoenix; its relics begin a new life, like a tree in spring. Votive lights, flickering and vanishing, become symbols of constancy. In the catalyzing air of evening a city and its traffic merge; it is as if all events of wheels and people, cobbling it, had left upon the avenue their passing strain of circumstance. My wish is to make something permanent out of the transitory by means at once colloquial and dramatic. Certain moments have the gift of revealing the past and foretelling the future. It is these moments that I hope to catch."

8. The painting *Jimmy Savo's Shoes* measures 22″ × 30″ and is in a private collection. It was painted in 1944.

9. *The Street* was painted from memories of a trip to Paris in 1956. The quote by MacIver was taken from the book *300 Years of American Painting,* by Alexander Eliot.

10. The painting *Les Marronniers* measures 51″ × 64″ and is owned by Lawrence Bloedel.

11. The painting *Naples* measures 66″ × 29″ and appeared along with *Les Marronniers* in a one-woman showing at the Pierre Matisse Gallery in New York City in 1956.

12. MacIver's method of approach regarding her French visit and the subsequent showing of her Parisian paintings in the year 1970 at the Pierre Matisse Gallery is described by her friend and critic, Pierre deLigny Boudreau, who wrote of her 1966–1970 works: "Thus begins her quest, a pursuit of the intangible. The years go slowly by—filled with emotions and daily discoveries. Her sensitivity flourishes, her vision enlarges. She walks about, grows older. Her avid glances collect innumerable sources of inspiration from papers, letters, leaves, toys, memories, souvenirs, cities, villages, stones, moods, and friends. As naturally as a tree she grows, to become an artist—but always remaining that girl working by a window with a friendly tree nearby—yet, what sort of a tree is it? Not one of those appearing always on the threshold of departure, nor one with needles, knotty bark and a doleful air. Perhaps a cherry or a lemon tree might be more suitable—yet would they grow in Paris—somehow they must, for Paris becomes your tree . . . certainly it does, since the paintings you have done here have that particular air, grace and nostalgia. I mean those glowing, mysterious landscapes which, before you glance upon them, were simple objects of everyday life. Topsy-turvy they rest in this corner—remnants of dreams back in their humble existence."

. 13. The painting *Green Votive Lights,* a 1980 version measuring a mere 22″ × 26″, appeared in the 1981 showing of her paintings at the Pierre Matisse Gallery.

14. Regarding her final showing, William S. Lieberman wrote in March of 1987: "In our harsh age of anxiety and despair, the lyric art of Loren MacIver shimmers with enchantment. Her observation distills the spiritual from the ordinary, and she expands the familiar into vivid patterns that constantly surprise. Color is pleasure and often joy. Overstatement is alien to MacIver's eloquence, and as an artist she fits no convenient category. She shares with us the clarity of her personal vision, and its essentials combine a poet's eye and a painter's craft. She discovers magic in simple truth, and we are richer and therefore greatly in her debt."

Bibliography

Barr, Alfred. *What Is Modern Painting?* New York: Museum of Modern Art, 1946.

Baur, John. *Loren MacIver & I. Rice Pereira.* New York: Whitney Museum of American Art & Macmillan, 1953.

————. *Revolution and Tradition in Modern American Art.* Cambridge, Mass.: Cambridge University Press, 1951.

Genauer, Emily. *Best of Art.* Garden City, N.Y.: Doubleday, 1948.

Getlein, Frank & Dorothy. *Christianity in Modern Art.* Milwaukee: Bruce, 1961.

Hale, Robert Beverly. *100 American Painters of the 20th Century.* New York: Metropolitan Museum of Art, 1950.

Henkes, Robert. *Eight American Woman Painters.* New York: Gordon, 1980.

Janis, Sidney. *Abstract and Surrealist Art in America.* Salem, N.H.: Ayer Co., 1944.

Larkin, Oliver. *Art and Life in America.* New York: Holt, Rinehart and Winston, 1949.

Seckler, Dorothy Gees. *Provincetown Painters.* Syracuse, N.Y.: Everson Museum of Art, 1977.

Soby, James Thrall. *Contemporary Painters.* New York: Arno Publishers, Inc., 1948.

Exhibition Catalogues

"Again, to the Ladies." Exhibition at the Whitney. *Saturday Review.* February 7, 1953.

Barr, Alfred H. *Art in Our Time.* New York: Museum of Modern Art, 1939.

_____. *Fantastic Art, Dada, Surrealism.* New York: Museum of Modern Art, 1936.

Baur, I.H. "Loren MacIver & I. Rice Pereira." *Review. Art Quarterly.* 16 no. 1:82, 1953.

Baur, John. *New Art in America.* New York Graphic Society. New York: Frederick Praeger Company, 1957.

Cahill, Holger. *New Horizons in American Art.* New York: Museum of Modern Art, 1936.

Circulating Exhibit in California. *Art News.* October, 1950.

Eliot, Alexander. *300 Years of American Painting. Time Books.* New York: Random House, 1957.

Exhibition at Pierre Matisse Gallery. *Art News.* October, 1949. Exhibition at Pierre Matisse Gallery. *Art Digest.* October 15, 1949.

"How I Work." Techniques of Loren MacIver. *Art News.* September, 1947.

Loren MacIver. *Magazine of Art.* January, 1948.

McBride, Harold. "Ladies Day at the Whitney." *Art News.* January, 1953.

MacIver & Modigliani Exhibit in *Chicago Review. Art News.* March, 1959.

MacIver Exhibit Review. *Art News.* January, 1971.

MacIver Retrospective at Matisse Gallery Review. *Art Digest.* October 15, 1944.

Portraits Exhibition Review. *Arts.* April, 1959.

Reproduction of *Blue Landscape. Art News.* October, 1946.

Reproduction of *Carey's Backyard. Magazine of Art.* November, 1946.

Reproduction of *Fisher's Island.* Brooklyn Museum Bulletin, Fall Issue, 1957.

Reproduction of *Floating Palaces. Life.* September 15, 1952.

Reproduction of *Floating Palaces, Venice. Art News.* Annual, 1950.

Reproduction of *Flowerscape.* Detroit Institute Bulletin. 1958–1959.

Reproduction of *Green Votive Lights. Art Digest.* April 1, 1952.

Reproduction of *Little Silent Christmas Tree. Art News.* December 1, 1944.

Reproduction of *Moonlight. Arts & Architecture.* November, 1944.

Reproduction of *Red Votive Lights. Werk.* April, 1951.

Reproduction of *Skylight. Art in America.* April, 1981. *Art Forum.* April, 1981. *Arts.* April, 1981.

Reproduction of *Spring Snow. Art in America.* Summer, 1958.

Reproduction of *Yellow Season. Studio.* July, 1945.

Selz, Peter. *Seven Decades: Crosscurrents in Modern Art.* Washington, D.C.: H.K. Press, 1966.

Soby, J.T. "Genesis of a Collection." *Art in America.* 49 no. 1:79, 1961.

Three Murals for American Export Lines. Exhibit at Museum of Modern Art. *Review. Art News.* September, 1948.

"Two Women at the Whitney." *Art Digest.* January 15, 1953.

"Villagers in Manhattan." *Time.* January 26, 1953.

Wight, Frederick S. *Milestones of American Painting in Our Century.* Boston: Institute of Contemporary Art, 1949.

"Woman's Intuition." Exhibition Review. *Art Digest.* December 1, 1940.

Marion Greenwood

Marion Greenwood gained fame as a Mexican fresco painter during her early years as an artist, and gained the respect of such renowned Mexican greats as José Orozco and Diego Rivera. It was not until 1940 at the age of 31 that she returned to the United States.

Born in 1909 in New York City, Greenwood's first significant American exhibition was in 1944. Spending 12 of her early years in Mexico taught her the courage of self-discipline and the development of a personal style which led to the eventual showing of her work at the Associated American Artists gallery.

Her painting titled *Rehearsal for African Ballet* is an example of her unique style of composition and theme. Of it, Greenwood has stated: "One night in Harlem I made sketches at a rehearsal of a dance group who study the ancestral dance forms, chants and drumbeats of Africa for recitals. In organizing the composition in plastic terms on my canvas, I was interested in the interplay of line and light and shadow masses, spatial and color relationships, and the mood and expression of the scene as I felt it."[1]

Greenwood's painting is a recording of a mood, not in the magical terms of a MacIver or with the primitive charm of a Doris Lee, but in a style of life which already exists. The painting amounts to a removal of an intimate, compassionate reality from the initial scene to a limited but permanent location on the canvas.

Rehearsal for African Ballet reveals an all-black troupe rehearsing amid swirling cigarette smoke and a darkened atmosphere. Shadows are formed by a small spotlight located atop the center of the painting. Greenwood has arranged her figures into a circular composition, relying on the light areas to form the circular movement. Several elliptical compositions overlap. The mysterious mood stemming from the interplay of light and shadow typifies her concern for the ethnic culture.

Greenwood's motivation was to record the culture and the people of underdeveloped nations. Her impressive murals of Mexico influenced the American government to commission her, but regulations and censorship erased much of Greenwood's enthusiasm. Unlike Doris Lee and Loren MacIver, whose artistic careers developed naturally in spite of both economic and artistic barriers, Greenwood deliberately sought

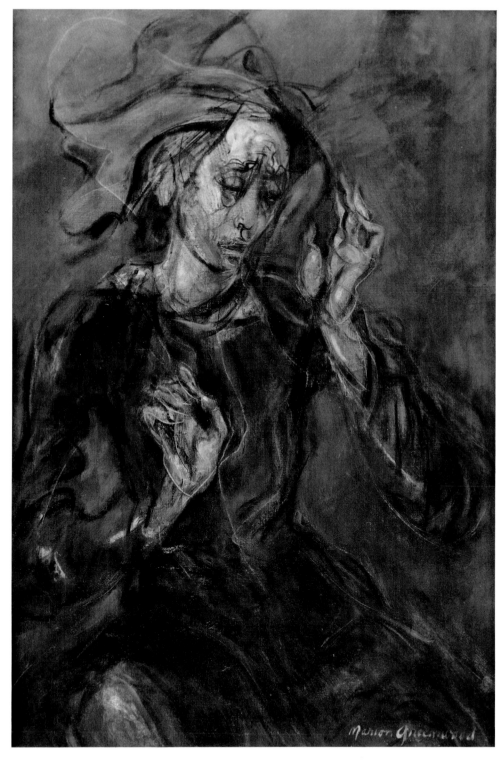

Marion Greenwood. *Eastern Elegy.* **Oil on canvas, 40″ × 26″. Collection of Butler Institute of American Art, Youngstown, Ohio.**

challenges. As a child prodigy, she excelled at an early age and developed a stamina and tenacity that caused such greats as Orozco and Rivera to admire and respect her.[2]

Although a practicing muralist, Greenwood's easel paintings gained popularity during the forties. Closely related to *Rehearsal for African Ballet* is *Dancers Resting.* This depiction of an intimate conversation illustrates Greenwood's interest in ethnic culture. The gestures and contours of the figures promote the freedom of expression she seldom experienced with government commissions. There is an exuberance which tends to explode but within limits, and Greenwood is able to balance her emotional and intellectual responses to her subject on this limited surface. This balance has created a nervousness, a tension which records the restlessness and hidden talents of the dancers depicted. Moving in a circular composition, the four dancers overlap, creating a unit while sustaining individual personalities. The background is subdued to fully capture the rapture of the conversation. The seemingly erratic brushwork illustrates Greenwood's emotional response to her subject matter. There is an excitement which abounds, yet is hidden within the personalities portrayed.[3]

Planned Community Life (Blueprint for Living), the fresco commissioned by the American government for the Red Hook Housing Project in Brooklyn, was executed in 1940. It was a compact, carefully conceived composition typical of the WPA projects of the Depression years. Monumental and masculine figures dominate the forefront, which includes the lone female form who appeared as the pivotal character. The artist was committed to the notion of low cost housing. In *Blueprint for Living,* Greenwood expressed the optimistic idealism of the post–Depression era. But as with other government murals, *Blueprint* met a destructive end.

Two years earlier, Greenwood was commissioned by the United States Treasury Department to paint a post office mural in Tennessee. It displayed a family enjoying the peace and prosperity brought about by the Tennessee Valley Authority project. Yet again, the government insisted on changes which prompted a dismayed Greenwood to reconsider future commissions.[4] Other assignments and independent easel painting occupied her time between mural commissions. In 1954 while a visiting professor at the University of Tennessee, Greenwood received another commission, a mural dealing with musical spiritualism for the University. Titled *Theme of American Music,* it was a composition which reflected a Thomas Hart Benton influence. Resembling the emotional content of her independent easel paintings, this mural is packed with emotional spiritualism, a moving testimony to the essence of Memphis jazz, country mountain music and folk dance.[5]

To the left of the canvas are the musicians: pianist, drummer, saxophonist and trumpeter. There is a relaxed dedication to music and to the lifestyle it perpetuates. To the right are dancers and toe tappers whose appreciation is reflected in their expressions and gestures. The Mississippi showboat occupies the background as bales of cotton identify the workers' occupations.

Greenwood's final mural was executed in 1965 and dedicated to

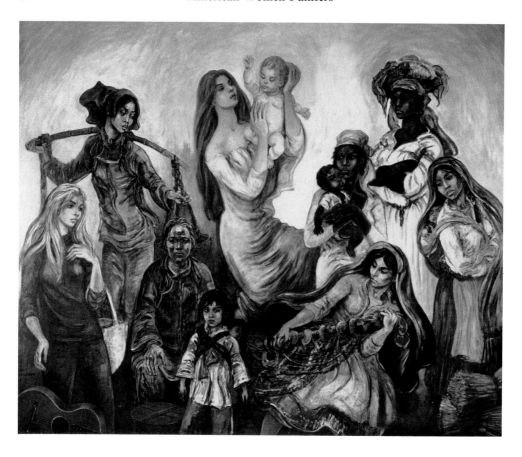

Marion Greenwood. *Tribute to Women.* **Oil on canvas, 14′ × 12′, 1965. Syracuse Art Collection, Syracuse University, Syracuse, New York.**

women throughout the world. It was painted at Syracuse University and was motivated by studies of different ethnic types taken from sketches made during her travels.

For practical purpose, Marion Greenwood's career as a muralist ended in 1940. She was finally free of government control whether Mexican or American. She pursued easel painting with a remarkable fervor in expressing the labors of humanity. Greenwood had actually become an integral part of her own expressions. Her philosophical outlook reflected the tense anticipation of a courageous act as

witnessed in *Toreador* and the dramatic movement of *Slaughter House.* The freedom to express resulted in the release of inhibitions long sustained by the government controlled murals of yesteryear. In *Slaughter House* Greenwood presented an objective painting, but included an environment identical to that of the action itself; that is, the butcher is surrounded by the stimuli that motivated the action. The circular movement of the butcher and the slaughtered carcass creates a focalized arena of action and necessitated the reinforcement of calves already butchered. Thus, a subjective

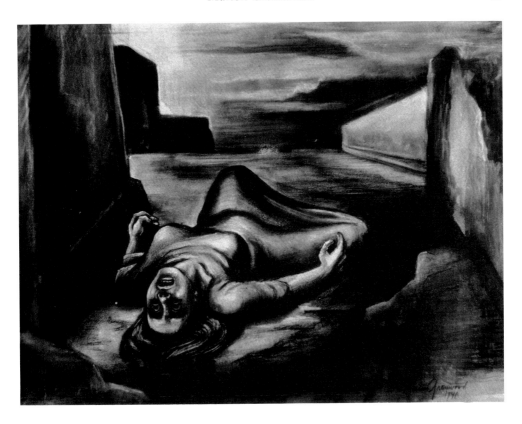

Marion Greenwood. *Night in Spain.* **Gouache painting, 1940. Collection of Madison Art Center, Madison, Wisconsin. Photograph by Wenzel Kust.**

expression resides within a similarly subjective environment.

The anticipation of an event generates an anxiety which frequently appears at ease. In *Toreador,* Greenwood has presented a figure of profound concentration on an event yet to occur. The subject of the painting is in rigid pose dominating the entire surface of the canvas. The set position of hands and feet and the set stare of the eyes illustrate the intense concentration essential to the role of bull fighting.

Such paintings as *Beggar Children, Spring Plowing, Sharing Rations, Slaughter House* and *Autumn Rice* reveal the fashion in which she expanded the boundaries of her sub-ject matter, her compassion for the downtrodden and unfortunate peoples, her indifference and disregard for social and racial barriers and her immense curiosity of different peoples and nations. Her works relate her inner strength, her spiritual optimism, her wit and her adventurous ambition.

The Toilers exhibits the strength, humility and power of the Chinese working class to which she identifies—the immense amount of physical energy expended for bare essentials of life. The forward action of the rickshaw is lessened by the vertical structure of the four figures assisting in its movement.

Drawings that precede these paintings record the raw guts of life in

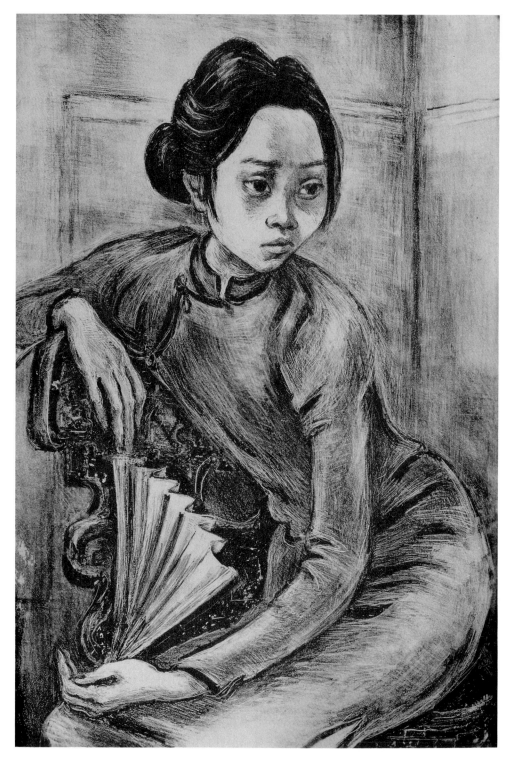

Marion Greenwood. *Chinese Girl.* **Lithograph, 322 × 226mm. The Cleveland Museum of Art. Gift of Lillian M. Kern. (68.266)**

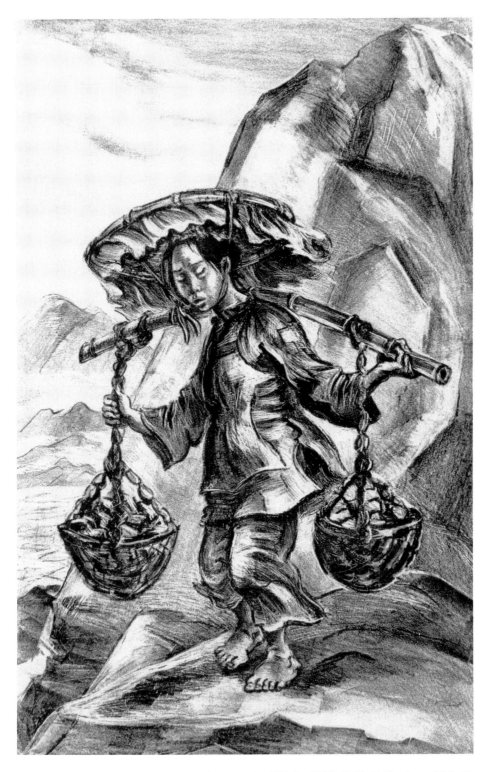

Marion Greenwood. *Coolie Woman.* **Lithograph, 13⁵/₁₆″ × 8³/₈″, 1947. Collection of Madison Art Center, Madison, Wisconsin. Photograph by Wenzel Kust.**

direct, honest portrayals. There is a unity of figure and stimulus, an attachment of man to his work. The drama of black and white further deepens the emotional elements of her drawings as can be seen in *The Rice Line, The Toilers, Rock Crushers, Noon Hour* and other works.

Marion Greenwood was noted for creating portraits of people in their own environments. Thus, the character identified with the action. In the case of *Hong Kong Girl,* however, an appropriate habitat was simplicity. The grey subtle background amplified the intensity of the red apparel of the girl and complemented the circular movement of the girl's body. Her rounded face balanced the arched arm which gently held a handmade fan. Penetrating eyes stare into space, leaving the viewer questioning her "presence."

In Greenwood's *Lament,* a simple notion becomes a provocative emotional event, an intimate relationship between a mother and her child, not in the serene sense that artists portray the theme, but in the harsh reality of war and tragedy. The environment is unidentified, thus releasing the subjects from particular circumstances. The subject matter becomes a universal theme so the viewer may adopt it to suit individual needs.

The composition is nothing more than a diagonal line forming a communicative link of love between mother and child. The distance registered between the two visual glances creates a sense of anticipation. One eagerly awaits a shortening of the distance, resulting in a loving embrace. The viewer is tempted to respond in a compassionate manner to Greenwood's plea.

She was a master of revelation, a recorder of the unfortunate victims of domestic economics, racial discrimination and the destruction of war. The lack of an identifiable habitat in *Lament* eliminates the risk of regional definition even though the mother image resembles a Chinese war victim. Generally, these instant recordings are well transmitted onto canvas, but the instinctive nature of the expressions presents a more immediate and reliable statement. Depending on purpose, the artist elected to present an individual recording or a broader coverage of a theme. *Lament* differs dramatically from *Rehearsal for African Ballet* in several ways, but foremost by the differentiation between subjective and objective approaches. The viewer shares *Lament* only with him or herself and directly, without interruptions, while *Rehearsal for African Ballet* demands an indirect sharing of all characters, causing intermittent disruptions.

The versatility of Greenwood is reflected in her easel painting and lithographs. Lack of color in the lithographic process is the cause of dramatic effects as seen in *Sisters* and *Black-Eyed Susan.* In *Sisters* the appearance strongly resembles the Mexican portraits of Doris Rosenthal. This is a beckoning appeal. The direct simplicity of facial expressions of the two sisters is in contrast to the rather intricate design of the clothing. The light source is created to meet compositional needs rather than a recording of nature.

It is the plea of Greenwood to recognize the ethnic culture. In *Sisters,* the viewer is treated to a humble, intimate love between two sisters. Their devotion to one another is obviously portrayed with the singularity of presentation. One is dependent

upon the other, creating a bond be-
tween two types of needs — one, the
need to love, and the other, the need
to be loved. Both, in time, will need
to give and to receive love. Green-
wood has presented her love of the
unfortunate to viewers in a society
that is sometimes hostile, at other
times, receptive, and sometimes in-
different or reluctant.

Black-Eyed Susan is an exquisite,
intimate portrayal of a charming
young girl. Wearing coveralls and
holding a delicate daisy in each hand,
the subject, Susan, stares into space.
The light source originates outside the
picture plane, focusing on the child's
face and her two hands and flowers.
The coverall bib picks up enough light
to make less obvious the triangular
shape formed by the highlights. Shad-
ows effectively dramatize the simple
pose. This subjective portrayal is
heightened by the subordinated envi-
ronment.

Greenwood and Rosenthal were
similar in their relationship with the
Mexican people, and yet their services
differed. While Rosenthal devoted her
life to the portrayal of Mexican life,
Greenwood relinquished her interest
in Mexican frescoes after gaining
respect and esteem from the Mexican
government. Her successful murals
prompted such great masters as
Rivera and Orozco to gain American
commissions for her and yet it was
her attitude and compassion de-
veloped for the Mexican people that
caused the success of her future en-
deavors.[6]

Marion Greenwood's drawings
executed in ink brushwork and washes
are as strong in composition and emo-
tional technique as the appearance of
her subject matter. Simple in concept
but carefully conceived and rendered,
Greenwood's drawings maintain the
ruggedness and relaxation of the Mex-
ican culture.

The humility of the Mexican peo-
ple was always a consideration in
Rosenthal's life as witnessed in such
works as *Street Vendor* and *Beggar
Children.* In *Street Vendor* the bid for
survival is recorded. Generally artists
will distort the natural for realistic
effects, but Greenwood preferred
reality as it appeared to exist.

Frustrated and weary, the vendor
in *Street Vendor* has reached the state
of despair, but the artist has dimin-
ished a bit of weariness with the in-
troduction of a horizontal crossbar,
thus diverting attention to the right
and left of the drawing.

Marian Greenwood's studies for
her Mexican murals are intimate por-
trayals of Mexican life. *Tarascan
Indian Child,* a charcoal drawing, ex-
emplifies Greenwood's profound con-
cern for the child's innocence and
resignation to Mexican poverty. Yet
Greenwood's almost masculine touch
generates a power which supersedes
the sympathy toward Mexico's
culture. A simple, honest, direct ap-
peal is made by Greenwood through
the eyes of the Mexican niño. The
typical bare feet and the piercing
wide-open eyes of the Mexican people
are prominent features.[7]

The drawing of the Tarascan In-
dian child measures $44'' \times 33''$. It is
signed and inscribed, "Study for
Mural, Mexico, 1933."[8] Lucy Lippard,
in her review of "Seven American
Women: The Depression Decade," an
exhibition held at Vassar College in
1976, said, "the star of the show was
Greenwood, whose immensely power-
ful fresco studies and powerful and
sensitive conte portraits of workers
and peasants combine the strength

Marion Greenwood. *Black-Eyed Susan.* **Lithograph, 8½″ × 11¾″, 1949. Collection of Madison Art Center, Madison, Wisconsin. Photograph by Wenzel Kust.**

Marion Greenwood. *Fringed Scarf.* **Lithograph, 11½″ × 9¼″, 1946. Collection of Madison Art Center, Madison, Wisconsin. Photograph by Wenzel Kust.**

that was the greatest virtue of the Mexican Mural Movement with a sympathetic view of humanity. There is a gentle solidity to the Rivera-influenced art."

According to art critic Emily Genauer, Marion Greenwood "has always maintained that she wanted no picture of hers to be merely an exposition of esthetic theories. Rather

Marion Greenwood. *Mississippi Girl.* **Lithograph, 12½″ × 9″, 1945. Syracuse Art Collection, Syracuse University, Syracuse, New York.**

has she conceived her works as human documents expressing her profound sympathy for humble and obscure but heroic people everywhere." The quote aptly describes her purpose in painting *Eastern Memory,* which reflects the misery and the desperate struggle for survival in China after World War II. *Eastern Memory* is a profound emotional statement which focuses on specific aspects of a racial group and yet goes beyond the particular to attain a universal awareness.

The tragic woman whose image occupies the entire canvas symbolizes the purification of grief and despair of women who toil to create and maintain, who see their efforts of work and love destroyed, but most continue with their lives.

Aside from the terrifying experiences of war and destruction of the Eastern world and the subsequent expressions, Greenwood benefited from the dynamic vitality of Chinese calligraphy which is witnessed throughout China. Although such stimuli may appear commercial in their usage, their adoption by painters has proven an exciting incentive to dramatize events. The jerky, triangular shapes seen in the blouse of the Chinese sufferer act to vitalize the clothing which in turn communicates the message of the artist.

In a similar vein is Greenwood's *Mississippi Girl,* painted in 1943. It reflects an inner strength on the part of her subject that no doubt relates to her personal hardships. And there is a determination that overrides any doubts of the future. The strength of the character is due partly to the artist's restraint of an emotional reaction to the theme underlying the subject's awareness of injustice. Greenwood's partiality toward the downtrodden is

reflected in her subject's set jaw and inquiring eyes and the aggressive application of paint. The rugged structure of the background environment adds to the vitality of *Mississippi Girl.* Like other Greenwood portraits, *Mississippi Girl* is structurally strong and masculine in its appearance.

Greenwood's murals in America concentrated on the themes of the Great Depression of the thirties. In her closely knit mural titled *Water and Soil,* constructed for the 1939 New York World's Fair, Greenwood illustrated the power of the American labor force. With the winding down of the Depression and the gearing up of the war effort, *Water and Soil* became a dynamic, emotional expression of American strength.

Negative space is lessened considerably since a compact composition is essential to its nature. *Water and Soil* records the hardships of the farmer and the laborer. To the left is a typical farm family weathering the storm, so to speak, while onrushing waters flood the landscape of the middle section.

A mural is a composite of several events brought close to the viewer so that perspective is subordinated to the composition, thus diminishing objectivity. Objective in imagery but with a quality of intimacy permitting individual scenes to transcend the totality, *Water and Soil* causes the viewer to absorb the entire mural simultaneously.

The plight of the farmer is witnessed in the symbolic goat draining the last ounce of water from the bucket while the family cling together in despair. A funnel cloud swirls in the distant landscape as one is reminded of Curry's *Tornado over Kansas.* Human hands are shaped like

Marion Greenwood. Housing Project Mural. Marion Greenwood Papers (CA-1933–1960). Gift, April 1964. Red Hook, Brooklyn, New York City. Archives of American Art.

gigantic wheat stalks to symbolize the oneness with the human condition.

In the right area one views a great Western dam generating power to America's factories. Smoke stacks, silos, oil derricks, telephone poles, windmills—all symbols of industrial progress—activate the mural. However, Greenwood never lost the touch of human sensitivity. In spite of natural disasters, man is in command of his own destiny.

Greenwood's strength has relied upon the stamina of her subjects. It was this compatibility of artist and victim, so to speak, that strengthened her own images and compositions. The tragedies of the ethnic groups, particularly of the far Eastern nations and the Central American Indian settlements, were the subjects of the artist's mission.

Greenwood's *The Window* displays a typical ghetto portrayal of entrapment. The despair reflected in the eyes of the victim exemplifies the fate of the underdog which has been the subject of Greenwood's agenda throughout her life. The subjective expression appeals to the viewer in a charitable sense, in a plea for aid. This was Greenwood's mission—to

Marion Greenwood. *The Window.* **Lithograph, 9⁵⁄₁₆″ × 12½″, Collection of Madison Art Center, Madison, Wisconsin. Photograph by Wenzel Kust.**

exhibit the needs of the underclass, the ethnic groups that fail to reach the mainstream of life.

The "window" is opened to the world outside, but the occupant seems anchored to her environment. It is the escape that remains a dream, an escape from reality to fantasy, for it is the dream that allows a hope for the future. Greenwood was part of that dream. Her work with the victims of the environment will continue to foster hope for those in need.[9]

Notes

1. This quote describes the motivation for Greenwood's painting *Rehearsal for African Ballet,* and appears in the book *Contemporary Painting,* the Encyclopaedia Britannica Collection, published by Duell, Sloan and Pearce. New York, 1943.

2. Harry Salpeter, reviewer, said of Greenwood, "She is a woman, but is not a member of the weaker sex. The story of her career makes the average male artist seem like a knit-by-the-fire body."

3. Although acclaimed as a powerful muralist, Greenwood was successful as an easel painter as well.

4. In 1938 Marion Greenwood was commissioned by the Treasury Department Section of Fine Arts to paint a mural on the theme of American music.

5. In 1954, Greenwood was appointed as a visiting professor at the University of Tennessee in Knoxville. While there, she completed a mural similar in style to that of the great regionalist, Thomas Hart Benton.

6. The Mexican muralist said of Marion Greenwood, "She could have been the queen of Mexico."

7. Marion Greenwood was the first woman to receive a Mexican commission to do a fresco mural. It was a mural on the wall of the Hotel Taxqueno.

8. In 1934 Diego Rivera, head of the government mural program, hired Marion Greenwood and her sister Grace to work on a mural in the Mercado Rodriguez, the central market and civic center in Mexico City.

9. Marion Greenwood worked with the famous artists of the period, such as José Orozco, Rivera, David Siqueiros, Hans Hofmann, Lee Krasner, Louise Nevelson, Lucienne Block and Caroline Durieux.

Bibliography

Abbott Publication titled, *What's New*. January, 1942, Vol. 55.

_____. *What's New*. February, 1951, Vol. 154, North Chicago, Ill.: Abbott Laboratories.

Chinese Scenes. *Art News*. December, 1947.

Exhibition. American Associated Artists. *Art News*. April 1, 1944.

_____. American Associated Artists. *Art Digest*. March 15, 1944.

Exhibition Review. *Creative Art Magazine*. March, 1932.

Fern, Alan. *American Prints in the Library of Congress*. Baltimore & London: Johns Hopkins Press, 1970.

Lippard, Lucy. *Seven American Women: The Depression Decade*. Exhibition Catalogue, Vassar College.

"Marion Greenwood: An American Painter of Originality and Power," by Harry Salpeter. *American Artist*. 1949.

Marion Greenwood Reviews. *Art Digest*. November, 1940; March, 1944; June, 1944; April, 1945; October, 1945; February, 1946; December, 1947.

_____. *Art News*. April, 1944; October, 1944; December, 1947.

_____. *Studio*. August, 1945.

Pagano, Grace. *Contemporary American Painting*. New York: Duell, Sloan and Pearce, 1945.

Red Hook Housing Project. *Art Digest*. November 15, 1940.

Reproduction. "Lament." *Art Digest*. April 1, 1952.

_____. *Mexican Harvest. Magazine of Art*. April, 1941.

_____. "New Years Eve." *Art Digest*. June, 1944.

_____. *Rehearsal for African Ballet. Art Digest*. April 1, 1945.

_____. *Water & Soil. Magazine of Art*. May, 1937.

Reproduction & Review. *Mississippi Girl. Art Digest*. October 15, 1944.

_____. *Art News*. October 15, 1944.

_____. *Mississippi Girl. Studio.* August, 1945.
Return from China Exhibition. *Art Digest.* December 15, 1947.
Rubinstein, Charlotte. *American Women Artists.* New York: Avon, 1982.
"The Vigorous Versatility of Marion Greenwood." *The Art Digest.* May 3, 1943.

Doris Rosenthal

Doris Rosenthal and Marion Greenwood were bonded by similar interests in Mexican culture. While Greenwood was devoted to murals of a political nature, Rosenthal painted the Mexican landscape and its people with delicate intimacy. Although she studied under such masters as George Bellows and John Sloan and travelled extensively in Europe before entering the teaching profession, Rosenthal preferred painting the Mexican people. She could be thought of as an unofficial ambassador to the United States' southern neighbor. She was repeatedly awarded Guggenheim fellowships, thus sustaining her presence in Mexico.

Rosenthal's devotion to the human spirit is reflected in the facial expressions of both children and adults. Humility is witnessed symbolically by the forever present bare feet and foreboding eyes. In her painting titled *Las Artistas,* eyes beckon viewers to participation, not in the activity identified in the background but rather as a sympathetic audience.

The circus environment, although highly objective, becomes mostly background partly because of the lack of spectators. There is a stillness that prevails, a quietness before the next performance.

The same bewildering eyes are in the schoolmates in *School in Ocatean.* Rosenthal concentrated on the occupants of the painting, then neatly tucked in the environment. The children appear frightened, as if Rosenthal were a stranger to them, or perhaps it is a quiet plea for mercy. Mexicans are a humble people and are of a deep faith. Simplicity marks their lifestyle, and it is this trait that Rosenthal has captured. Her subjects face their viewers pleading for attention.

In *School in Ocatean* Rosenthal achieved a circular composition initially with individual figures, which she then proceeded to blend into a single circular arrangement. In contrast to this arrangement is the combination of the horizontal and vertical planes of the background.

In a lithograph executed in 1933 and titled *Mexican School,*[1] she revealed an orderly, compact arrangement of a crowded school. The children are pictured in a rote educational procedure. Again, bare feet were a trademark. Rosenthal had purposely jammed her drawing with school children, thus diminishing the negative space. Even the small upper lefthand

Doris Rosenthal. *Tops.* **Oil on canvas, 24″ × 20″, 1949. Collection, The Museum of Modern Art, New York. Gift of Abby Aldrich Rockefeller.**

corner of the drawing was reserved for the children's sombreros.

The circular composition again prevails in *By the Sea*[2] and is controlled by the hammock which is a cheaply made swinging cot ideal for short naps. The figure to the left of the Tarascan girl occupying the center hammock looks directly at the viewer. It is the inquisitive look on the part of her subject matter that continued to intrigue Rosenthal. The environ-

mental structures and the female figures complement each other. Each figure with its own compartment blends into a union of figurative forms.

The masculine hands, symbolic of heavy toil, identify with Rosenthal's subjects, who appear disturbed at the interruption. There is a plea, an inner desire for affection which is revealed by the piercing eyes and relaxed but tired bodies. The weariness is a reflection of the acceptance of a humble and simple, perhaps even backward, life.

A simple portrayal of two Mexican youngsters titled *Tops*[3] concentrates on bare feet, large hands and piercing eyes. Even though the children are preoccupied with a newly discovered toy, there remains that inquisitive look, almost a daring glance at the donor. The ever-present companion is the faithful dog which Rosenthal has considered an integral aspect of the peasant family.

The floor is roughly painted to suggest the poverty of the situation. Rosenthal's deliberate attempts to record the hardship of the Mexican Indian were at times causes for alarm. Not always were her journeys into desolate lands accommodating. In fact, "perilous" may describe certain aspects of her jaunts.

The composition of *Tops* is simple, with diagonal lines of both the positive and negative aspects. Rosenthal sustains an exciting background with rough brushstrokes tilted diagonally or corresponding to the more subtle lines of the Mexican youngsters.

In contrast is the smoothly painted *Girl with Banana Leaf Stalk,*[4] in which the circular composition completely absorbs the painting. The usual trademarks—large hands, pierc-ing eyes, bare feet—occupy the canvas along with stalks of bananas arranged in a circular fashion. The artist chose to approach her subject matter in a childlike way from top and front views simultaneously. There is present a particular joy, a reason for rejoicing. *Girl with Banana Leaf Stalk* is a joyous picture.

At the Blackboard is an unusual composition since the focus is on the product of the role players. Rosenthal has concentrated on the blackboard and its inscription although the characters dominate the theme. The action is between the role players and the product of their actions, namely, the writing on the blackboard. The artist has suggested activated space which remains hidden, but exists between the characters and the product of their actions. It is the rear view of the role players that causes the viewer to react to the space existing between them and the object of attention. If the characters had faced the viewer, the activated space would have disappeared, and the focus of attention would have been on the three characters. The dog, a common companion to children, lies around the schoolroom throughout the school day.

Devoted to the welfare of Mexican children, Rosenthal, in her work titled *Sacred Music,*[5] uses an academic approach to express a commemoration of All Souls Day, a Roman Catholic holy day. The artist recorded the children during a devotional activity and recognized the fervor which accompanied their action. Rosenthal continued to rely on the circular arrangement of her characters in spite of the unusual parallel of heads and feet forming dual compositions. The overlapping figures facing the right are counterbalanced by the single

Doris Rosenthal. *Girl with Banana Leaf Stalk*. **Charcoal on paper, 23⅞″ × 18¾″. Columbus Museum of Art, Ohio. Bequest of Doris Rosenthal.**

Doris Rosenthal. *Sacred Music.* **Oil on canvas, 32″ × 40⅛″, 1938. The Metropolitan Museum of Art. George H. Hearn Fund, 1940. (40.79)**

figure to the right of the organ. Bare feet are again evident and identify with poverty, and it is precisely this state of being that is superseded by a profound faith. The unusual presence of a vase of flowers in an otherwise poorly equipped schoolroom symbolizes the rebirth, the resurrection of man.

Rosenthal's occupants are performers. In the case of *Sacred Music,* each figure, although motionless, is an integral part of the action. Activated space is at a minimum. Unlike the hidden action of *At the Blackboard,* Rosenthal profiled her performers in order to witness the activity. Head

coverings are worn by the female participants according to early Roman Catholic ritual. This custom became optional after Vatican II in 1963.

Rosenthal's disregard for perspective is seen in the staircase to the left of the painting. Stairposts are diagonal in structure, and not unlike those seen in the drawings of the young child. Usually, her concern for her subject matter dominates the working surface and supersedes any concern for environmental apparatus.

Her paintings of adults, especially those executed during the forties, appear more objective than those related to children. *Nude at Table*[6] seems

complete before the nude was added. She seems more an afterthought than a part of the original concept. And yet, she fits into a well conceived and constructed composition. The human touch, essential to Rosenthal, is an emotional accessory. Her placement in shadow subdues her presence and the contrasting lights adjacent to her figure seems to justify the extreme objectivity of the painting. There are awkward intersections, however, which suggest the need to forsake the objective in favor of the human figure. The furniture itself is a still-life set-up whose success relies upon a spatially well balanced composition. Rosenthal's concern for her female nude has created congested traffic amid overlapping objects.

The Source[7] shows Tarascan Indian women bathing in water that had been piped many miles from Michoacan mountains in hollowed-out tree trunks placed up on forked trees. After bathing, women carried water home in handmade red jugs.

This private portrayal indicates Rosenthal's search for the unusual. Recording the scene generally demands additional incentives for satisfactory results, but the rich jungle foliage and brown native bodies were sufficient motivation.

Compositionally, Rosenthal has split her canvas into three vertical panels, each recording a different activity. In this case, the environmental apparatus is essential to the subject matter. The Indians' crude methods of transporting water from village to village exemplifies the hardships that Rosenthal endured in order to show her devotion to the Mexican people. The lack of modern conveniences made more dramatic the dependence of man upon his environment.[8]

The Tarascan Indians, so reminiscent of Gauguin's Tahitian natives, glow in rich sunlight and, blended with the lush, earthy colors of the dense environment, made for a sensuous portrayal of an intimate but natural activity.

The bathing scene takes a humorous twist with Rosenthal's painting titled *Between Two Screens,*[9] in which a little Indian housemaid modestly takes her bath in a washbowl. It was painted with a zest for life and glows in the brilliance of the Mexican sunlight. *Between Two Screens* is a formally balanced composition altered only slightly by the tilt of one screen and the huge drapes which diminish the intense sunlight. It is a vertical composition created on a horizontal plane. The circular movement, a trademark of Rosenthal's work, is opposed by strong vertical lines. Nonetheless, the Mexican Indian monopolizes center stage.

Role playing is a prominent segment of Rosenthal's work and her incisive characterization became a dominant feature. Her subject matter is stripped of all nonessentials. The simplicity of clothing, shelter and outward expressions reflects the humility of the Mexican people. The realities witnessed in the facial and bodily gestures of her characters reflect inner realities as well. Removal of extraneous matter releases and makes evident inner hope and faith.

The viewer becomes a part of Rosenthal's painting. One easily identifies with the customs, mores and culture of the Mexican people as in the case of her painting titled *Enchantment*. The women garbed in simple clothing listen intently to the gramophone.[10]

The same compact unity prevails

Doris Rosenthal. *Summer Studio.* **Lithograph, 9¾″ × 11⁹/₁₆″, n.d. The Baltimore Museum of Art. The Cone Collection, formed by Dr. Claribel Cone and Miss Etta Cone of Baltimore, Maryland. (BMA 1950.12.346)**

in *Don Pasquale.*[11] Rosenthal has employed the idea of several aspects of nature being brought together into a single unit. Each character is a subjective issue, each possesses an individual personality, and the composite of all characters becomes a single personality as it contributes to the whole. In addition, the compact group resides within its proper environment. This artistic principle is evident in all of Rosenthal's work.

In *La Criatura*[12] Rosenthal has reverted to a single aspect of nature (a child), but has surrounded it with an appropriate but unusual habitat. Cradled in a leaf of nature is a sleeping child supported by a linear mesh which contrasts delightfully to the voluminous form of the baby. The circular forms of the child are repeated in the similarly shaped bananas in the foreground. Again present is the rich color scheme featuring the red and orange browns.

Similar in appearance but with fewer supporting factors is *Girl with Banana Leaf Stalk.* It is a simple display of a common custom. Rosenthal's characters grab the viewer's

attention. A 1940 painting, it relates a typical theme with precise characterization.

Seldom has Rosenthal created a dual spectator event in which the characters of the painting respond to stimuli within the painting. *At the Blackboard* was a previous example. In *The Nativity,* Rosenthal expressed the birth of Christ with a descriptive banner showing the Blessed Mother crowned as the Queen of Heaven and surrounded by a bevy of flowers and serenading angels. The Christ child cradles the base of the banner which is revered by a group of Mexican Christians. The viewer is invited to genuflect before the image of the Blessed Mother and Her Son as well as appreciate the precious moments of prayer transpiring between the Mexican adorers and the image of the Nativity. The artist echoed the Christian birth with the addition of a mother and child as spectators.

Occasionally an artist will express a theme contrary to her general production. Such is the case with Rosenthal's painting titled *Cattle.* It is another example of a unit of single aspects of nature forming the entire composition. Complex overlapping of cattle is a lesson in control without losing ease and a relaxed atmosphere. In spite of the all-over pattern of cattle forms, the lone Mexican worker to the extreme right of the canvas casually performs his duties.

For 13 consecutive summers originating in 1932 and continuing through the year 1944, Doris Rosenthal journeyed into Mexico and Central America. She stayed in hidden mountain villages where tourists seldom ventured and where foreigners were considered outcasts until suspicions gave way to mutual trust and friendliness. In time, the Mexican government regarded Rosenthal as an ambassador of good will from the United States, and by the people of Mexico she was regarded as an exciting and welcomed visitor.

After several trips into the uncharted mountainous sections of Mexico, Rosenthal added to her summer agendas the West Indies and Central America. In 1944, she stated her thoughts of her Guatemalan summer:

> How terribly cold the tropics on the heights can be. I travel as lightly and compactly as possible. Possessions are strapped on the tops and backs of mules. One always leaves at 2:00, 3:00 or 4:00 A.M. and crosses mountains 10,000 feet high. The cold is terrific, but the chauffeurs are the best in the world.
>
> I never wear slacks. Overalls on horseback, yet, but pants offend the Indian and I take great care to be as inconspicuous as possible. On these trips I am merely gathering first-hand information and experiencing the natives' way of living. The impressions come so fast, one leaps from one entrancing episode to another. It is impossible to settle down to the serious business of painting a picture. My motto is, "Get what you can when you can get it! Anything may happen in the interim, and usually does."
>
> It's hard getting material. Indians don't come to you. You go to them and in deep humility and respect. Mere money doesn't buy models. There is suspicion and distrust and ancient tribal taboos to overcome.[13]

In order to fully understand and appreciate Rosenthal's efforts in depicting the lives of the Central

Doris Rosenthal. *High Priestess.* **Oil on canvas, 26″ × 32″, 1945. Lyman Allyn Art Museum, New London, Connecticut.**

American Indian, one needs to under-
stand the local culture and atmos-
phere of living conditions as well
as the hardships confronted along
the way. Rosenthal described the
village in which she lived as fol-
lows:

> Santiago Atitlan is sur-
> rounded by volcanoes 12,000
> feet high, and is more like a
> South Pacific island town than
> an American Indian town. The
> comedor, or eating place, where

I live has three rooms. My
room is tiny, white-washed
(shows up the enormous spi-
ders—which are harmless I am
assured, nevertheless, slightly
disquieting). Sweet smelling pine
needles cover the bare dirt floor
of the tiny room, a tiny window
opens on the yard next door; a
little almond-eyed boy is romp-
ing with his puppy; a tiger-
striped cat nestles on the
thatched roof—oblivious of the
vultures preening themselves on
the top beam, even standing on

Opposite, top: **Doris Rosenthal.** *Permenentes.* **Oil on canvas, 24″ × 32″. Courtesy of the Butler Institute of American Art, Youngstown, Ohio. Gift of the Doris Rosenthal Estate.** *Bottom:* **Doris Rosenthal.** *Backstage, Brownsville.* **Oil on canvas, 24″ × 30″. Courtesy of the Butler Institute of American Art, Youngstown, Ohio. Gift of the Doris Rosenthal Estate.**

and soiling the inevitable cross
which crowns every house.[14]

From the description of her hum-
ble abode, Rosenthal, in a sense, be-
came a member of the Guatemalan
culture. She endured the hardships
and the disciplines in order to express
honestly and humbly the lives and
destinies of these peoples of God's
kingdom. Rosenthal further described
the town itself and its inhabitants:

> The thatched roofs of the
> town descend tier on tier to the
> purple blue waters of the lake;
> green banana leaves sway gently
> in the warm breeze against a
> gentle, dappled gray sky.
> Flowers everywhere—bougainvil-
> lea, roses and graceful luxuriant
> bamboo. Ears of multi-colored
> corn dry in the well-swept yards
> or dangle on the corner house
> posts. Women ascending and
> descending the volcanic, rocky
> streets to the lake carry on their
> heads or shoulders their great
> pale cream, water jugs decor-
> ated with age-old, henna de-
> signs. The women are so beauti-
> fully stately and rhythmic in
> their vivid red skirts, red and
> blue rebozos, and their very
> novel red "halos" in their hair.
> All this against the stunning
> volcanoes—extinct and verdant
> now—and usually crowned with
> lazy clouds.[15]

In spite of the trying experiences
and hardships of her Guatemalan
journey, Doris Rosenthal completed
over 600 drawings during the summer
months, drawings which captured the
spirit of the land and its natives.
Guatemalan Indians were recorded in
the unusual bits of life, the simple yet
customary activities which brought
pride and respect to their culture.

Her drawing, *Girl with
Estrellas,*[16] reveals a charming
barefoot niña with an armful of long-
stemmed flowers. The initial vertical
stance of the young girl is interrupted
with sprigs of estrellas which expand
the arrangement into a circular com-
position. The flower blossoms form a
delightful compositional balance as
well as a suggestive lacy dress hem.
The vertical posture is sustained by
the fleshy areas (face, feet, hands)
equally spaced as integral segments of
the whole.

Her lithograph titled *Plum
Girls*[17] is a further example of several
aspects of nature forming a single
unit. Each of the three girls is given
an individual personality and is por-
trayed as in a state of helplessness.
They plead. *Plum Girls* is a simple
display of poverty, a subjective depic-
tion of overlapping figures, each
beckoning to the viewer.

The black and white medium pre-
sents dramatic effects which are les-
sened with the addition of color.
There is a monotony, a sameness that
prevails, almost a cultural stigma that
exists in spite of attempts to indi-
vidualize. Mexicans are a family-
oriented people whose religious beliefs
bind them together and simulta-
neously hinder them from making in-
dividual decisions. Economics may be
the cause, but religious devotion is the
safeguard and the salvation.

In *Girl with Estrellas,* the upper
lightened background is repeated in
the flowing skirt of the girl while grey
tones dominate the lower environ-
ment. Rosenthal has also introduced a
balance between the linear and the
solid. The star-shaped linear flowers
add a delicate touch to an otherwise
stolid figure of the young girl.

During the years 1941–1947,

Doris Rosenthal. *Tehuanas.* **Lithograph, 14⅞″ × 11⅜″, n.d. The Baltimore Museum of Art. The Cone Collection, formed by Dr. Claribel Cone and Miss Etta Cone of Baltimore, Maryland. (BMA 1950.12.349)**

artists, in an attempt to offset a decline in the number of government commissions, accepted commercial assignments. One such endeavor was Rosenthal's painting titled *Coffee Sorters,* commissioned by the Chase and Sanborn Corporation. *Coffee Sorters* became an unusual two part painting revealing an intimate view of Mexican sorters arranged in the typical Rosenthal circular composition. In the distance behind the circular formation are Mexican workers tilling the soil for future production. It is this dual subjective and objective portrayal which extends the recording of an event beyond the literal. There is the humility, determination and discipline reflected in the facial and bodily gestures of the coffee sorters that have earmarked the Mexican people portrayed in Rosenthal's works.

Although distant in the picture plane, the awning of trees shading the activity creates a three-dimensional effect of forcing the viewer to move to the forefront. Rosenthal was careful to alter slightly each of the six workers so that a particular individuality absorbed each figure. The placement of hands and the direction of visual glances determined the final arrangement and enforced a unified composition.

Coffee Sorters was influenced by earlier works such as *A Lively Tune* and *Nude on Sofa.*[18] Both paintings are concerned with the preoccupations of a lone figure within an enclosed environment. *A Lively Tune* portrays a young girl at the piano, surrounded by several objects which interrupt the viewer's subjective appreciation of the dominent subject matter.

In a similar manner, *Nude on Sofa* reveals a lone figure reposing on a sofa. Surrounding her are the haphazardly arranged staircases, the window-door, the objects on the staircase and the ever-present cat. An intricately designed sofa covering underlying the nude figure adds to the objective response.

A similar objectivity is to be seen in a pastel drawing of 1927 titled *Woman Dressing.* Because of a lack of any extraneous matter influencing the subjectivity of the theme, there is a semblance of group activity. In spite of overlapping figures, there remains a lack of unity.

In works of the thirties and forties, Rosenthal employed her circular arrangement of subject matter. In *Girl with Cat*[19] several circular movements occur within a larger oval shape. This lack of sharp intersections in favor of soft, gradual movements coincides with the compassion, humility, honesty and sense of humor of the Mexican people. A related composition is tucked into the foreground in the form of the ever-present pet — a cat.

Rosenthal presents a sprawling, overlapping, circular composition of Mexican natives curled in bunches at siesta time in a work titled *Boys Sleeping.* The artist has utilized the entire canvas, allowing a minimal space for identification of environment. Sombreros and the ever-present dog curl into circular compositions to augment the arc-like figures nestled in comfortable repose. The environmental space was brushed onto the canvas in a fashion identical to that rhythmic pattern of the characters. Although bare feet are again in evidence, the piercing wide-open eyes are absent except for those of the dog.

Rosenthal's practice of audience appeal, of thrusting her subject for-

Doris Rosenthal. *Berthelia.* **Charcoal and pastel on paper, 60.4 cm. × 47.5 cm., 1952. National Museum of American Art, Smithsonian Institution. Gift of the estate of the artist.**

ward, of beckoning the viewer into action, never fails to cause reaction. Her personal devotion and love for her Mexican subjects translates into intimate charming shifts from artist to canvas. Her painting, *Maria Margarita,* is a transference of such love.[20]

Rosenthal's works are not without humor. *Bottoms Up* is a satirical statement in which the title pertains not so much to "drink up," but more to the visual display of masculine buttocks. The lone woman with her dog is a welcome interruption to the lineup of male bar occupants. Rosenthal retains her compact arrangement of her idea. The circular bar adheres to the basic composition of Rosenthal's other works. Although individually conceived and executed, the bar tenants and tender form a single unit, a team of six players, so to speak, which are viewed as a subjective response to a commonplace scene. The monotony is broken slightly by allowing space to exist between the drinkers. In spite of its comical message, Rosenthal sustained her devotion to the Mexican culture.

Swinging from a compact singular grouping of figures witnessed in *Bottoms Up* to a panoramic stage production of a Hollywood musical, *Coffee* pictures a splendid manipulation of figures in a continuous flow of activity interrupted only by slight shifts of posture and body action. Unlike other Rosenthal paintings which are intricately knit to eliminate negative space, her painting *Coffee* breathes and frees the occupants for a more leisurely movement. There are, however, a series of compact groupings in which semi-nude and fully clothed figures overlap.

One of Rosenthal's few objective compositions, the panoramic view in *Coffee* serves to encompass a complete activity. Undoubtedly, several individual drawings and paintings preceded this final work, which sustains a more individualistic style.[21]

Plume Dance is an unusual panoramic view of a landscape in which the activity of humanity becomes secondary to the landscape itself.[22] Margaret Breuning describes it as follows:

> A group of dancers have attracted idle spectators of a village. The scattered huts, the little clusters of cultivation, the patient donkeys waiting the return of their masters, the straggling streets of the village all present a world that is alien to the experience of most of us, but it is made convincing.[23]

Notes

1. Rosenthal's lithograph titled *Mexican School* was purchased by the Library of Congress and is reproduced in *American Prints in the Library of Congress* published by Johns Hopkins University Press in 1970. It measures 24 cm. × 32 cm.

2. The painting *By the Sea* appeared in the Midtown Galleries of New York City in 1940 and was later purchased by the Museum of Modern Art of New York.

3. *Tops,* a painting, was also bought by the Museum of Modern Art of New York.

Doris Rosenthal. *Summer Breezes.* **Lithograph, 13¾″ × 9¹³/₁₆″, n.d. The Baltimore Museum of Art. The Cone Collection, formed by Dr. Claribel Cone and Miss Etta Cone of Baltimore, Maryland. (BMA 1950.12.347)**

4. *Girl with Banana Leaf Stalk* was purchased by the Toledo Museum of Art in 1942 after being completed in 1940. The painting also appeared in an exhibition of paintings by Rosenthal at the Midtown Galleries in March of 1941.

5. The painting *Sacred Music* was purchased by the Metropolitan Museum of Art in 1936.

6. Rosenthal's painting *Nude at the Table* is now owned by the Carnegie Institute of Pittsburgh.

7. The painting *The Source* was exhibited at Midtown Galleries, New York, during the month of March, 1945.

8. Regarding her exhibitions of Mexican paintings, the *Art Digest* had commented: "For twenty years Doris Rosenthal had made repeated trips to Mexico, interpreting its subject matter with a sympathy which is unsentimental, yet somehow works its way to the surface of the dark skinned figures she depicts so that they emerge warm blooded and vital, alert even in repose . . . reveals again her dispassionate rapport with the human aspects of her themes . . . which lend impact to her work pictorially. Perspectives are suggested but flattened inventively to hold the canvases' two-dimensionality without losing depth."

9. *Between Two Screens* was painted in 1937 and was featured in a *Life* article March 9, 1942.

10. Of her painting *Enchantment,* which won a prize in the third annual Pepsi-Cola Exhibition of 1946, Rosenthal had the following to say: "*Enchantment* easily could have happened but it actually didn't. Old style grafonolas abound in Mexico. The great drooping horns are like giant petunias, burnt orange, or deep purple, or lemon yellow and cerise, or a clear bottle green and gold. I have greatly admired them in the pulquerias and little restorantes, but it wasn't until I came home and found one in a second hand store here in Connecticut that I was able to realize the idea that had been an obsession in Mexico. The Tarascan women in their great plaited flowing skirts are a natural for the grafonolas, and so I worked out this incident."

11. The painting *Don Pasquale* was donated to the Davenport Municipal Art Gallery, after her death November 26, 1971. Alan Gruskin described her painting as follows: "*Don Pasquale* tells its story with the utmost pictorial economy. The concentration on the teaching and learning tasks is complete, both on the part of the serious actors in a little drama and on that of the picture as a picture. There is no wasted motion. Characterization is uncannily shrewd; the grouping is compact but varied. Note how the one note of distortion, in the door, adds a touch of liberation from the dominately real."

12. Alan Gruskin has stated in a Midtown Gallery brochure of Rosenthal that "her design is functional, but it appears at times from the sober confines of function and gambols happily about the painting on its own. It does this delightfully, for instance, in *La Criatura,* where the bars of the basket and the criss-cross motif of its sides play a delicate counter-note to the sturdy forms of the baby—and the smaller repeats of those forms in the fat bananas with their subtle variant of the dots. The frills of grayed white around the infant's head echo this light motif differently but keep the sound. And there in the center, holding the pictorial stage with complete assurance, is the sleeping child—serious and very real. The design gets more serious, incidentally, in the billowing form arrangements of pillow and body, and in the subdued color harmony."

13. This quote was taken from the June, 1944, issue of *American Artist,* pages 23–24.

14. *Ibid.*

15. *Ibid.,* pages 24 and 26.

16. The drawing *Girl with Estrellas* appeared in the publication *Parnassus,* February, 1937, in an article written by art critic Emily Genauer.

17. Her lithograph *Plum Girls* was designed as a Christmas card and featured at a Christmas Group Exhibition at the Midtown Galleries.

18. The paintings *Lively Tune* and *Nude on Sofa* were executed in February of 1929 and reside in the American Art Archives in Washington, D.C.

19. The painting *Girl with Cat* was painted in 1937.

20. Regarding her drawing *Maria Margarita,* Robert Coates, critic for the *New Yorker,*

wrote, "No other artist I'd seen had been able to catch the spirit of Mexican life as simply and naturally as she had, or to portray it so poetically."

21. The reproduction of the painting *Coffee* appeared in the April, 1945, issue of the *American Artist*.

22. The painting titled *Plume Dance* was executed in 1944 and appeared in a showing of Rosenthal's paintings at the Midtown Galleries of New York during May of 1945.

23. Margaret Breuning's remarks about the painting *Plume Dance* appeared in a 1945 issue of *Art Digest*.

Bibliography

Baigell, Matthew. *The American Scene.* New York: Praeger, 1974.

"Doris Rosenthal." *Forbes Watson D54 Papers.* Archives of American Art. Washington, D.C.: Smithsonian Institution.

_____. *Newsletter.* New York: Midtown Gallery, April 29, 1952.

_____. *New York Public Library Papers.* Archives of American Art. Washington, D.C.: Smithsonian Institution.

Eliot, Alexander. "Christmas Cards Painted by the Top Artists in America." *Life.* December 16, 1940, pp. 64–66.

_____. "Doris Rosenthal: Exhibition Catalogue." New York: Midtown Galleries, March 3–22, 1941.

_____. "Doris Rosenthal: Exhibition Catalogue." New York: Midtown Galleries, May 1–19, 1945.

_____. "Doris Rosenthal: Exhibition Catalogue." New York: Midtown Galleries, November 23–December 11, 1943.

_____. "Doris Rosenthal: School Teacher Paints Lovable Pictures of Mexicans." *Life.* November 22, 1943, pp. 64–68.

_____. "Doris the Gringa in Guatemala." *American Artist.* June, 1944, pp. 23–26.

_____. "Texas Sees New Crop of Figure Paintings." *Life.* March 9, 1942, p. 46.

_____. *300 Years of American Painting.* New York: Random House, 1957.

Fern, Alan. *American Prints in the Library of Congress.* Baltimore & London: Johns Hopkins Press, 1970.

Genauer, Emily. "Doris Rosenthal." *Paranassus.* February, 1937.

Gruskin, Alan. "Doris Rosenthal." Exhibition Catalogue. New York: Midtown Galleries, January 25–February 12, 1955.

_____. "Doris Rosenthal." Exhibition Catalogue. New York: Midtown Galleries, October 26–November 20, 1965.

_____. *Painting in the U.S.A.* New York: Doubleday, 1946.

Andrée Ruellan

Artist Andrée Ruellan has conceded that the artist and his or her work is one and the same. "My work can be no better than I am myself as a person and no deeper than my understanding of life as a whole."[1]

Born in New York City in 1905, Ruellan, at the tender age of 17, spent a year in Rome under the tutelage of the American artist Maurice Sterne as a prerequisite to an ensuing six years of study in Paris.

Ruellan has relied upon her philosophy of life. "My deepest interest has been for people at work or at play. It seems to me that it is in the most everyday surroundings—a subway entrance, a market place or on the street—that one finds the unexpected in situation and aspect."[2] In a sense this philosophy is not unlike that of Loren MacIver except that Ruellan dealt with the human condition instead of inanimate objects.

In *Market Hands,*[3] Ruellan favored the downtrodden. The painting resembles a hobo corner in which a burning barrel serves the needs of shivering occupants. Her use of the human characters draws the viewer into the painting while suggesting that others remain outside the picture plane. One feels compassion for Ruellan's figures. *Market Hands* is a classical composition dealing with a commonplace scene in a realistic manner. Although coupled in compositional unity, each figure suffers individually. While the one figure warms his hands over a heated barrel, the other uses his pockets as a warming device.

Rather than casting shadows according to legitimate sources of light, Ruellan preferred to adjust lights and darks according to compositional needs. Shadows are structured to accommodate an informally balanced arrangement of softly applied brushstrokes. There is a melancholy atmosphere at the market place, and Ruellan made a strong note of it.

Ruellan appreciated privacy and artistic freedom, neither a notable American attribute. According to Ruellan, "Art was not held in high regard in the United States during the twenties. There were few galleries in New York City, so Americans went to Paris where they were able to live cheaply," she recalls. "There was real artistic ferment at that time. People were expressing themselves freely. In addition, my friends and I were indignant about social injustice. We wanted society to improve and we felt injustices deeply. Our aim wasn't to

get rich. We wanted freedom in our work and in our careers. We wished it for everyone and we expected to find it in Paris. We did."

Ruellan remained in Paris long enough to meet and marry Jack Taylor, returning to America before the stock market crash of 1929. Her work suddenly changed when she accompanied her husband who toured America as a visiting art professor. Her drawing became essential to her "locale" paintings. Ruellan believes in good drawing. "For a time," she stated, "there was a tendency to paint directly on canvases rather than to explore ideas through drawings." She described drawing as intuitive. "Drawing is a revelation of what's in your mind and heart, something that can be beautiful and important, a jumping-off point for a more complete work."

Her "site" drawings led to such paintings as *City Market* and *Children's Mardi Gras.* The mystic quality embracing the New Orleans celebration reminds one of Philip Guston's psychological works of the forties, which engaged in symbolic journeys of the human spirit into the unknown. One is never quite sure of the artist's intent and yet speculation fails at times to record a profound message. *Children's Mardi Gras* seems delightful enough and since it represents a gala celebration prior to the season of Lent, it seems to elude the apparent mystery that shrouds the canvas.

Regardless of intent, a barrier exists between the uninhibited, playful youngsters in the foreground and those in the background seemingly engaged in a struggle for freedom. Perhaps it is a jocular activity designed to offset the usual intoxication of adult celebrants.

In spite of the objective arrangement of characters, Ruellan has presented a surreal atmosphere which invades the entire canvas. Floating baselines anchor the children only momentarily as the fluid brushwork blends together the foreground and background. Ruellan has created two worlds, one free of containment only to find it mysteriously unreal, and the other honed in darkness but edging an awakening. Whether she intended to or not, Ruellan in *Children's Mardi Gras* has transformed an annual gala affair into a symbol of freedom and eventual eternity.

In spite of attempts to sideline the poverty of the Great Depression and the tragedies of the world war, a scene such as *Children's Mardi Gras,* although not a direct call to arms, does in an eerie nostalgic way enunciate the evils underlying the cause of such atrocities as the Jewish holocaust. To speculate is to interpret. Inasmuch as the artist is frequently unaware of inner thoughts which materialize on canvas, so too is the viewer excused from misinterpretations especially if credit is given to a more profound statement than initially and actually intended by the artist.

The partially hidden figures scaling the wall in order to engage in the merriment beyond become a symbol of freedom from imprisonment. And why the masks? Why must man wear a disguise to celebrate life? Is it because sins can be committed without identifying oneself? Are the children guilty of similar tactics, or is it just a game they play?

Ruellan's sensitive rendering of human gesture has been witnessed not only in *Children's Mardi Gras,* but in figurative drawings and paintings executed after her return from France

Mending the Nets. Rockport.

For Barbara and Howard.

Justice Russell

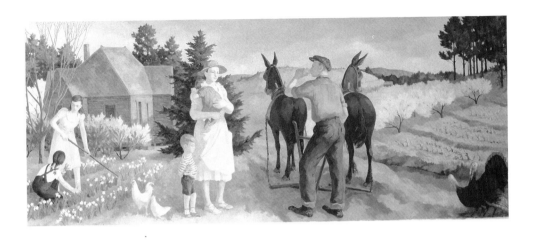

Andrée Ruellan. WPA Mural. National Archives of American Art.

where her early commitment to humanity's underdog had expanded and deepened. "There was a lot of sorrow among the French people," she recalls. "Life had been extremely difficult after World War I in which two million people lost their lives. Reconstruction added to the problems." This sense of compassionate dedication sustained her presence in France.

After returning to the United States in 1929, the countryside stymied Ruellan's approach to painting. "I remember arriving in Woodstock in the morning after a night cruise up the Hudson River. The countryside appeared to be a dirty spinach color compared to what I was used to in France. Everything there was so groomed and well cultivated." I asked myself, "How will I paint this?"

Strange that her concern for the landscape was so indelibly etched in her vision especially when it served as a backdrop for her serious figurative works. And yet, it was the landscape that concerned the French during the twenties, and this carry-back attitude prevailed. Adjustments were made to the Woodstock landscape in addition to the political and economic changes.

Ruellan forfeited WPA art assignments that assisted most American artists during the Depression even though her paintings reflected the economically difficult times. Ruellan has not pleaded a cause in her more than sixty years of recording the people of America in their natural environments and economic circumstances. Although alert to the hardships of the Depression and the tragedies of the ensuing world war, she averted the expressions of the sorrow, anxiety and anticipation of these two worldwide events. She lived the Depression and war as a human being, but as an artist ignored the opportunity of

Opposite: **Andrée Ruellan.** *Mending the Nets.* **Lithograph. Courtesy of The Slater Memorial Museum. The Norwich Free Academy, Norwich, Connecticut.**

commissions by publications such as *Life* and *Fortune* and by corporations such as Upjohn, Abbott, IBM and Dow.

Instead, she created sensitive portraits of people of the South and preliminary sketches of regional territories that later resulted in some of her major works. Drawings reflected the woes of the Depression. In *Portrait of an Old Man,* executed in 1926, the subject reflects the coming age of deprivation. Facial gestures register the aging of man and the anticipation of a worrisome future.

Traveling with her husband enabled Ruellan to execute a series of such sensitive drawings of peoples of varying climatic locations from the swamplands of Louisiana and Florida to the coastal shores of New England to the waters of the Caribbean.

Andrée Ruellan was an objective painter in the sense that she revealed the cause or effect of an emotional state of the human condition. The environment became the cause of joy or sorrow, or it defined the location of the situation or circumstances under which the emotional event transpired. It is difficult to be both subjective and objective in one's approach to expressing life in the form of a painting. Does one establish the environment and then insert the players, or are the role players portrayed and the habitats added? Ruellan sought environments in which the human aspect appeared and presented the unusual. "Such situations arise," she stated, "in the most normal surrounding—a subway entrance, a marketplace or on the street."[4] It was in the usual that one found the unexpected. Ruellan claimed that the artist should avoid the ivory tower image and cry out against war and poverty, and race discrimination, and that technique should serve the purpose of meaning. In spite of poverty and constant struggle for survival, Ruellan marveled at the presence of kindness and courage.

Like so many native New Yorkers, Ruellan painted Washington Square, and it was during the winter of the Great Depression, in 1938, that she painted *Spring in Bleecker Street.* In it, each of the six role players sustain individual concerns, and yet each is an integral part of the whole. Each relies on the other, in a compositional sense as well as conceptual. The painting is a combination of horizontal and vertical planes. The background is horizontally fashioned, interrupted only by the vertical display of window frames. The insertion of the human element disrupts the horizontal flow. Interestingly, the vertical postures of the newsboy and grocery boy assist in the continued horizontal movement, even though they overlap several horizontal planes, until Ruellan's insertion of the woman with the umbrella and her child.

Understanding the compositional manipulation is essential to a full appreciation of the work. Ruellan had succeeded in sustaining the viewer's attention within the picture plane while offering a fleeting glance of a typical big city daily occurrence. In manipulating the objective within a subjective environment, there exists the danger of

Opposite, top: **Andrée Ruellan.** *Savannah Landscape.* **Oil on canvas, 26″ × 40″, 1943. Private collection. Photo courtesy of Kraushaar Galleries, New York.** *Bottom:* **Andrée Ruellan.** *April, Washington Square.* **Oil on canvas, 26″ × 36″, 1938. Private Collection. Photo courtesy of Kraushaar Galleries, New York.**

Andrée Ruellan. *Spring in Bleecker Street.* **Oil on canvas, 35″ × 51″, 1938. Collection of Mr. Howard Meyers, Dallas, Texas. Photograph by Geoffrey Clements.**

overworking the composition to satisfy technical needs and thus diminishing the personal nature of the work. It is true that the more objects added to a painting, the more objective the painting becomes. A sharing of ideas takes place, and the more ideas to be shared the more one's time spent with each idea diminishes. This notion does not hold only if the sum of ideas constitutes a single broader idea. For example, to single out and concentrate upon one character in *Spring in Bleecker Street* as a single unit of concentration is a subjective experience. The addition of five single characters forces the viewer, and artist, to share concentration among the six characters. Thus, in order to fully appreciate *Spring in Bleecker Street* from a subjective viewpoint, one is forced to evaluate the painting as a whole, not as single characters within a whole.[5]

What appears to be even more objective is the painting titled *River Boys,* and yet, after a prolonged study, the objects and figures can be seen to be a natural part of the scene. Remove the four figures and the adjacent apparatus and one is faced with a provocative, quietly emotional environment. The replacement of the figures and apparatus merely confirms the human element apparent without their presence. *River Boys* relates the dependency of the scene upon the task at hand in order to avoid attention between the role players and their environment. Each object and figure seems attached to its surroundings. Ruellan had arranged individual aspects in an overlapping fashion so

as to create a oneness. *River Boys* is contemplative, a serious slice of life which the artist had to record. A bit of mystery is added with the open door of the fishing shack, which seems to invite the viewer onto the scene. *River Boys* is one of several paintings recording the life of the South, particularly the markets and river fronts.[6]

Market Place is a bustling array of individuals eager to sell their wares. Venders are pitted against each other in concept and in compositional positioning. The constant and consistent interplay of opposing movements excited Ruellan to record this daily event.

The market place is one of humility, but indeed, of need. It determines the degree of poverty, and becomes a matter of life and death. Yet, Ruellan managed a bit of humor and gaiety. The market place is a friendly meeting place full of eager buyers and sellers, and there is a sense of faith and fulfillment in spite of signs of economic decay.[7]

A painting closely related to *Market Place* is *Randy, Julie and John,* a segment seemingly plucked from the *Market Place.* Several pencil sketches and color preliminaries preceded the final composition. It was Ruellan's practice to record a single event, theme or personality from several angles as well as with several different media. *Randy, Julie and John* was the result of such practices. Each of the characters positioned in her paintings have been altered, modified, erased, duplicated, painted and repainted until the precise personality emerged.[8]

Captain's Roost pictures the beloved captain recalling the yesteryears. The site was composed before

the role players were added. Ruellan had conceived a compatible union of human existence and appropriate habitat. Indeed, objectivity is apparent. Two individual events—the captain/visitor dialogue and loading the boat with supplies—capture the viewer's attention.

There is a freedom one senses, a total freedom to explore the surroundings. Thus, the human figures have inherited the earth, so to speak. They belong, and subsequently become one with the surrounding landscape. Ruellan has diminished the objective aspects of *Captain's Roost* and has granted a spacious atmosphere to allow for a contemplative approach. Each of the two singular compositions establishes a distance between the role players, and one can only question the audible or invisible dialogues in session. This mystery of the unknown identifies with the characters in *Captain's Roost* and in many of Ruellan's figurative works.[9]

As late as 1945 Ruellan was still recording commonplace events of life. In street scenes such as *City Market,* one witnesses a sunlit panorama. Architecture dominates the scene, which is interrupted partially by a trio of trees spiralling high above the rooftops. Townspeople, soaked in an early morning sun, began their daily chores.

A preliminary drawing for a city market painting indicates Ruellan's need for supporting apparatus. A conversation transpiring between a buyer and seller invites the viewer to participation in the dialogue. The drawing is subjective if only the two figures were present. Tools of the trade (a need to identify the role players with their environment) become essential to the whole; that is, if the expression is to remain an objective recording of an

Andrée Ruellan. *Randy, Julie and John.* **Pencil and charcoal, 15″ × 23½″. Virginia Museum of Fine Arts. Gift of the Childe Hassam Fund of the American Academy of Arts and Letter, 1946.**

incident, those objects which identify with the role of the players are indeed essential to its meaning. The objects are not essential to the work itself if suggestive environments are optional. The overlapping of these objects present delightful compositions which could well exist as total and complete expressions.

Savannah Landscape, "the same market from another view is a well-formed picture in every way and, further, it brings shade trees, their shadows, the people crossing the wide and lazy street, the lanes of sunlight, into convincing relationship and within an understood envelopment of atmosphere."[10]

Savannah Landscape was the last of her representational style. During the fifties, nature became a symbol in which visual perspective was adjusted to incorporate nature from several angles. The theory of interpenetration became a major factor in creating a frontal plane, unquestionably the result of her husband's indirect influence. The overlapping of horizontal

Opposite, top: **Andrée Ruellan.** *River Boys (On the Savannah).* **Oil on canvas, 18″ × 24″. Courtesy Wichita Art Museum, Wichita, Kansas; the Roland P. Murdock Collection. Photograph by Henry Nelson.** *Bottom:* **Andrée Ruellan.** *Market Place.* **Oil on canvas, 28″ × 42¼″, 1939. The Metropolitan Museum of Art. George A. Hearn Fund, 1940. (40.83)**

planes with vertical buildings and trees became a natural temptation to abstract, and it was this need for change and the convenient example of her husband's work that was the final determinant. The abstract French movement and the eventual influence of Japanese scroll painting became strong influences in her work of the fifties and sixties.

Ruellan's attachment of subject matter to environment was an intuitive response to nature; that is, color, technique and composition simultaneously coincided with the intellectual, emotional and visual forces into a singular act of doing. Thus, the attachment of forms to an environment emerged from the environment instead of adding to it. However, in later works of the fifties, Ruellan introduced the theory of interpenetration which in an obvious sense united foreground with background, the positive with the negative.

In *Bridge at Arles,* a lone figure is on the canvas. The multi-technical approach to this painting typifies the transition of one school of thought to another. One questions the formation of abstract shapes where no purpose is served other than a superficial one, that being to provide an abstract tone toward a total union of foreground and background. A large transparent, rectangular shape is superimposed over much of the canvas.[11]

Flowers on a Green Table has an abstract tone to it without being abstract. A rectangular shape similar to the one that appears in *Bridge at Arles* also is seen in *Flowers on a Green Table,* the difference being an opaque quality which disregards the abstract notion. The shape acts as a middle plane setting the vase of flowers apart from the background. The source of

light originates outside the picture plane. Ruellan seems to have drifted into the realm of semi-abstractionism, unlike her work of the thirties and forties.

In *Entr'acte,* Ruellan introduced a series of linear compositions which seem to have little meaning except to create an exciting counterpart to the nuances of color which inhabit the spaces. And yet, the semi-abstract appearance neglects the interpenetration theory and relies completely on superficial brushstrokes. Light sources again originate outside the picture plane and are distributed appropriately throughout the painting. The viewer is treated to an engaging figure and the outlying apparatus of the scene. Three spatial planes occupy the painting, the female form residing on the frontal plane while facing the middle and distant planes.

The Accordionist, painted during the fifties, is similar to *Entr'acte* and *Bridge at Arles.* Brushstrokes seem intuitively applied and reflect an aggressive approach to an actual performance. The statuesque figure performs with distorted hands, enlarged to match the nature of the musical instrument. Highlights are distributed within appropriate areas to guarantee a unified composition. The background sustains brushstrokes similar to those within the major stimulus.[12]

Before Ruellan drifted into semi-abstractionism she made a short trip into Surrealism, which can be seen in such works as *Pink Masks*[13] and *Nomads.*[14] *Nomads* illustrates her ability to incorporate serious notions with symbolic means of a whimsical, imaginative nature. The usual distance in space is marked by the diminution of man disguised as a magical performer. The horizon

Andree Ruellan. *Entr'acte*. **Oil on canvas, 35″ × 27″. Courtesy of Kraushaar Galleries, New York.**

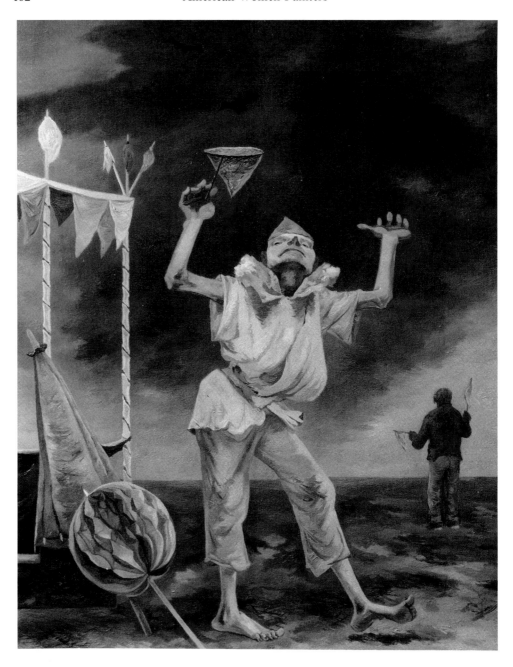

Andrée Ruellan. *Nomads.* **Oil on canvas, 38″ × 30″. Collection of the artist, Andrée Ruellan.**

line creates the illusion of infinite depth. The viewer is treated to the magical charm of the performer while measuring, so to speak, the distance between the two performers. Large,

distorted hands, as seen in *The Accordionist,* again refer to the tactual act of doing, in this case by the magical performer.

Pink Masks differs in its symbolic

images from *Nomads* by virtue of its compact nature. Although sided by the usual still-life apparatus, pink masks are positioned in obvious compositional locations. A circular movement of forms occupies the central segment of the canvas while vertical and horizontal lines form rectangular shapes in the background. *Pink Masks* is a still-life painting which incorporates two pink masks to suggest personal dramatic interpretations. One mask, by the cut of the eye symbols, suggests the state of pleasure or joy, while the other seems to represent despair or tragedy. These two extreme states of emotion are handled in a quiet manner and can easily be interpreted as mere compositional devices.

Ruellan's excursion into the symbolic was short-lived, but essential to her artistic growth. Recording the human within natural habitat was Ruellan's most successful motivation. The objective arrangement of *Pink Masks* is less intuitive, and thus less personal than the compositional urgency of *City Market, Market Hands* and other subjectively rendered expressions.

Ruellan has explained discrepancies in her approach to art by pointing to her technical flexibility. "Less tangible," she stated, "than technique, however, is my personal problem as a painter; that of the world I wish to create, from within myself, and which in turn partly depends on my relationship to the outer world. With maturity I trust intuition more, know how to take advantage of the unexpected, the accidental. But how can I explain in words my approach to this world of personal vision? About all that I can say is that, working through the

'imagination,' the sensibilities and the emotions, I would have, if I had succeeded, a work open and vibrant. Space and poetry would become one."[15]

Ruellan throughout her career has shifted from the objective to the subjective, this change occurring to meet pertinent needs at the time of creation. *April, Washington Square,* for example, is highly objective, quite reminiscent of Doris Lee's rendition of the same subject. The Square is viewed from a single angle incorporating within a single sweep numerous combinations of human activities. The rain soaked atmosphere, however, tends to bind the occupants to their environment by casting reflections onto the wet pavement. Spiralling, leafless trees overlap the horizontal string of park benches and fences surrounding the Square. The viewer is forced to note each individual common event before recognizing the similarity of objective stimuli. However, the objectivity is heightened by the stark silhouettes formed by the naked tree branches piercing the April skies.

Similar in composition but with fewer objective stimuli is Ruellan's adaptation of *Carolina Shrimpers.* Again, the artist brings the viewer into the painting from a singular angle. A simple architectural design sets the stage for the shrimp vendors who await the unloading of a shrimp boat. The artist properly locates two figures moving toward the viewer to the left of the canvas, where they act as an invitation to participate.

In her later works, Ruellan ignored reality and sped directly to abstractionism with such works as *Saraband* and *Lake Alice.* Both paintings appeal to the instinctive responses of the Abstract Expressionist

movement. Of the two, *Saraband* appears more tightly controlled and resembles the top view of a major urban center. An informal distribution of darks and lights inhabits the canvas as one delights in an excursion of stop-and-go. Ruellan avoids congested areas with free-flowing brushstrokes that veer at appropriate junctures to gradually coincide with similar intersections further into the picture plane.

Ruellan seems more successful in total abstractions than in her semi-abstract attempts at reality. *Lake Alice* is different in its compositional arrangement. The artist has established three neutral planes in a completely negative space. Each of the three middle planes or tones is occupied by seemingly symbolic images which tend to float in space. None of the floating objects is anchored to an environment. Rather, Ruellan preferred to explore a freedom which remains loose and carefree, but which exhibits a degree of abandonment. And yet, the tonal changes differ little from her early realistic works. The subtleties remain.

The abstract nature of *Saraband* and *Lake Alice* and others had already been envisioned in an earlier work titled *Children's Mardi Gras.* Similar brushstrokes appearing in both foreground and background are also witnessed in her paintings of the sixties. The relinquishing of visual perspective, which was partially done away with in *Children's Mardi Gras,* is evident in such works as *Saraband* and *Lake Alice,* in which a distinction between foreground and background is eliminated. Although exhilarating in its change, and stable in its gallery exposure, Ruellan's abstractions reflect a dual personality as if an embrace of humanity succumbed to abstract experimentation. Even though a gradual

change is evident throughout her career, threading through her paintings is always a profound concern for the betterment of mankind.

One finds in *Little Circus,* rather than the isolation of figures Ruellan usually achieved, an amassing of human beings engrossed in the activity of the circus. The artist has set a background of shrieking audiences peering at the main attraction, namely, a tightrope walker. The main character occupies a space between the figures in the forefront and those forming the audience in the background. Thus, three planes are established and the depth of the painting is recorded. *Little Circus* is an objective work, but the unity of separate aspects of the painting relates a personal, subjective view.

Of a similar theme and title is *Circus,* a lithograph executed during the Depression after the artist's return to America from France. Notwithstanding critic Clinton Adams' insistence that Ruellan's use of tusche washes was brilliant in her lithographs printed by Desjobert, *Circus* lacks the delicacy evidenced in her drawings and paintings of the same period. Gesture drawing is the source of her figurative forms, which suggest the movements of the rhythmic trio and the emotional reactions of the limited audience. Ruellan has allowed the texture of the lithographic stone to penetrate the drawing, resulting in a rough, unfinished appearance. This quality of the stone dominates both the environment and its inhabitants so much that any attempts at refinement were sidelined in favor of the strong application of both brushwork and linear strokes.

This 1931 rendition preceded her

Andrée Ruellan. *Flowers on a Green Table.* **Oil on canvas, 24″ × 20″. Collection of the artist.**

more refined works of later years such as *City Market, Charleston* of 1936, *The Trio* of 1940 and *Clown* of 1951.

Lithography was not Ruellan's chosen medium and yet, because of her direct and sensitive drawing, it seemed an ideal medium for her form of expression. Considered to be one of America's finest recorders of her native land, Ruellan needed color to

Andrée Ruellan. *From Quai Montibello.* **Oil on canvas. Collection of Lehigh University Art Galleries, Bethlehem, Pennsylvania.**

fully exploit the American landscape and its people.

Andrée Ruellan's lithographs became permanent images of her hundreds of gesture drawings. *Trio* is an example. Violin, cello and flute blend into a melodic and artistic composition. The young male flautist is flanked by a young female violinist and cellist.

The staidness of the event is offset by the whimsical postures of the trio of players.

Trio is objective in the sense that three figures must be shared individually, but subjective in the sense that the three figures form a single unit, and thus is viewed as an individual team or trio.

Notes

1. Quotation from an article titled, "Andrée Ruellan," by Ernest Watson, in *American Artist,* October, 1943, page 8.

2. *Ibid.*

3. A reproduction of the painting *Market Hands* appeared in the book *Contemporary American Painting,* the Encyclopaedia Britannica Collection, 1945.

4. Quotation from an article titled, "Andrée Ruellan," by Ernest Watson, in *American Artist,* October, 1943. A further quote regarding Ruellan's philosophy, which was taken from the same article follows: "People are never just spots of color. What moves me most is that in spite of poverty and follows the constant struggle for existence, so much kindness and sturdy courage remain. Naturally I want to paint well-designed pictures, but I also wish to convey these warmer human emotions. No Ivory Tower — I feel strongly that the artist is an important member of society, and he should do his part to build a world where war and poverty as well as racial discrimination, are impossible. I want as good a technique as possible, yet with subtlety, what I feel about life. It is true that I paint some landscapes and still-lifes, but from the earliest drawings my deepest interest has been and is for people, at work or at play."

5. One of her most famous paintings, *Spring in Bleecker Street,* was painted in her studio on the south side of the square during the winter of 1938. Frank Seiberling commented: "*Spring in Bleecker Street* is the situation of an instant and a rather commonplace instant. These six young people have been brought together for a moment and a moment later will be separated again.... It is a fleeting moment of the day, but if these people, who happen to pass together, are psychologically unrelated, that is an occurrence which is typical of the big city.... I have said that the approach is objective, and indeed, when you look at the grocery boy and the girl you are struck by the detachment of the treatment. There is a spiritual separation, though friendly, which exists between strangers. They are just what they are represented to be, people who pass in the street. But look at the newsboy. The generalized detachment in the other faces is missing here. In its place you feel a personal attachment on the part of the artist and so, on your part, for this boy. Your heart is touched. The charm is broken. We are no longer the object observer but are related to the scene by a personal bond. We are looking at someone whom we know far better than we do the passing stranger. But still, it is a picture of passing strangers and it gives us a strange feeling to see someone for whom we have a personal regard. There is a part of ourselves in the painting." These comments appeared in the *Toledo Sunday Times,* June 30, 1940, and were reprinted in the October issue of *American Artist,* 1943.

6. The painting *River Boys* measures 18″ × 24″, and is reproduced on page 12 of the October issue of *American Artist.*

7. The painting *Market Place* measures 28″ × 42¼″, and is owned by the Metropolitan Museum of Art of New York City.

8. The painting *Randy, Julie and John* measures 27″ × 38″, and is in the permanent collection of the Art Institute of Zanesville, Ohio.

9. The oil painting *Captain's Roost* was received in the 1943 Carnegie Show at Pittsburgh.

10. This quote was taken from the magazine, *Art Digest,* February, 1945.

11. The painting *Bridge at Arles* appeared at the Storm King Art Center in Mountainville, New York, June 14–August 14, 1966.

12. The paintings *Flowers on a Green Table, Entr'acte,* and *The Accordionist* appeared in a 1956 showing at the Kraushaar Gallery in New York City.

13. A 1952 showing of Andrée Ruellan's work included a painting, *Pink Masks,* which was reviewed by the *New York Times,* March 2, as follows: "With the paintings of Andrée Ruellan at the Kraushaar Galleries we are almost back in the everyday world, though landscape and figure here are cast in a romantic mood that is intensified by a modicum of surrealist fancy. The latter aspect resides entirely in the dramatis personae of her subject matter, the saltimbanques, harlequins and wistful children and the bits of still life that refuse to remain still. But no matter how poetic this allusiveness may be it is firmly controlled by the rules of time tested design which see to it that the dovetailing shapes and colors are ultimately locked together in a satisfactory fashion."

14. A March, 1952, showing of Andrée Ruellan's work included a painting, *Nomads,* which was reviewed by the *New York Herald-Tribune* as follows: "As fantasy has entered the

arena of popular affairs, Miss Ruellan has seen in it a means for her own youthful and buoyant vision to recreate itself. *Nomads,* thus, is a particularly apt illustration of her ability to embody a serious thought in symbolism of a pleasant, imaginative nature."

15. Quotation was taken from the catalogue of her show of 1966 at the Storm King Art Center at Mountainsville, N.Y.

Bibliography

Andrée Ruellan Reviews. *Art Digest.* June, 1934; March, 1937; June, 1938; August, 1942; February, 1945; March, 1952.

_____. *Art News.* May, 1938; January, 1938; February, 1945; March, 1952; November, 1963.

_____. *Coronet.* 1938.

_____. *Magazine of Art.* September, 1936.

Chomicky, Y.G. *Watercolor Painting.* 1969.

Exhibition Catalogue. *Andrée Ruellan.* New York: Kraushaar Galleries, 1945.

_____. *Andrée Ruellan.* New York: Kraushaar Galleries, 1956.

_____. *Andrée Ruellan.* New York: Kraushaar Galleries, 1963.

_____. *Andrée Ruellan.* Mountainsville, N.Y.: The Storm King Art Center, 1966.

Fern, Alan. *American Prints in the Library of Congress.* Baltimore & London: Johns Hopkins University Press, 1970.

Forbes, Watson. *American Painting Today.* New York: American Federation of Arts, 1939.

Kent, Norman. *Drawings by American Artists.* New York: Watson-Guptill, 1947.

Pagano, Grace. *Contemporary American Painting.* New York: Duell, Sloan & Pearce, 1945.

Reese, Albert. *American Prize Prints of the Century.*

Salpeter, Harry. *About Andree Ruellan.* Coronet, 1938.

Watson, Ernest. *Andree Ruellan.* American Artist, October, 1943.

Zaindenburg, Arthur. *The Art of the Artist.* New York: Crown, 1951.

_____. *Twenty Painters and How They Work.* New York: Watson-Guptill, 1942.

Mabel Dwight

Carl Zigrosser, curator of prints of the Philadelphia Museum of Art, has labeled Mabel Dwight a master of human comedy. His description of her follows: "Dwight did not just skim the surface of the comic and incongruous, but probed into the depths, ever imbued with pity and compassion, a sense of irony, and the understanding that comes of profound experience. There is as much of the tragic as of the comic in the human comedy; the contrast between what is and what might be. There is detachment also, the sense of seeing life from afar, the long view of things."[1]

Perhaps it is not so much living life from afar that motivates Mabel Dwight, but rather the creation of life from afar. It is essential to experience life intimately and to express that experience in seclusion or isolation. The artist must first make note of the experience of an event in a visual sense, and after moments of visual absence and the allowance of emotional reaction to the event, a blend of the visual and emotional results in a formidable portrayal. The emotional reaction must be allowed time to generate and manifest momentum to advantage.

Whether humorous or dramatic in concept, her lithographs demanded contemplation before actual initiation. Her motivation had been the city; her subject matter, the people of the streets and subways of New York, from Coney Island to Harlem.

Although considered a strict adherent to the human comedy, Mabel Dwight excelled as well as a dramatist. What was inconceivable in drawing, was accomplished in writing. The ability to switch media to satisfy one's total self is not unlike other artists, but the use of words as that satisfying medium is rare. She explained that "only one angle of a scene can be caught pictorially. With words I can swim further, dive deeper and capture more angles. I am tired of composition, balance of parts, organization; I want to cut loose, and I could never do it in pictures."[2]

If such were accomplishable according to her inner self, perhaps her success as an artist would have never been realized. Her inner life, as it were, reflected surreal tendencies and consequently, had they been expressed, would have surfaced as an art form unlike that of Mabel Dwight. In fact, the master of the human comedy would have disintegrated. The will to life is evident in Dwight's lithographs;

Mabel Dwight. *Queer Fish.* **Lithograph. The Slater Memorial Museum, The Norwich Free Academy, Norwich, Connecticut.**

the will to negate life had dominated her writing. It is the inner life that strengthens and directs the objective portrayal that inevitably treats the visual senses and tantalizes one's emotions. The visual motivates only the recording of an event. The contemplation, which is the result of the inner self mobilizing its forces, is what turns a commonplace aspect of life into a work of art. The inner life is a detachment from life that exists outside oneself. This is not a luxury but an essential of life particularly for the artist. Sometimes the inner life contributes to that life outside oneself,

and thus the inner and outer intermix resulting in a lithograph such as that titled *Queer Fish,* which is described by the artist as follows:

It was dark under the balcony and the people were silhouetted black against the lighted tanks. It was dreamlike; dark shadows moving against a glass screen, and beyond the screen, beings of a different world, darting, blinking, gleaming colorfully, seeing but not knowing, perpetually moving, but perpetually in the same place. Sometimes it was very

funny. People twisted themselves into grotesque shapes as they leaned on the rather low railing; posteriors loomed large and long legs got tangled. One day I saw a huge Grouper fish and a fat man trying to outstare each other; it was a psychological moment. The fish's mouth was open and his telescopic eyes focused intently. The man, startled by the sudden apparition, hid his hat behind him and dropped his jaw also; they hypnotized each other for a moment, then swam away. *Queer Fish.*[3]

Born in Cincinnati in 1876, Mabel Dwight spent her childhood in New Orleans and California, traveled extensively in Europe and the Orient and studied at the Hopkins School of Art in San Francisco, but never took art seriously until 1927. Although her lithographs made her famous as an American artist, her earlier paintings had already established a direction in terms of content or subject matter.

Her painting titled *The Ocean,* which later was transferred into a lithograph, was painted in 1929. She had typically jammed the shoreline in which the sandy beach is all but eliminated by the comical display of unusual anatomies, some partly naked, others fully clothed. The usual crying baby being diapered in public highlights this distasteful event among New York residents. *The Ocean* is a Coney Island experience and compares to the later depictions of the same theme by Americans Paul Cadmus, Reginald Marsh, Raphael Soyer and others. Dwight had recorded a familiar sight, but added a sardonic exposure of the New York inhabitants.[4]

Another early painting dealing

with the circus shows the typical barker convincing people that the show that they are about to witness is the greatest show on earth. The image of the typical fat lady holds a prominent position above the barker. The crowd making its way into the big top reveals a popular event of the Great Depression. With a few exceptions, Dwight has led the mass of humanity away from the viewer.[5]

However, those few exceptions had beckoned the viewer into the action by reversing key figures while creating several in-depth situations within the crowd. Again, the compositional positioning of figures ushered in similar figure placements in such works as Marsh's *Tattoo* and Soyer's *Shopping Girls.*

The portrait of John Ringling, one of few portraits painted by Mabel Dwight, was executed before her interest in lithography. *Portrait of John Ringling* was painted at a point of departure from art. Her painting, aside from her subject matter, was acceptable but lacked the power and mystery of her later works in lithography.

Portrait of John Ringling[6] is a simple, direct visual image of the man. It is a recognizable portrait, a typical illustration accompanying an article relating the business account of the giant in the circus world.

In some resources, Mabel Dwight has been referred to as a painter as well as a lithographer, and yet, paintings of any great importance are yet unknown. Even though *The Ocean* identified with such later greats as Soyer and Marsh, the painting itself lacked the intensity of her lithographs.

Although born in 1876, it was not until 1927 that Mabel Dwight discovered the medium of lithography as

her artistic forte. It was a year later that her first American lithographs were printed. In collaboration with George Miller, Dwight printed 17 lithographs including such notable titles as *Hat Sale, Brothers, The Clinch* and *Aquarium.*

Although hats were a popular item of apparel during the 1920s, the hats occupying the shelves in *Hat Sale* resemble those of a factory production line, and the pathetic-appearing participants who hope to gain a bit of sex appeal through purchase fail to realize that the solution to their vanity lies elsewhere.

In spite of numerous mirror appearances, each buyer hopes for a transformation, a reincarnation, a miracle. Dwight had formed a unit of buyers, a team competing for victory over vanity. It is a team with a common goal but with individual desires. Yet each contestant yearns for a solution that accentuates the positive or eliminates the negative. Each member of the team despite differences in physical structure and attraction succumbs to a limited variety of hats. Among the team members is a male stranger wearing what appears to be a military helmet clawing his way into the midst of the encounter.

Dwight was remarkable in posing questions to which appear no answers. *Hat Sale* is a provocative, highly sensitive work of a political nature — or simply a common depiction of a common event.

The titles of Dwight's lithographs are often clues to the artists' intentions. Remove the title, *Brothers,* from her depiction (see page 147) and it becomes a daily occurrence at the local zoo. However, a direct correlation exists between the title and the local ministry. The Darwinian theory of evolution becomes the topic of Dwight's satirical exposure of monkey business. Communication between the four caged monkeys and local human spectators irritates the local minister whose strong opposition is registered visibly with a facial sneer. Again, Dwight has established dual concepts of space. The link between the monkeys in action and the absorbed audience creates a normal spacial environment which sets the viewer outside the experience. And yet, the viewer is invited into the scene by virtue of the outgoing minister whose pivotal position not only explains Dwight's title but creates a three-dimensional depth between himself and the viewer. There are three phases of this diabolical scheme. The monkeys themselves form the most recessive environment. The spectators form a second or middle environment while the minister forms a third or forefront plane which subsequently creates a fourth spatial dimension outside the picture plane.

In *Mechano, Wonder of the World,* a 1928 version of sideshow freaks, one sees a world of humans whose lives differ drastically from those pictured in the foreground as potential paying spectators. Dwight has related a series of subjective expressions within the whole, with each figure sustaining its own personality. Compositionally, the quintet on stage is a team of disgruntled characters paired against a team of ruthless spectators off-stage.

Mechano is a hypnotic human activated to the whims of the hypnotic spell. In 1928 it was common to accept as freaks those unfortunate creatures born with physical handicaps whose purpose in life is to be objects of ridicule.

Mabel Dwight. *Hat Sale.* **Lithograph, 12⅛″ × 10⅛″ (image), 16⅛″ × 11½″ (sheet), 1928. Collection of the Whitney Museum of American Art. Gift of Gertrude Vanderbilt Whitney. (31.721)**

Mabel Dwight. *Mechano, Wonder of the World.* **Color lithograph, 12⁵/₁₆″ × 9⁵/₁₆″ (image), 16″ × 11³/₈″ (sheet), 1928. Collection of the Whitney Museum of American Art, New York. Gift of Gertrude Vanderbilt Whitney. (31.722)**

Mabel Dwight. *Barnyard.* **Lithograph. Collection of the Library of Congress, Washington, D.C.**

Although it is different in concept from her lithograph *Queer Fish,* in *Aquarium* Dwight has focused on both the interplay of spectators outside the aquarium and the fish within. The viewer is drawn into the scene as one of several spectators, or remains a sole viewer outside the picture plane. The spectators' obsession with the aquarium residents is not unlike the chicken feeder's fondness for the hen house dwellers in *Barnyard.* Both subjects physically sustain characteristics of their recipients. There is a common denominator among Dwight's participants. Her characters in *Aquarium* are family orientated and lower middle class people who enjoy commonplace activities. Not all of Dwight's lithographs reflect satirical or ironic circumstances. Some reveal irritating events which occur daily, as witnessed in her piece entitled *The Clinch.*

The cinema had always been a popular form of entertainment, especially during those years preceding the Great Depression of the thirties. *The Clinch,* a 1928 Dwight work, is such an example. An intriguing scene is flashed upon the silver screen but interrupted by a passerby whose body blocks out the scene that the audience patiently waited for hours to enjoy; this is a common occurrence but seldom a cause for artistic expression. And yet Dwight delighted in the commonplace, and because of its appeal to the masses, *The Clinch* had an established audience. Perhaps more important was the familiarity with the theme and its subjects that created a comfortable and receptive mood among Dwight's audience.

Once again, Dwight's team of players distinguished themselves as

personalities and the interweaving of individual figures aided in a subjective display. The visual dialogue existing between the screen's image and the audience gave way to the disruptive force which blocked the dialogue and initiated communication between the audience and the patron exiting from his seat. This innocent act, nonetheless, was considered by those affected as unforgivable. The creation of several situations caused by a single act was typical of Dwight's expressions as her work consistently reflected her joy and or cynicism of life's situations.

Dwight created a situation between the focus of attention and its audience. Fantasyland became realityland as spectators reacted to the cinema's message in *Stick 'em Up.* This 1928 illusion of depth was created by the facing-off of the screen's image and its audience. The viewer is left as a single witness responding to the reactions depicted in the scene. Again, the composition is direct: the viewer is treated to a simple exchange of emotional reactions to a single circumstance. Dwight has characterized the vulnerability of society. She replaced reality with the cinema image which entertained some, but mesmerized others. Dwight played to her audience. She allowed her spectators an escape route—an exit sign positioned to the left of her expression.

Mabel Dwight was not known for her landscape themes. Seldom were her works without the human element, but in *Deserted Mansion,* she displayed an intricately designed combination of building and trees. The omission of human characters allowed for an atmospheric mood, a concentration on nature without situation or circumstances. Dwight recorded a

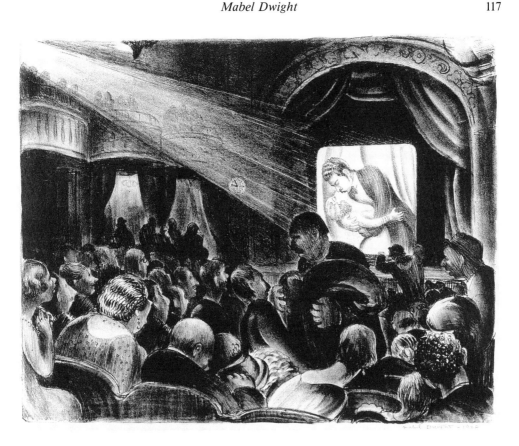

Mabel Dwight. *The Clinch, Movie Theatre.* **Color lithograph, 9⅛″ × 11¾″ (image), 11½″ × 15⅞″ (sheet), 1928. Collection of the Whitney Museum of American Art, New York. Gift of Gertrude Vanderbilt Whitney. (31.720)**

stately mansion nestled amid an over-nourished environment.

In *Old Greenwich Village,* a 1928 depiction of a famous locale, Dwight has returned the family to the environment. She shares with the viewer several "little" events, daily, routine acts which enliven family neighborhoods. *Old Greenwich Village* is a charming picture of outdoor clotheslines, flower boxes, brick sidewalks and cobblestone streets which act as a backdrop for uneventful human gestures.

The lonesomeness of life dwells in her masterful lithograph titled *Winter,* in which three birds reside on a naked tree branch while the lush wintry snowbanks highlight the countryside. Although Dwight had avoided the human exchange of emotions in *Winter,* her depiction of two birds in intimate conversation seem modeled after her several versions of *Gossips.* Even the third bird perched in isolation upon a single branch preferred a distant role. The gnarled tree with its three occupants overlooks a forested valley contrasting sharply with the starkness of the bird-laden tree in the foreground.

Although the human figure is

Mabel Dwight. *Winter.* **Lithograph. Courtesy of the Library of Congress, Washington, D.C.**

omitted from the wintry landscape, the human touch prevails. Dwight's sensitive awareness of human dependency upon the animal kingdom is compassionately expressed in *Farmyard* and satirically recorded in such works as *Queer Fish, Brothers* and *Aquarium.* The juxtaposition of the three birds, although echoing a birdlike formation, was conceived in human terms. That was the nature of a Dwight animal/human combination.

One cannot deny the beauty of God's creation. In *Winter* Dwight exhibited the beauty of nature untouched by human hands. Even she denied temptations to disrupt the landscape or to incorporate man's inability to cope with life's problems.

Mabel Dwight's first American lithograph is titled *In the Subway,* also called, *Abstract Thinking.*[7] Three

derby hats sit at ease upon the heads of indifferent, nervous gentlemen resigned to the routine of the subway ride. Without question a forerunner of later versions of the same theme by such formidable American realists as Reginald Marsh, Raphael Soyer and Louis Ribak, Mabel Dwight's version is well dressed. Each head is tilted slightly, individualizing the abstract nature of the act. Each personality is frustrated within its own shell. Hands grasped in dejection, mouths shaped in despair and eyes gazing in space, the three riders with highly polished shoes are transients of another sort.

It is ironic that the Great Depression ushered in a stream of highly successful lithographs. In fact, much of Mabel Dwight's success hinged upon the social aspects of humanity during the impoverished times of

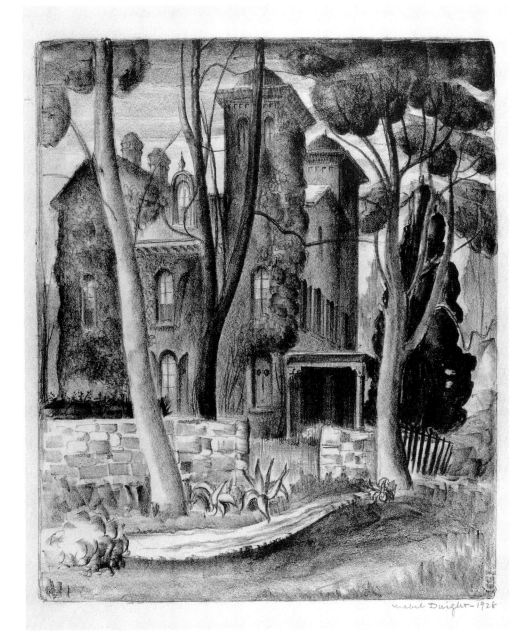

Mabel Dwight. *Deserted Mansion.* **Lithograph, 11¾″ × 9⅛″ (image), 15⅞″ × 11½″ (sheet), 1928. Collection of the Whitney Museum of American Art Purchase. Gift of Gertrude Vanderbilt Whitney. (32.6)**

America's Depression years. The thirties produced such great works as *The Ocean, Hat Sale, Queer Fish, The Survivor, Dusk, Ferry Boat, Rain, The Great Trapeze Act* and *Circus.*

The Great Trapeze Act expressed Mabel Dwight's belief that "the modern circus has lost its innocence, and it robs us of ours. It is an amalgamated, consolidated, five-ringed

monstrosity that floors our imagination in one round. Many people nowadays never see the arena at all; they just get close-ups of the 'ten cents, only one dime' buzzards who carry a basket large enough to blot out all of the Great Trapeze Act."[8]

The audience become pawns on a chessboard, but instead of being moved about, they remained glued to their seats, enduring the extraneous acts which greed had taken over. Individual delights and frustrations occur throughout Dwight's audience. The "circus" transpires among the spectators while the genuine circus remains hidden from the viewer.

Dwight makes a plea for reapproaching the circus dilemma. She had pictured an audience who with paid admissions were to be treated to circus entertainment but instead suffer the disastrous effects of an impatient and at times rebellious crowd. It is indeed comedy for the viewer who is outside the experience, and certainly a common human element of society.

Mabel Dwight's use of telephone poles has established and isolated individual human episodes. In *The Survivor, Staten Island,* executed in 1929 at the beginning of the Great Depression, the viewer is left questioning the definition of the survivor. Two weary laborers, trudging homeward, are visually separated from the major portion of the lithographic expression by the intrusion of a slanted pole. Are they the survivors? To the far right of the expression is a family trio which Dwight has refused to identify. Are they the survivors? Sandwiched between these two individual incidents is a young girl trudging along the sidewalk. Is she the survivor? Or is it the home dwarfed between towering oil tanks and sky-reaching derricks which

is designated as the survivor? Or was Dwight concerned more with the psychological effects of industrial encroachment upon a nation about to bankrupt itself?

The Survivor is a dramatic expression. The swirling, smoky atmosphere adds to the gloom surrounding the foreboding oil tanks and the disparaging figures pictured in the foreground. Impending peril is suggested in the trolley approaching the scene.

The intent shifted drastically with a lithograph of 1931 titled *Life Class,* which is an assemblage of individual character studies. The practicing "artists" in *Life Class* represent the male population except for a single female who may well have been the incomparable Peggy Bacon. The audience, so to speak, of *Life Class* is varied according to age, temperament, talent and intent. Each facial expression denotes individuality with a universal application.

Life Class is a single composition. Participating figures overlap within an arc-like shape and focus upon a single entity—the young female nude. Thus, activated space transpires between the foreground figure (the posed nude) and her audience (students), thereby creating a visionary depth of intensified spacing. Each spatial dimension between student and model creates an individual episode affecting the sensual stability or instability of each student.

Even her *Self-Portrait* of 1932 creates a philosophical link between herself and her audience. One views a musing individual who dares the viewer to acknowledge her provocative works.

Ferry Boat,[9] one of Mabel Dwight's most popular lithographs, is typical of the balance she maintained

between characterization and carica-
ture, drama and comedy. One never
fully understands the message of the
artist. As one assumes the innermost
thoughts of the two buxom ladies
peering at the beauty clothed in nun-
nery cloth, one may question the sa-
credness of the chastity vow and the
seeming impossibility of fulfilling it.

"Boy! If I had her body and
looks," or "Who does she think she's
kidding," are remarks registered on
the faces of the two lay ladies. The
sheer detachment of one whose devo-
tion to God contradicts the message
of love, the nun so consumed with
her own calling becomes unaware of
the life around her.

The positioning of the nun is
significant. Were she to occupy the
center spot, her placement would have
caused immediate attention, whereas
Dwight wished that concern be
granted to the fat ladies as the in-
sulters and instigators of any ensuing
event. Besides, the obvious formality
of balance is eliminated at the outset.
The focus is on the nun, but the
viewer reacts initially to the fat ladies
who in turn, direct the viewer's atten-
tion to the nun.

Her print, *Life Class,* "is an
assemblage of individual studies of
characters, which by the logic of sit-
uation also acquire a comic aspect.
This casting of character absorbs an
extraordinary amount of time and
energy. When successful her charac-
ters are endowed with the breath of
life. She has the rare faculty of
creating types, of portraying figures
with individual traits and universal
application. Each figure is a portrait
and a personality. She gossips neither
in her conversation nor in her art."[10]

Mabel Dwight's home base was
New York City and upon reflection
of the concepts of beauty regarding it,
the artist had the following to say:

> Beauty is relative. When beauty
> travels between two points,
> everyone will report of her pass-
> ing differently. She enters into
> some people and lets them ex-
> press her, but they cannot tell
> you what she is. Perhaps there
> is less separation in the duality
> of beauty and ugliness than in
> most dualities. It is one step
> from the sublime to the ridicu-
> lous; possibly only half a step
> from the beautiful to the ugly.
> Maybe no step at all. They are
> one, but there are many view-
> points. It is a poor artist who
> cannot find beauty anywhere. It
> is his prerogative to reveal the
> beauty hidden in misshapen, ill-
> adjusted objects and people.
> Many adjectives can describe
> beauty: tragic beauty, terrible
> beauty, austere beauty, serene
> beauty, grotesque beauty, mys-
> terious beauty, pure beauty.
> There is the beauty of the Par-
> thenon and there is the beauty of
> African negro sculpture, and
> there is the beauty of a lusciously
> rusty tin can and an old green
> bottle sunning themselves on top
> of a city dump. But because
> beauty can be found on a dump
> is no excuse for cluttering up the
> water front with them. Beauty is
> an equivocal jade. Don't let her
> weave exquisite cobwebs about
> you. Order her around and make
> her build for you. Some artists,
> especially the modern artists, are
> accused of making a fetish of the
> ugly, the distorted. There is some
> pretentiousness, some charlatanry
> of this kind; but very little, I
> think. Trust the artists; they are
> healthy-kind; but very little, I
> think. Trust the artists; they are
> healthy-minded, and know how
> to handle beauty. They can op-
> erate on her like a surgeon, if
> she needs it, and win her like a
> lover, if they try.[11]

Mabel Dwight. *Ferry Boat.* **Lithograph, 9¼″ × 10″, 1930. Philadelphia Museum of Art. Purchased: The Harrison Fund.**

The above quotation did not suggest that Mabel Dwight converted the ugliness of nature into beauty in the form of a lithograph, but nonetheless, the moment the image of ugliness is transferred onto stone in the form of a lithograph, it is no longer ugliness, provided it also is a work of art. Beauty is subjective. Emotion is subjective. The technique employed by the artist should be subjective. Thus, the appearance of the lithograph should be viewed subjectively.

Beauty in a lithograph cannot exist merely as pleasing to the eye any more than a musical score is heard as beauty by the ear. This is only the initial step toward truth in beauty. To see a beautiful print and be pleased by it denotes a pleasure beyond physical enjoyment. It leads to contemplation of the soul. The eye continues to see, but in seeing, the mind operates the spirit, and the spirit with which the lithograph is experienced determines its degree of beauty.

The beauty of *Ferry Boat* is the manner in which the components of

art blend into a single and powerful expression. The beauty lies in the message or intent of the artist. The manner in which the muted conversation transpires is the beauty of the expression, *Ferry Boat*. Subordinate forms of beauty exist in the varied interpretations of the viewers reacting to the scene.

The subject of *Self-Portrait* may be beauty if one were able to consider the inner thoughts of the subject. The outward appearance suggests a sensitivity toward life and nature, and reflects a concern for humanity. Even with herself as the stimulus, Mabel Dwight created a mysterious and provocative portrait.

At the age of 71, eight years before her death in 1955, Mabel Dwight created a delightful work titled *Farm Yard* which highlights the animal kingdom. In it, the geese and chickens outwit the subject (farmwoman), but not the wit itself. Dwight devised a technique of entertaining the viewer while the subject of the lithograph (the farmwoman) treats the animals. This dual form of amusement has occurred in other Dwight lithographs, *Queer Fish* and *Ferry Boat*, for example. The victim is generally unaware of the entertainment occurring outside the picture plane.

Farm Yard is a snug composition with three overlapped farm structures forming a unique, peaceful landscape. The addition of animal inhabitants breathes life into the expression, but the inclusion of the farmwoman really relates to the human condition. To avoid the commonplace of vertical and horizontal planes, Dwight introduced diagonals into the vertical structures with adjacent shadows and reflections echoed in the foreground. Normally acceptable horizontal and

vertical planes are altered slightly to add to the dynamics. Negative space is carefully balanced above and below the significant subject matter with appropriately shaped clouds to correspond with the similarly shaped animal life. The foreground is shaped to relate to the roof structures of the farm buildings.

The beauty to which Mabel Dwight subscribed varied in degree and type according to concept rather than subject matter. Each lithograph was approached as an individual challenge, never as a routine effort or as a series on a particular theme, and it was this personal attachment to life that dictated a personalized approach to individual themes. Dwight has frequently depicted the beauty in humor as well as beauty in nature with such masterful pieces as *Summer Evening, Dusk, Silence* and *Winter*. And the beauty in tragedy is found in such superlative lithographs as *Derelicts, Brothers* and *The Survivor*.

In spite of the apparent simplicity of theme and the visually distant portrayal of *Backyard,* the satire of Dwight's philosophy creeps into this innocent depiction of a Depression locale, even though it fails to record the poverty and chaos generally associated with backyards.[12]

The positioning of the fire escape to the far left leaves the enclosed figure nestled within the window frame at the far right without an exit to freedom. The introduction of the stark, partially naked tree as a blockade, further hampers, at least pictorially, an escape from the doldrums of apartment life. The black cat walking the fence, which incidentally separates the two environments, adds to the dilemma attached to the encased solitary figure.

Mabel Dwight. *Farm Yard.* **Lithograph on wove paper, 9¹⁵/₁₆″ × 10¾″ (image), 12¼″ × 15½″ (sheet), 1947. Collection of the National Gallery of Art, Washington, D.C. Gift of John Nichols Estabrook and Dorothy Coogan Estabrook. (1987.41.27)**

The exquisite technical rendering of *Backyard* is enhanced by the compositional maneuvering of tree foliage (the black of the upper segment and the white of the lower section). As knotholes dominate the rhythmic pattern of the backyard fence, the monotony of an otherwise dull environment is broken. Mabel Dwight has bent reality to suit symbolic and compositional needs.

Dwight had established two visual planes with the dominant tree acting as a separator of the two worlds. And yet, *Backyard* is an example of an ordinary scene being transformed into an artistic pleasure.

Backyard publicizes the human figure by minimizing its presence. The male figure reading his newspaper occupies a remote corner of Dwight's expression, and yet, its seemingly insignificant location and comparatively diminutive size are precisely the causes

Mabel Dwight. *Backyard.* **Lithograph, 1933. Collection of the Library of Congress, Washington, D.C.**

of its dominance. Dwight's lithographic production rarely excluded the human element. On such infrequent occasions, the emotional tone was usually one of peace and tranquility.

Dwight's concern was the city and its inhabitants. She called her urban environment a happy hunting ground. Although she had executed few pure landscapes such as *Dusk, Summer Night* and *Summer Evening,* she retained within these expressions remnants of the human environment.

There is no irony in *Derelicts,* only despair.[13] Each hopeless figure degrades the humanity of the other. Dwight's line-up of human refuse bares their souls openly. Faith has given way to a helpless society, which during the Depression of the thirties was unable to aid those of unfortunate circumstances.

Mabel Dwight was a forerunner in recording the slum conditions of New York City. Her influences were seen in the later works of Reginald Marsh, the Soyer brothers, Paul Cadmus, Philip Evergood, Ben Shahn and others. Interrupting the string of drunks lining the gutter in *Derelicts* are two creatures in friendly embrace.

There is a bond among the unfortunate, a willingness to forgive and assist, but it is often accompanied with a sense of despair due to a loss of religious beliefs. And yet, there exists a peculiar suspicion, a distrust which Dwight allows.

Dwight had individualized her characters, but mutual circumstances create a thematic team. The isolated figure to the right seeks attention from a drunk fellow whose personal misery prevents such an acknowledgment. The dwellings in the background, sleeping in quietude, cast

bleak shadows of emptiness and loneliness, while a lightened horizon suggests a new day, and perhaps a new beginning.

The artist has carefully positioned her role players in the forefront, each figure slouched in some degree of frustration and despair. Faces record similar degrees of shame, pity and agony.

The frustration of life is seldom idealized by Dwight. *Derelicts* supports her serious intent toward events that exist without hope of change. If solutions were available, one might make light of the derelicts' plight. *Derelicts* is a direct statement of honesty and humility. It is this versatility of attitude, this shift from serious intent and biting irony to subtle hilarity that identifies Mabel Dwight.

Silence (see page 143) is one of several lithographs picturing a nun as the focal point in which satirical circumstances prevail.[14] The left-handed nun pursues her research with eyeglasses fastened to hidden devices rather than ears. Dwight refused to give hints, thus leaving the viewer in confusion. The condensed library space contains the usual oddballs whose lives are consumed in the silent world of books.

The overlapping of figures becomes a conglomeration of ogres resigned to the inevitable thrill of an evening of literal fantasy. The figures, tightly grouped, resemble a monologue of daily routine leading to dead ends. One questions the presence of the young man whose identity remains unknown except for a nomadic lifestyle, in contrast to the entrenched positions of the faithful communicants of old age dialogue.

Two situations exist—the trio

Mabel Dwight. *Derelicts.* **Lithograph, 1933. Collection of the Library of Congress, Washington, D.C.**

occupying the forefront and the quintet secured in the background. They co-exist compositionally and thematically, and although each figure is isolated, all blend into a single environment.

Different in both composition and theme is Dwight's *Museum Guard,* which, likened to other Dwight commentaries, leans dangerously close to resembling a cartoon.[15] Again Dwight allows for choices, but the message becomes obviously a single point of departure. The museum guard, imbued with rote procedure and boredom, gives way to fantasy. The elderly couple, of course, view the cherubic architecture as a new and exciting experience, while the guard envisions an activated bedroom scene. Compositionally, Dwight has isolated the trio of characters. Although the images reside at opposite ends of the lithographic dialogue, they respond to a similar display. However, Dwight has pictured the guard's version to which the appreciative couple remain unaware.

The cherubs in a fantastic display of aerobic exercise and gymnastic versatility had left their century old perch to perform a daring display of acrobatic dexterity.

Mabel Dwight. *Museum Guard.* **Lithograph. Collection of the Library of Congress, Washington, D.C.**

The deliberate isolation of the role players leaves open the question of the vacated bed. However, Dwight has avoided the bed as a focal point by challenging her characters to individual responses to the scene. Each is engrossed in reaction to personal needs, and compositionally it was essential to de-activate the central area in order to sustain attention for the important images.

The barnyard theme has undergone several versions, each sustaining the Dwight trademark of satire. *Barnyard* suits the oft-repeated phrase — the more one associates with feathered friends, the more one takes on similar characteristics.[16] The farm woman whose web-like hands, long, skinny legs, beak nose and upswept hair bun characterized the hungry chickens, occupied center stage. Of the 19 chickens pictured, each varies in the nature of its eating habits.

The dog and cat, alien to the field of chickens at mealtime, are rebuked by the gregarious fowl and ignored by the master feeder.

Barnyard's composition is direct and simple. The major figure is centrally located, surrounded by subordinate but essential creatures. The act of feeding the chickens and the effects upon the recipients has resulted in a transformation of the principal figure, that of lessening the human condition to one of the lower animal kingdom. Yet, it is accomplished in the typically satirical manner of Mabel Dwight.

Titled *Dusk,* another masterpiece of the Depression era pictures a gathering of friends or neighbors as a typical scene of the Depression of the thirties.[17] It was also a popular event, free of expense and media propaganda. It was a social gathering, a communicative link between segments of society, but most importantly, it was a contemplative experience — the corner lightpost where thousands met in intimate groups in hamlets, towns and cities throughout America. The role players in *Dusk* recede in importance in order to include the pastoral surroundings. Dwight has deliberately diminished her characters and transformed an objective landscape into a subjective expression. The trio of vertical poles sets up an enclosure which had become a symbol of limitation. It was never a visible thing, but a psychological barrier to total freedom.

Regardless of outward appearances, Dwight's artistic images represent deeply personal emotions. However, compositional needs hampered instinctive responses to natural events. For Dwight there was always a compromise, an emotional rampage tempered with intellectual consideration. Irony and satire were the results of restraint and soft punches. Her personal nature was transmitted into characters who became pawns manipulated by a master choreographer. Except for such works as *Derelicts, The Survivor* and *In the Crowd,* in which technical knockouts occurred, Dwight succeeded with a series of decisional wins.

Group in Central Park and *Old Aquarium* are two such "wins." The former, executed in 1934, pictures a trio of obese women accompanied by a young child destined to a similar fate. A study of Dwight's lithographs would indicate a search for satire or irony even when none exist. Hidden circumstances could well be the reason for misunderstanding. *Group in Central Park* may represent only what the title indicates, and yet, a

Mabel Dwight. *Dusk*. **Lithograph. Collection of the Library of Congress, Washington, D.C.**

Mabel Dwight. *Old Aquarium.* **Lithograph, 252 × 356 mm., 1936. Courtesy of the Brooklyn Museum, Brooklyn, New York.**

Dwight lithograph without a purpose other than the recording of an event seems unlikely. Obesity becomes an obvious visual reality, but perhaps it is the generational theme that promotes the scene. In spite of an intimate portrayal of human dialogue and a close knit composition of humans, two separate communicative activities exist even though they are indirectly linked together.

Old Aquarium, a 1936 edition of the theme, is a meeting place similar to that of Central Park. Dwight has expanded the environment thus incorporating several objective situations to accompany the subjective experiences of the foreground. Indirectly the days of the Great Depression are identified by the free entertainment housed in the old aquarium and the seemingly unemployed figures occupying the scene. The composition is a direct, honest statement. Mothers and their children monopolize the park bench as an appreciative father marvels at his son's progress. The transients slouched on park benches and reading the daily news habituate the background. Further signs of the Depression are witnessed in women's curled-up hairdos — knots of hair shaped like buns.

Dwight shuffled back and forth in positioning the viewer. In *American Art Gallery Auction,* the viewer remains outside the experience of the auction, Dwight preferring a viewer

verdict of the clients themselves. Rich, old fossils are pictured in formal dress plumped into an ornate gallery or balcony and insidiously attempting to outfox and eventually outbid each other. A guard observes the bidding as well as the bidders. Each character epitomizes the greed which had absorbed each one's life. The exercise of comparing notes and tabulating results seems more a game of chance than an aesthetic interest in the works themselves. There is no question that *American Art Gallery Auction* is an event of the rich.

Compositionally, Dwight offset a powerful diagonal (balcony rail) with the inclusion of hands and ruffled papers, thus slowing down drastically the visual movement. The carved designs of the ornate balcony are updated in the symbolic bowties and flowered lapels.

In the case of *Guignolette,* another 1928 work, the viewer becomes a dual spectator to both the audience witnessing the event and the event itself. As a spectator outside the picture plane, the viewer is treated to a Sunday dressed audience of children engrossed in the antics of a Punch and Judy show. Less emotional than other works, *Guignolette* objectively portrays several characters of individual personalities which form a unit surrounded by an ornately decorated background. The children, except one who preferred the attention of the viewer, focus intently on the puppets and the musical accompaniment of the accordianist. What appears as an afterthought is the elderly lady cuddling a young child whose attention matches that of the other children. *Guignolette* is a recording of a delightful event rather than a display of a satirical image such as that seen

in Dwight's *Proof of Greeting Card for 1928 with Caricatures of E. Weyhe and Carl Zigrosser.*

Dwight has invited the viewer into the House of Weyhe with an introduction to the owner and Carl Zigrosser, art critic and friend of the artist. The usual nude artifacts and books line the walls as inquiring minds peruse the latest in reading materials. Stylishly clad patrons snoop their way about the elite establishment. Clients become mainstays and eventually differ little from the statuettes that occupy conspicuous spots throughout the area. Three obscure wreaths identify the holiday season. Dwight had set an environment and introduced characters into meaningful communication and purpose.

Portrait of Carl Zigrosser, one of few portraits by Mabel Dwight, is a serious and sincere image of her critic and friend. His whimsical bowtie tends to offset the rigid jaw and mouth and the expressive eyes, and although his white, plentiful hair suggests frivolity, a serious attitude is sustained with the peaceful and simple background. Carl Zigrosser, a writer and critic of art concerned with the inner drives and undefined images of the artist, has reflected the somber side of the creative drive. His eyes indicate a search for the mystery of Dwight's efforts, which are often disguised under subtle innuendos, but nonetheless, he was serious in his efforts to uncover her intentions. Her portrait of Zigrosser is not unlike her self-portrait in that meaningful images suggest a seriousness in the creation of art, and in the criticism of it. Even though the two (creator and evaluator) stand at opposite ends, they merge in their respective roles in a oneness.

Mabel Dwight. *American Art Gallery Auction.* **Lithograph, 187 × 217 mm., 1932. The Cleveland Museum of Art. Gift of the Print Club of Cleveland. (32.325)**

Dwight's most productive decade continued during the thirties of the Depression. An exquisite example, the 1936 version of a medical clinic titled *Children's Clinic,* differs little from the crowded and seemingly unattended clinical patients of the 1980s. Several mother and child compositions overlap in confusion as doctor and nurses attempt to ease the crowded conditions. Mothers in attempts to restrain the agonies of their crying offspring patiently await the doctor's cursory look-see to ascertain the serious nature of each patient in what ap-

pears to be an emergency situation. The viewer becomes a witness to the event. Dwight further dramatized the scene by pushing the characters to the forefront thus diminishing the spatial relationship between the viewer and the picture plane.

Summer Evening (see page 138) identifies with the events of the Great Depression. Dwight as a recorder of truth translates a single street light into a subtle but complex composition of horizontal and vertical planes. Because of its objectivity, the viewer assumes judgeship over the proceed-

ings. *Summer Evening* depicts the mood of the thirties, that in spite of hard times, life continues to celebrate. Dwight has created decades of remembrances into groups oblivious to each other, thus bridging generation gaps. There is an idyllic appearance, a peaceful almost unrealistic portrayal of humanity enjoying the divine gifts to which all are entitled. *Summer Evening* is a picture of truth during the thirties. It would not be so today.

Mabel Dwight, mentioned several times as the forerunner to Reginald Marsh, Raphael Soyer, Paul Cadmus and others in the choice of subject matter, exhibits her biting wit in such fleshy scenes as *Houston Street Burlesque* and *The Ocean, Coney Island.* In *Houston Street Burlesque,* Dwight treated the audience to ugly obese strippers unlike the choice of Marsh, Cadmus and others who relished in recording the attractive female image. Dwight ballyhooed the establishment by victimizing its participants. Even though Dwight focused on the stripper, she engaged in the reaction of the audience so that the viewer became a spectator to the show itself as well as a spectator of the audience.

The Ocean, Coney Island foretells Paul Cadmus' famous painting of the same theme. Executed in 1928, Dwight's version again exhibits the gross physical characteristics of humanity. The pleasure of a day at the beach becomes a nightmare as grotesque segments of the human race jam the proverbial "can of sardines." Comedy becomes satire almost to the point of despair were one to dwell upon *The Ocean, Coney Island.* Only Cadmus' version provokes a more disdainful reaction.

In the Crypt at Chartres, also printed in 1928, portrays the mystery of Dwight's inner thoughts. Shadows of immense magnitude are cast onto the cathedral siding, creating an awesome sense of fear and sanctity on the part of the mourners. The silhouetted figures enhance the focal point and establish a compositional formula. The viewer is led into the picture plane via light and shadow. It is the negative aspect, the lack of light, which sustains the composition. The shadows and silhouettes formed by light radiating from the crypt dominate the theme.

In her lithograph titled *Gossips,* Dwight has utilized a familiar setting, the urban park, to project her notion of "busy-bodying." Even though *Gossips* has a French origin, it sustains a Central Park nostalgia. The viewer witnesses the proceedings, but remains outside the picture plane. Although it is daily in its occurrence, Dwight has attached a great significance to this simple event of relating tales of woe and discontentment.

In several of Dwight's works a sense of imprisonment exists that suggests that humanity has encased itself, literally segregating itself from the mainstream of life. In *Gossips,* role players are enveloped by stalwart trees and barricaded by iron fences, subtle perhaps, but nonetheless a compositional device which serves an emotional as well as intellectual need.

The viewer is only a witness to the event and yet, for the compatible, allowances are made for participation too. The park becomes a meeting place for the elderly and gossip becomes a way of survival. Dwight's gossips are sinless. Their victims remain beyond actuality. The result is wasted years of wisdom, the accumulation of knowledge resting in the confines of senility.

The six exposed figures, although enmeshed in dual combat, form a trio of duets each objectively portrayed. Yet, a glimpse of intimacy is reflected even though one is tempted to explore other possible titles like Refugees, Political Discussion, Outcasts, The Elderly. One is never sure of Dwight's intent. The seemingly obvious satire is at times sidelined in favor of apathy, and a serious expression is seldom without the desire to search for satire. Because of this combination of opposites, one may enjoy both extremes simultaneously, if such a rarity is possible.

From the most normal circumstances, Mabel Dwight has created satirical expressions from various modes of life, which has led numerous artists of later decades into subsequent expressions of similar themes. The great names of Paul Cadmus, the Soyer brothers, Reginald Marsh, Don Freeman, Gorsline and others have echoed her influence.

Dwight invites the viewer to share in the anticipation. In *Houston Street Burlesque,* a second dancer appears at the runway whetting the sexual appetites of the spectators. The rotund audience is treated to a rotund performer. Unlike her followers — Marsh, Cadmus, Soyer — Dwight exploited the empathy underlying the sensual appetites of her victims. Comedy surrenders to pity. Although it has never been discussed, Dwight's lithographs lack a spiritual message. Even though she did more than record a common event or incident, her works assume the status of mystery, a level of attainment beyond visual recording.

There is a thing about obesity, a ready-made jocularity which Dwight has used effectively. In *Ferry Boat,* it becomes a major factor in its inter-pretation. It added an element otherwise forfeited in the case of slender participants. Likewise, in *Gossips* and *Group in Central Park,* the obese factor draws immediate responses. It is this emotional factor of the physical structure of nature that Dwight forced upon the viewer. Were her images expressed as gaunt and emaciated, there would appear no comedy or satire in her works. Instead her expressions would reflect the factual recording of a Marsh or Cadmus etching.

There is a coordinate reaction of sympathy and pleasantry amid her works. One may question the circumstances of her most productive period, namely the pre–Depression to post–Depression years, as to whether prevailing economic conditions influenced her approach to recording the events of the day. American apathy was prevalent. Yet the economic outlook, although bleak, was ideal for the American recording artist. While others recorded the troubles of the thirties, Dwight skirted the problem areas in favor of light-hearted attacks on the human condition.

Free and cheap entertainment became the norm for American society. Dwight never belittled the drought-stricken farmer or the unemployed worker. Instead, there lingered a bit of sarcasm underlying the apparent nonchalance.

The background treatment of a lithograph or painting frequently determines the locale and circumstance of the role players. In some cases, the background dictates the mood as in *Dusk* and *Sunday Evening.* In others such as *Gossips* and *Ferry Boat,* the background seems incidental, or perhaps it becomes a device to simply "finish off" the picture. In her litho *Gossips,* even

though the background appears to be brushed in quickly, it involved diligent deliberation. Dwight was a compositional perfectionist. Such decisions were made well in advance of the final application of medium even though the application itself appeared casual and incidental.

The shift of eye contacts or bodily features affected both the visual and emotional reactions of the viewer. In the case of her Coney Island portrayals, experimentation with facial and figurative adjustments became tedious as the positioning and maneuvering affected the whole. A single facial gesture determined the viewer's participation, for Dwight was never certain as to the degree of involvement her viewers should be exposed to. The viewer became either an outright spectator and witness to the event or a victim of her satirical plots. In either case, one was always invited.

Mabel Dwight had belittled the art process because of its emotional limitations; that concern for composition became a major barrier to complete freedom of expression. Perhaps her acknowledgment of such limitations had thwarted attempts to deepen her expression as well as her ideas. Yet, others had found it more difficult to control in words several episodes or events simultaneously while maintaining a unity. If Dwight had succumbed to her "written word," she might have entered the twilight zone. Several of her expressions, namely *Backyard, Aquarium* and *Art Exhibit,* rim the edge of surreality, while others such as *The Survivor, Staten Island, Summer Evening* and *Mechano, Wonder of the World* promote a realism that ranks with such greats as the late Clare Romano, William Pachner and Abraham Rattner.

Accused by several critics of doing morbid cemetery scenes, Dwight felt compelled to ignore personal statements in favor of satirical commentary. Her need for complete artistic satisfaction was fulfilled, not with her lithographical prowess but with unpublished thoughts which were never meant for public consumption.

Dwight relied upon people. Her concern for the human condition was evident throughout her life and her work. Even her infrequent portrayals of figureless landscapes reflected the use of nature. For Dwight believed that humanity relied upon nature, but was cautious to make dominant the human element within society. In other words, she selected an environment and then united her victims to the chosen surroundings. Her subjects, always attached to appropriate habitats—the farmwoman in the chicken coop, the transients on the el, neighbors on a street corner—adhered to circumstances which appeared not only logical but true to life.

The portrayal of tragedy in Dwight's lithographs was not always physical, but instead pertained to circumstances or situations in which humanity prevailed. The greed of buyers in *Hat Sale,* the lust of the audience in *Houston Street Burlesque,* and the envy witnessed in *Ferry Boat* reflect tragedies of the soul. These sins of greed, lust and envy are the closest indication to a spiritual reflection that Dwight engaged in. Yet, her works reflected a hope for redemption and ascension. Her choice of satire indicates a look at life beyond its own nature, a feeling that one need not accept life as it is dealt, but overlook or to overrule the rudiments of nature in favor of a distant solution.

Mabel Dwight. *Group in Central Park.* **Lithograph, 10½″ × 9¾″, 1934. Courtesy of The Brooklyn Museum, Brooklyn, New York.**

The tool of satire acted as an extension of life; were satire to disappear, life as it would normally exist would now appear. And further introductions of satirical statements would prolong life, place life in a state of infinity, so to speak, until reality reappeared. Such works as *The Survivor, Abstract Thinking* and *Derelicts* indicate the truth of Dwight's statements. Her persistent remarks

about the technical demands of her task preventing her from a free expression are cause enough to wonder about possible future greatness.

Were her innermost thoughts transferred onto the lithographic stone, the results would verge upon surrealism resulting in a less receptive audience. For what one does not understand one will reject. Thus, her personal reactions to life although

Mabel Dwight. *Summer Evening.* **Lithograph, 1934. Collection of the Library of Congress, Washington, D.C.**

disparaging and lamentable, may well have been tempered with time and consideration resulting in her comical, satirical and ironic interpretations of life.

Dwight enlisted no hope. She presented no cure. She either recorded life in tragic situations caused by unforeseen circumstances or she diverted the unfortunate aspects of life into situations that superseded life itself. She preferred not to dwell upon the tragic, but instead to bypass the tragedy and elevate it to another state of existence. Tragedy became a state of limbo, not a realization but a postponement. Dwight's display of poverty, pathos and despair were recordings of life surfacing from the artist's visual and emotional constitution, yet lacking in spiritual hope and aspirations.

The injection of humor, although intended to alleviate the agony, instead initiated a graver situation—the acknowledgment of the hopelessness of life, an endless parade of inconsequential events which plagued the participants and led to a waste of the human condition.

And in particular works such as *Dusk, Sunday Evening* and *Winter,* one senses the notion of eternity. A peculiar tranquility absorbs the atmosphere and elevates the viewer's thoughts to a spiritual level. Her use of shadows in *In the Crypt at Chartres* and *Dusk* creates a mysterious sense of belonging, and yet not belonging, again encouraging a sense of urgency—a need to understand the purpose of life. Dwight's inner drive to understand, not only one's own existence but the existence of others, has led to a vacillation between actualities and circumstances. In some works consequences were not identified. In

others such as *Derelicts* and *Survivors,* physical damages were already evident. Perhaps in such situations the inevitable occurred, and one only has compassion to offer. With lesser events Dwight unleashed a barrage of satirical comments perhaps to offset the inability to resolve existing dilemmas.

Yet, this willingness to accept the inevitable with candor and assist further in its application to the viewer indicates a resiliency to life's problems. And always, Dwight has allowed freedom of interpretation. One is not always sure of the victim of her satire. For example, in *Children's Clinic,* one may question the identity of the anguished. Who are the victims of pain—the children, the mothers, the doctors, the nurses? Identity with the role via experience determines victimization. Thus, the viewer as doctor identifies with the victim; likewise with the professional role of nurse and career mothers.

The spread of divergent interpretations is a routine matter for the artist and frequently becomes a stabilizing force in the success or failure of the expression. It is similar to a playwright who creates dissimilar roles for his cast while devising techniques to corral them into a satisfying, unified performance, or the novelist whose characters defy time periods with flashbacks and scene changes, but who inevitably resign themselves to preconceived destinies. Mabel Dwight possessed that ability of arranging several role players onto a single working surface each of which possesses a personal reaction to life and its environment while contributing to the unity of the whole. There existed always a oneness, a single theme transcended by the inclusion of several

different versions. Her subjective reactions to life were mellowed considerably with time. Since the objectivity that resulted was enhanced by the deliberate satirical commentary that became her trademark, one looked beyond the image recorded.

Her unusual emphasis upon the arrangement of her characters suggests the use of an expressionistic technique, a freer form of expression which would accommodate her emotional drive. The technical demands of the lithographic process negate the intuitive response to an idea or situation. Chancing a surreal image, Dwight preferred to acknowledge and record life's tragic events and relied upon a painstaking method of expanding and deepening those images to coincide with the artist's emotional senses. The degree of objectivity essential to Dwight's sardonic images creates a kind of insight into the mystery of the human condition which could not have been garnered by the intuitive method. Instinctive responses occur in the pre-planning stage, and the refinement or objectification of Dwight's images occurred during the process of re-creation. Had the artist halted her expression at the intuitive stage, multiple interpretations would occur and confusion result. In addition, fulfillment of the original idea would not have materialized.

Throughout her career Dwight favored details, seemingly insignificant gestures which would have gone unnoticed if presented in an emotional style. In *Summer Evening* such simple gestures as the tilt of a head, the clasp of hands and the welcoming glance provoke the idea of young love. In *Ferry Boat,* the devastating smirk aimed at the precocious nun would be lost in the emotional clamor of expressionism. In *Backyard,* the lonely figure posed in the upper window frame in the background hints at a beckoning call for service. The fact that Dwight could sublimate emotional stress in favor of the objectification of emotional situations became the utilization of an objective approach to a subjective notion.

Mabel Dwight had looked at life from afar with a view of eternity. Although life is personal, it is also remote, and it is the balance of life and death that Dwight approached. As a master of the human comedy, Dwight played on human emotions while adhering to the tenet of eternal life. She believed that tragedy had its own reward, that its consequences were short lived and that humanity possessed a capacity for laughter that was underplayed. Her works tend to foster a temporary relief from a seemingly permanent handicap. It is this clinging to survival that captures the minds and hearts of the viewer. Personal problems seem to vanish or at least diminish under the scrutiny of Mabel Dwight.

In order for art to be created, detachment from life, as much as this is possible, becomes essential. Artistic creation in the midst of emotional turmoil is impossible. Dwight's lithographs reveal a calm after the storm. The artist produces during quiet reflective seclusion, in isolation. The artist experiences life to its fullest in order to liberate herself so that life's experiences take on meaning; to contemplate one's beliefs; to assimilate significant aspects of life's meanings; and to produce an expression worthy of one's convictions. It is during this period of seclusion that Dwight determined the destiny of her

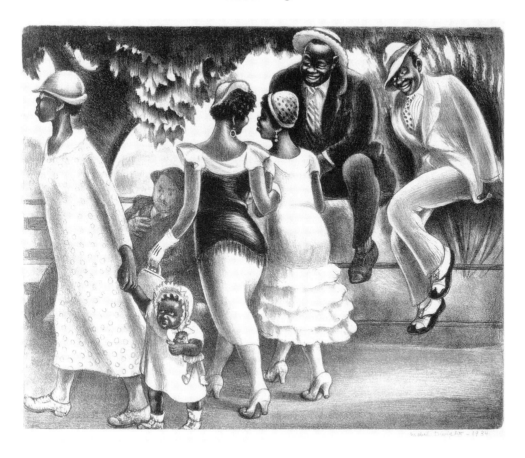

Mabel Dwight. *Sunday Afternoon.* **Lithograph, 1934. The Library of Congress, Washington, D.C.**

lithographic message, whether to display a recording of a tragedy or to accompany the event with irony or satire.

Dwight proclaimed that the beauty of life and of nature was everpresent and that the ugliest of creatures sustained an element of beauty. It was the task of the artist to uncover and discover beauty and express it in its purest form. Dwight would have agreed that ugliness existed in the mind of the interpreter, not in the art form itself. The purpose of ugliness has served the purpose of beauty. Dwight's *Houston Street Burlesque*

portrays the evils of the flesh. The arousement of sensual appetites via the burlesque house might be considered by some to be ugly in its purpose, but because of its exposure, beauty could emerge as a result of spectator atonement and reconciliation.

Dwight claimed little difference between ugliness and beauty. She may well have agreed with the thesis that a work of art became beauty according to the artist's intent. For example, if the purpose was to express and transmit ugliness in order to reveal its essence in contrast to good so that

good acts would result by means of contrition or penance, then not only is the lithograph an example of beauty, but one must concede that Dwight's idea is also beauty.

In the case of Mabel Dwight, beauty in a lithograph cannot exist merely as something pleasing to the eye any more than a musical score is heard as beauty by the ear. This is only the initial step toward truth in beauty. To see a beautiful lithograph and be pleased by it denotes a pleasure beyond physical enjoyment. It leads to contemplation of the soul. The eye continues to see, but in seeing, the mind operates the spirit. And the spirit with which the lithograph is experienced determines its degree of beauty.

The beauty of an idea rests in its potential value to the universal betterment of mankind, not in the physical sense but in a spiritual reorganization of one's soul. Dwight as such did not create ugliness. Instead she expressed its presence to those ignorant of it and made of it beauty to those aware of it.

Beauty does not exist in the material itself; the stone upon which the lithograph takes form is of little significance. It is the artistic image inherent in the stone itself brought about by the artist's intuitive order that produced beauty, and it is this order that incorporated the idea, technique and spirit that lie before the eye and soul of man.

The cliché that beauty is "skin deep" denies beauty to other than that which is physical. Beauty resides in the intellectual, the emotional, the spiritual. Dwight has ballyhooed the physical segments of the human condition with her obsession with the obesity of women, but did not negate her respect for womanhood. She preferred a more provocative inquiry. She respected the inner promptings of the heart and soul and felt that the artist's task was to uncover the hidden beauty of the visually grotesque and to express it in such a way as to cause spiritual response.

Beauty also has its place and is identified not only within a given object but within a given environment and under certain conditions. Thus, beauty may benefit both winner and loser, depending on circumstances. Therefore, it appears that the artist has vast leeway in her search for beauty.

In the case of Dwight's *Derelicts,* one responds compassionately to the victims, and questions the presence of beauty. Beauty becomes the convincing manner in which Dwight had exposed the fallibility of man — the degree of despair reflected in the bodily gestures of the victims. Beyond the physical presence of rejection is the call to a spiritual level in which beauty is no longer real, but surreal. Dwight saw no difference between beauty and ugliness, only different viewpoints.

Beauty is relative according to Dwight — a sparkling jewel amidst cobblestones would lose its degree of beauty when placed amid other sparkling gems, and that degree of beauty would also vary when judged by several individuals.

Dwight was a fastidious draftswoman. She was proud of her keen observation and diligent rendering of nature's peculiarities. Casting of characters and setting the stage for each individual became a painstaking task. The shift of a body, the tilt of a hat or the nod of a head would alter drastically the personality of the character or the circumstances of the event.

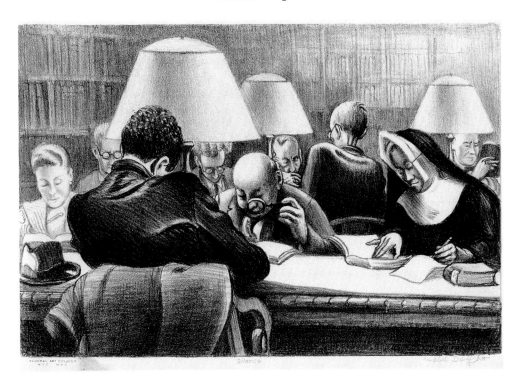

Mabel Dwight. *Silence.* **Lithograph. Collection of the Library of Congress, Washington, D.C.**

Although individually conceived, the role players were universally recognized, a rare combination indeed.

In lithography as in painting, an established style frequently generates a prolific output. Yet, her lifetime production was a scant 100 lithographs. Dwight was one of those rare individuals whose production represents singly aesthetic processes. Each was a newly discovered phenomenon oblivious of past experiences or future thoughts.

Mabel Dwight claimed that she could never completely express her feelings. The need to compose, arrange images and to hone her technique hampered the profound nature of her experiences. Were she able to subjectively express her emotions in the form of gesture drawing, she may

have satisfied her inner frustrations. Had Dwight had such an opportunity, her works would have differed considerably. Humor would have been disguised through the suggestive nature of the drawing. She would no longer have been identified as the master of human comedy, but more as an emotional expressionist.

If Dwight's response to instinct had been different, she would have eliminated the contemplative spirit so evident in her lithographs, in favor of an action-oriented response. The viewer would have reacted to the appearance of the recorded gestures and responded accordingly. The meditative process, if applied, would have become an aftermath, a response after the fact. Even then, it would be a viewer's interpretation of the act of

doing instead of a reaction to the effects stemming from an event.

Dwight's claims that words allowed for a greater extension of her experiences and a more profound result tend to contradict her lithographic messages. She suggested that words were more powerful than visual images and that compositional techniques were less essential to profound statements.

The expression of a single angle is envisioned and executed in visual form. Dwight was hampered by a single view of life as an artist, whereas a single word would have fragmented itself into several meanings according to Dwight. Word passages accelerate into powerful images and eventual tragedies, whereas the drawing of an event is set in place. It remains in place forever while a phrase may alter an event considerably within a single paragraph.

Words are immediate. Dwight's lithographic process was not. This fact frustrated Dwight. And yet, words written in profound irrationality and paradox became the essential contrast to her rational effects of tragedies. Thus, although her writings revealed her innermost nature, they remained as an emotional balance between the real and the surreal. There are graphic artists who successfully incorporate several angles into a lithographic expression but who are completely frustrated with a manuscript attempt.

Dwight's works are dominated by a single theme, accompanied by subordinate characters. It is true that cause and effect are frequently absent when recording an event. The event itself is the focus in Dwight's work. It is impossible within a single work to include the cause and effect of an event unless expressed in an abstract style in which formal recessive and advancing phenomena are excluded. In other words, the visual expression eliminates the baseline theory and natural planes of land and sky. In Dwight's case, the stone itself becomes a single frontal plane upon which several angles can be recorded as well as the cause and effect of an event.

It is the written word, as claimed by Dwight, that can reveal both cause and effect. In such lithographic works as *Hat Sale* and *Barnyard,* the event alone was recorded, and in works titled *Survivors, Derelicts* and *Farm Yard,* the effects of the event were recorded. On rare occasions both the event and the effect are expressed.

Just as each Dwight lithograph is an image individually experienced and executed in artistic form, so too are her subjects of portraiture singularly selected and profoundly portrayed. Dwight's lithographic portraits suffer the loss of human intercourse and communication between two or more subjects, but advance instead a mysterious calm which seems to place the subject in jeopardy. Although representing a photographic pose in the *Boy Resting,* Dwight has deliberately slanted the bodily segments in diametrical opposition to ward off any rigidity of form. In fact, the unusual position of the arms and legs subordinates the passionate calm registered within the facial features of the subject. The minimal space surrounding the character adds to the subjective experience released by the

Opposite: **Mabel Dwight.** *Boy Resting.* **Lithograph. Collection of the Library of Congress, Washington, D.C.**

artist as well as the personal visual interview between viewer and subject.

The cause of an event locates outside the expressed image. Were it expressed within the working surface, it would become the event itself and consequently would demand a second cause. Thus, it seems most logical to record the event itself (action). The effect becomes the result of the action which could be considered an event following the original event. In the case of *Derelicts,* the effect of their nomadic life is physical deterioration and psychological frustration. Despair becomes a state of being and consequently the current event.

In the case of *Brothers,* the event of the monkeys' responding to human inquiry or curiosity causes the minister's appalling reaction to become the effect *and* the event and thus creates a second event, which in turn, causes a reaction from the viewer. Aside from the interchange of animal and human endeavors, one may consider the entire composition one event.

The title *Brothers* implies that the minister of God had accepted the evolutionary theory that he must be his "brother's" keeper. Thus, the effect of this theory registered by his facial expression invites the audience (viewers) to respond not to the monkey antics but to his personal displeasure. Whether it be a laughable matter or a case of misrepresentation depends upon the receptive mood and the spiritual belief of the viewer. Aside from the enraged minister, the other occupants seemingly enjoyed the "monkey-shines" unaware that the evolutionary theory had been employed. If titled otherwise, the viewer would question the minister's reaction and enjoy the scene as Dwight's characters have done.

Other deceptive titles are *Ferry Boat* and *Queer Fish.* The title *Ferry Boat* has no relationship to its three figures. It misleads the viewer by declaring the presence of a ferry boat. Instead, the viewer is treated to a satirical human triangle. Likewise, the title *Queer Fish* deceives the viewer since it neglects to include the oddities of the human character. The viewer is treated to a similarity of animal and human. Not all of Dwight's titles are misleading. Some are commonplace and direct in identifying the event. Thus, titles hamper, diminish, destroy or enhance the opportunity of appreciation. This too was a devious technique of the Dwight trademark.

Dwight had envisioned separate aspects of nature each individually conceived and expressed as an integral part of the whole. Her role players became team players. The environmental influence was insignificant since her characters dominated the working surface except in such cases as *Dusk, Sunday Evening* and others in which the role players and surroundings share equally not for purposes of equality but rather to deliberately serve the idea. In *Dusk,* for example, a trio of humans is placed into a pastoral setting in order to set the mood. In this case, the habitat becomes significant because it identifies the personalities of the characters from a distant viewpoint.

The environment determines the style, the leisure gestures of its occupants. In this sense, the foreground tenants and the background become a single entity. To release one from the other would alter considerably the mood of the expression as well as the intent of the artist. In other works such as *Hat Sale, Ferry Boat, Gossips* and *Coney Island,* the human

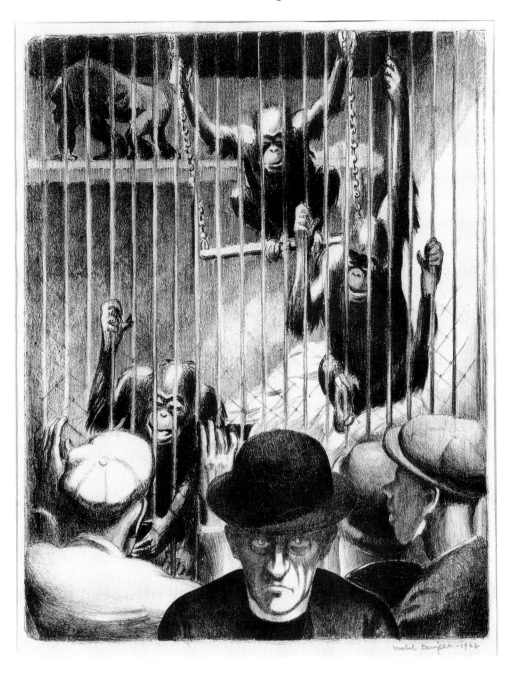

Mabel Dwight. *Brothers.* **Lithograph, 12½″ × 9¹³/₁₆″ (image), 16″ × 11⁷/₁₆″ (sheet), 1928. Collection of the Whitney Museum of American Art. Gift of Gertrude Vanderbilt Whitney. (31.719)**

characters dominate the scene and the background becomes incidental to the artist's intent. Facial expressions significantly portray the message — the acts of envy, greed, lust, jealousy and sinful exaggerations. In such close-up views of humanity, Dwight disregarded the environment as a clue to understanding. However, in *Survivors, Dusk, Sunday Evening* and others, bodily gestures clue in the observer. The characters are not merely placed into an environment, but grow out of it in a way that is similar to trees in the meadow or weeds surrounding a gravesite. The characters of *Survivors* are natural citizens of their environment. To exit would be to become strangers to an unknown land. In *Dusk,* life is tranquil and basic to human needs.

Dwight's singularity of purpose differs with each recording of life. Although the intensity of struggle is refined and in some cases lessened almost to carefree abandonment, the effects of the initial intensity prevail. The action of the scene gives way to the effect of that action upon the role players and it is the effect that continues to haunt the viewers.

Mabel Dwight seldom recorded life at a distance. In such instances, the prevailing landscape melted the human aspects of nature into itself. Such works as *The Survivor, Old Greenwich Village, Dusk* and *Summer Evening* survived subjectively because of this duality of service. Dwight was not unlike Ben Shahn, a later advocate of subjective portrayal who blended the remote with the detailed into splendid recordings of man as linked to nature outside of man.

Instead of engaging in separate environments for individual ideas, Dwight had contained three notions within a single environment. In the case of *Brothers,* social intercourse transpired in three separate ways: the participants (monkeys) among themselves, the audience to the performance, and the minister to his audience outside the picture plane. With her lithograph titled *Stick 'em Up,* Dwight played to both the theatre audience and the viewer audience, each of which displayed a different response. Neither episode demanded individual segments of the working surface, but was resolved with the application of spatial techniques. Similar phenomena exist in her works titled *Queer Fish, The Clinch, Old Aquarium* and others.

In some works, life was recorded for the viewer alone. *Silence, Hat Sale, Children's Clinic* and *Art Auction* are examples in which communication exists between the viewer and the work of art itself. All utilize the team approach in which individual personalities form a single unit or aspect of nature. The environment becomes the locale of the activity, but remains subordinate to the task at hand. In *Art Auction,* Dwight has assisted the viewer in identifying the event. Although conceived as individual aspects of nature, the figures assist in the formation of a total experience dealing more with compositional needs than with the idea itself. The occupants pay tribute to an event which has occurred outside the picture plane forcing the viewer to witness not the event but the witnesses to the event.

However, in *Children's Clinic, Hat Sale* and *Silence,* the viewer becomes an immediate observer of the event. Again, each figure becomes an integral part of the whole.

Because Dwight's works are intimate views of humanity, baseline

theories which generally accompany environmental pieces lack authority in her case. Also, the objectivity of her portrayals diminishes as the figures were enlarged on the working surface. For Dwight, the human form was essential to her work and her profound concern was revealed in her personal traits registered in facial and bodily gestures. A human form placed distantly into the picture plane is anchored to its environment so that reliance upon detailed subjectivity gives way to a oneness of the environment and its inhabitants.

However, in *Old Greenwich Village,* Dwight had ignored the oneness present in several distant figure portrayals *(Dusk, Sunday Evening).* Figures were objectively positioned to overlap the several horizontal planes. Even though several baselines were evident, they remained unused as anchoring devices of the human form.

Mabel Dwight produced a limited number of lithographs during her lifetime, and each involved several versions and detailed renderings before becoming final. Each lithograph became a singularly conceived and executed experience. For example, her lithograph *Old Aquarium* displays 11 events, each carefully arranged to avoid compositional breakdowns. Bodily movements, tilted heads and eye contacts assist in groupings of intimate conversations, casual activities and loving reunions. In spite of its obvious objectivity, Dwight's work expresses a human closeness, a natural togetherness that supersedes the juxtaposition of human forms for the sake of a unified composition.

For a change of pace she plucked a grouping of humans from the crowd and featured it as the dominant theme in such works as *Ferry Boat* and *Art Auction.* Suddenly, the warmth and closeness became a revelation of personal details. It was this manipulation of remote, yet accessible incidents, and intimate displays of affection toward humanity that delighted her audience. In spite of compositional objectives, which she admitted were essential but aggravating, her works sustained elements of personal judgment and emotional restraint. She inherently recognized that the future was untouchable and that each day was a new dawning.

Mabel Dwight was a realist in life and in her creative world. She envisioned a life beyond the earthly experience and expressed her surreal attitudes in such works as *Ferry Boat, Brothers,* and *Queer Fish.* Her satirical expressions were in actuality expressions of disregard for mortal pleasures and a plea for eternity. Her ironic commentary on life was not a contradiction. She fully lived her finite humanity because of the realization that a happier life existed in infinity. There is no clue in her work to a spiritual attachment, and yet one cannot record such events as are depicted in *Survivors, In the Crowd* and *In the Subway* without sensing the need for spiritual aid. And her humor, as witnessed in *Hat Sale, Farm Yard* and *Ferry Boat,* becomes a slap at the injustices of life's peculiar circumstances.

In a manner not unlike that of Loren MacIver's versions of the incidental, Dwight sought and discovered the insignificant and made it significant. Her lithographs lacked the magical charm of a MacIver painting, but instead incorporated human insights that eased the pain, so to speak, of

this earthly life. Her lithograph of subway occupants *(In the Subway)* amplifies this theory of awareness for human problems. Alternately titled *Abstract Thinking,* it bespeaks social incompatibility. Although compositional unity is evident in the physical closeness of the three subway riders, each character remains isolated, alone in an alien world leaving the viewer with the responsibility of their welfare. The title relates to the victims' inner thoughts which are abstract in the sense that they remained concealed within the minds of the occupants.

Throughout her career, Mabel Dwight blended tragedy with comedy, reality with surreality and fact with fantasy, and it was not always a simple matter to differentiate between such extremes. Tragedy found its silver lining, reality hinged on infinity, and fact invited fantasy. This balance of life allowed Dwight the freedom to exploit the human condition and challenge the viewer's inquisitive nature although her concern was not for a viewer response, but for the exhilaration of free expression.

The dramatic appeal of *In the Crowd* is due to its simplicity and its use of shadows. One senses a tragedy outside the picture plane. Ideally titled, *In the Crowd* strongly suggests a segment of a larger crowd and widens the scope of the event. It is this piece of life chopped out of a larger incident that Dwight has presented. At a single glance the figure foremost in the picture plane appears to be the victim. Another look suggests a witness to a tragic event, and still another glimpse indicates that all are victims. Figures to the right and left are cut, squeezed out so to speak, but nonetheless, are essential to the tone and mood of the expression. The

tragedy is questionable, but its effects are unmistakeable in the faces of the onlookers.

One readily recognizes the resemblance to an enthusiastic follower of Dwight; namely, Raphael Soyer. Dwight's positive approach to life is revealed in her compact arrangement. Negative space is minimal; one focuses on a team of six humans each individually consumed by a tragic event, but all sharing a sense of loss.

The questions asked frequently of Dwight's recordings of life refer to circumstances surrounding a victim's dilemma. The set jaws, piercing eyes and motionless bodies add to the mystery. Dwight has refused to identify the circumstances or the situation. The shadows underlying the provocative stares of the victims add to the drama as if further torture lurks in the background. Suspicion and injustice are read throughout the crowd.

Each victim seems chained to unchangeable circumstances. *In the Crowd* is not a typical Dwight lithograph, although it may well be a typical scene of the Depression years. Each compelling figure is stunned into a state of spiritual anonymity. Absent is an answer to whatever questions are raised. An answer is unlikely in any Dwight lithograph. It is unfortunate that more of these bits of life were not a significant part of her production. Unquestionably, *In the Crowd* was a direct response to human suffering.

Dwight's lithographs of the late twenties lacked the technical refinement of her later works, because of either the newness of the medium or a disinterest in the locale. *Basque Country* pictures a farmer tilling the soil with the aid of oxen. Furrows of land

Mabel Dwight. *In the Crowd.* **Lithograph. Courtesy of The Slater Memorial Museum, The Norwich Free Academy, Norwich, Connecticut.**

consume the front plane while billowy hilltops reign in the background. The lack of attention granted the distant landscape hints at a nonchalant attitude unlike other works executed that year. Outlines flourish in unwanted places and reverse shadows define three-dimensional figures. *Basque Country* seems more a preliminary attempt at a permanent expression rather than a permanent recording of life.

Even more obtuse in compositional portrayal is her depiction, *Fishing Village, Nova Scotia.* Recessive and advancing qualities forfeit visual truths and engage in more immediate contrasts. The totality of expression becomes a combination of dual contrasts in which three-dimensional forms are matched to produce sharply contrasted advancing figures rather than a detailed recording of advancing forms. There is a certain rawness that invades the scene. However, as in *Basque Country,* the immediate foreground and distant background lack the refinement of her other works.

A mist swallows up the distant landscape but allows the presence of two fishermen minutely depicted near their habitats. This is a rare objective portrayal of life, and yet, it sustains a measure of subjectivity. A quaint fishing village becomes a lonely habitat for an isolated community. The curious presence of the fishermen maintains a peculiar significance because of their diminutive stature.

Again, it is a mutual attachment of human to environment which creates a oneness. In spite of the distant view of its tenants, *Fishing Village* is a recording of life in a fisherman's survival. It represents the opposite view of *Basque Country* in which the tiller of the soil emerges from the environment and dominates the scene. In spite of architectural dominance, it is the human trait that attracts the viewer into a world of simplicity and hardship when viewing *Fishing Village, Nova Scotia.*

Sunday Afternoon (see page 141) is a pleasant one. The theme celebrates a sexual encounter, the highly polished dudes ogling the passing damsels and fantasizing future activities. Again Dwight's casual, nonchalant manner of recording life's situations is sometimes disguised by innuendoes. The positioning of an unhappy grandmother and her reluctant grandchild may well be a forewarning to the sexual anxiety of the male onlookers. In spite of her obvious objectivity, there remains a personal instinctive jab at humanity, an irresistible urge to record with a purpose.

As mentioned elsewhere in this book, to speculate is to interpret in spite of consequences. It is this mystery of the unknown that intrigues Dwight's viewers. One must assume that Dwight's escapades on the lithographic stone are more than mere expressions of daily events. Such events reflect joy, sorrow, tragedy and despair and the degree to which they affect Dwight's interior life determines the nature of the result.

Again, one is reminded of Reginald Marsh. His highly acclaimed painting titled *High Yaller,* picturing a handsome haughty black woman strutting proudly, unaware of the male form lurking in the background, is attributed partially to the discoveries of Mabel Dwight.

Sunday Afternoon, printed in 1934, exhibits singular emotional tales. The Depression was a time for "street cornering," a time of free discussion. Dwight had picked the time and place in *Sunday Afternoon.* Dwight's overlapping of figures serves the purposes of several visual dialogues and hidden anxieties as well as contributing to the whole in a design sense. The lone occupant who seems to serve a compositional need is also placed on the scene to intrigue the viewer.

Her groups are carefully anticipated and rendered. Each eye glance, wave of the arm, tilt of a head or turn of a foot — all are carefully planned in several preliminary sketches before appearing on the lithograph stone. And yet, a spontaneous image appears before the viewer. Dwight's images excite and propel the viewer into a delightful, sometimes dramatic excursion. *Sunday Afternoon* happens to be a delight.

Notes

1. Quotation appeared in the magazine, *American Artist,* June, 1949, page 42. The article was titled, "Mabel Dwight: Master of Comedie Humaine," by Carl Zigrosser, Curator of Prints at the Philadelphia Museum of Art in 1949.

2. *Ibid.*

3. *Ibid.,* p. 43.

4. Reproduction of the painting titled *The Ocean* appears on page 88 in the May, 1932, issue of *Fortune.* The article is titled "Joseph P. Day."

5. The painting referred to accompanied an article titled "To Make a Circus Pay," which appeared in *Fortune,* April, 1930, pp. 38–44.

6. A reproduction of Dwight's painting *Portrait of John Ringling* appeared in the April 1930 issue of *Fortune,* page 44.

7. *In the Subway* was printed in 1928. It measures $9\frac{1}{2}'' \times 10\frac{1}{4}''$.

8. This quotation appears on page 44 of the *American Artist,* June, 1944.

9. The lithograph *Ferry Boat* measures $9\frac{1}{4}'' \times 10''$ and is in the permanent collection of the Philadelphia Museum of Art, and others.

10. This quotation appears on page 45 of the *American Artist,* June, 1945.

11. *Ibid.*

12. One of several lithos titled *Backyard* and executed in 1933, this is owned by the Library of Congress.

13. *Derelicts,* executed in 1933, is owned by the Library of Congress.

14. *Silence,* executed in 1936, is owned by the Library of Congress.

15. The litho *Museum Guard,* executed in 1933, is in the possession of the Library of Congress. It is also reproduced in *Treasury of American Prints* by Thomas Craven, published in 1939.

16. The litho *Barnyard* is owned by the Library of Congress, 1933.

17. *Dusk,* a lithograph, is owned by the Library of Congress.

Bibliography

Craven, Thomas. *A Treasury of American Prints.* New York: Simon & Schuster, 1939.

Fern, Alan. *American Prints in the Library of Congress.* Baltimore & London: John Hopkins, 1970.

Graphic Art of Exceptional Quality Exhibition. *Art News.* January 8, 1938.

Kistler, A. "Merchants of Death." *Prints.* October, 1935.

Mabel Dwight Reviews. *Saturday Review of Literature.* June 2, 1934.

———. *Vanity Fair.* April, 1930; March, 1928; August, 1929; March, 1929; November, 1929.

Reproduction of "Barnyard." *Art Digest.* February 1, 1939.

Reproduction of "Dusk." *Arts.* April 23, 1932.

———. *London Studio.* February, 1934.

Reproduction of "Fish." *Creative Arts.* November, 1931.

Reproduction of "General Siminary." *Prints.* February, 1936.

Reproduction of "Harlem Rent Party." *Art Digest.* January 1, 1930.

Reproduction of "Life Class." *Art News.* February 1, 1943.

Reproduction of "Nova Scotia." *Art Digest.* March 1, 1936.

Reproduction of "Paul Robeson As Emperor Jones." *Brooklyn Museum Quarterly. Art Digest.* May 1, 1935.

Reproduction of "Queer Fish." *Architectural Record.* March, 1937.

———. *California Arts & Architecture.* December, 1936.

———. *Prints.* February, 1937.

Reproduction of "Rain." *Prints.* February, 1936.

Reproduction of "Sacco & Vanzetti." *Creative Arts.* March, 1933.

"Satire in the spirit of aren't we all." *Exhibition Review. Art Digest.* January 15, 1938.

Zigrosser, Carl. "Joseph P. Day." *Fortune.* May, 1932.

———. "Mabel Dwight: Master of Comedie Humaine." *American Artist.* June, 1949, pp. 42–45.

———. "To Make a Circus Pay." *Fortune.* April, 1930.

Helen Sawyer

Born in Washington, D.C., during the year 1900, Helen Sawyer became an early enthusiast of the art process. European travel was a natural part of her early life, and her interest in art was heightened by her studies at the Art Students League. In the North her subject matter became the surroundings of Cape Cod, while the Southern motivation was the environment of Sarasota and the Ringling Brothers circus. She did more than record the scene. She painted moods.

During an interview, Ernest Watson observed that "she had painted the Cape's rugged landscape and the windy shores and sea. She had painted those sparkling days when the Easterly winds gave a pure, undiluted quality to the light; she had no less eagerly captured the effect of gray, stormy landscapes when a tempest was brewing and storm clouds scudded across the sky. She always painted to express a mood rather than record a specific scene — spring rather than an orchard, the threat and fury of sea and sky rather than a particular place

in time of storm. She absorbed the world she painted into something both personal and endowed with the rhythmic quality of nature."[1]

Watson claimed that Sawyer was one of few contemporaries who utilized the sky area to create an emotional tone. The sky, considered by some artists as negative space, an area that exists merely as a remainder, in fact sets the stage for events to follow. The emotional reactions of the viewer are determined by the mood of the sky alone, which gives the tone of the entire painting. Shadows cast by the sun upon the earth's surface, shimmering reflections of nature's objects upon a rain-drenched pavement, the threat of a tornado, cyclone or hurricane — all determine the mood of the painting. The emotions of drama, turmoil, tragedy, peace and tranquility emerge from the artist's decision to set the tone of the painting.

The above intent applies to her painting titled *Pamet River,* a dramatic exposé of ships at sea. The strong winds bounce the ships about

Opposite, top: Helen Sawyer. *An Outdoor Rehearsal.* Casein/Board, 15½″ × 20″. Courtesy of Corbino Galleries, Sarasota, Florida. *Bottom:* Helen Sawyer. *Rehearsal.* Casein/Board, 15½″ × 20″. Courtesy of Corbino Galleries, Sarasota, Florida.

the swirling waters in spite of anchors. The subsiding storm clouds indicate an oncoming calm. The rather peaceful sky is not a contradiction. Sawyer has relied upon the anticipation of action. Frequently her expressions of skies predict the future as in her work titled *Fishing Before the Storm.* She explained further with her remarks:

> Sometimes a fleeting effect in nature that is passing quickly, overwhelmingly appeals to a knowledge and an impulse already formed; then the moment must be seized. In *Fishing Before the Storm,* I saw the wonderful darkening light on the water almost at the end of the day. The relationship between the pale shingle, pink and gray sky and sea was so fine that I immediately made a small oil sketch working as quickly as possible to recapture the real mood and color relationships.[2]

Fishing Before the Storm reflects the anticipation of a coming event. Sawyer's major use of a violent sky contrasts to the narrow strip of calm waters in which a lone fisherman is anchored. Fishermen on shore to the right of the canvas await the storm as winds blow nearby trees and foliage. In a sense, the insignificance of humans is pitted against the awesome forces of nature.

In the same interview with Ernest Watson, the words of Helen Sawyer describe a work similar in subject matter titled *Sailors Take Warning,* of which she said:

> I made first a small oil, then organized a larger painting which I started outdoors. To help with some of the structural detail of the tower, beacon and other elements, I made a few detail drawings, and also made sketches of earth contours, masses and renderings of weeds and grasses, with color notes in writing. These written notes on color crystalize more fully the first impression.
>
> The landscape as finally worked out became more strongly stated and dramatic than the sketch had been. I could have worked on the picture entirely in the studio but I preferred to keep it outdoors in its elements of cold and salt wind. Drawing the detailed red and white trusses of the radio beacon and construction of the tower was difficult with my large canvas billowing like a square sail.

Her following statement hints at surrealism: "In this lighthouse painting I tried to suggest the presence of the unseen ocean beyond the drop of the lighthouse buildings."[3] This illusionary device adds to the tension of the painting. The oceanside buildings ride on a crest, a baseline which demands a compatibility of sky and land. Thus, the sky acts as a buffer, a wall that props up the recessive land and avoids a further drop into surrealism.

The several pencil studies prior to the painting of *Sailors Take Warning* are delicately rendered works, carefully detailed and accented with textural qualities not evident in the final work.

At times, subject matter will dictate a compositional approach or a technical application of pigment. However, in spite of a dramatic change of scenery, from the North to the South, Helen Sawyer sought out the unspoiled elements of nature and continued to paint in the same mood

as that applied to her Northern landscapes. She traveled the "back country of primitive forests with negroes fishing on the edge of the shore and swamp, a blue-green lagoon known only to fishermen and sea birds. She discovered that much of it was a primitive Eden still."

Sawyer stated:

> Most of my landscapes were only started after I had looked at the subject matter for days, weeks and sometimes years. By the time I paint the thing itself, its significance, its salient color relationship, and its mood are so much a part of me that I can think of a painting as a manifestation of life and the natural world, and the subject as notes and indexes to procedure. This is a curious psychological reversal which identifies the artist closely with his work and, strangely enough, allows great freedom of expression.[4]

Not so strange since freedom stems from a thorough knowledge of nature similar to the notion that in order to distort an aspect of nature, one must first express it as it is and as it appears to be.

Sawyer had done several preliminary sketches of a single idea before launching into the final work. And yet, Sawyer admitted to what had been considered a truth by artists and critics both, that

> these sketches are more than shorthand. To be valuable they have to convey the essence of all the structure needed in the picture—what is growing in this and that patch; why the sand looks darker here or there, or wetter; if deer moss or dried fern is what gives a certain

hollow its peculiar color or texture; how the wind is blowing and if it smells of sand or bay or a distant fox.[5]

Helen Sawyer claimed that her approach to a still-life painting differed from her landscape technique. After a satisfactory set-up was established, her approach was that of an intuitive application of paint, with composition and mood in constant control. In a sense, Sawyer became an abstract expressionist with a pre-arranged concept. Freedom to deviate from the original arrangement was not allowed, but in order to sustain the initial mood, paint was applied on those areas of the canvas corresponding to similar areas of the still-life set-up in a seemingly reckless manner. In actuality, such brushstrokes sustained the original position of the still-life while retaining the essential mood.

In her still life painting *Early American Bowl,*[6] Sawyer utilized the background area as a sky-like anxiety equal to that of her landscapes and seascapes. Sawyer's *Early American Bowl* is not a still-life painting in the traditional sense. Even though her still-life arrangements were altered several times before a satisfying composition was established, they became a guide rather than a dogma, as with Gladys Rockmore Davis. *Early American Bowl* is deliberately arranged so its transfer onto canvas differs not in composition but in the application of pigment.

According to the writer Ernest Watson, in order to control the aim of the painting and sustain its mood, Helen Sawyer has drawn

> directly on the canvas with lines of thinned paint, using ultra-marine warmed with umber or

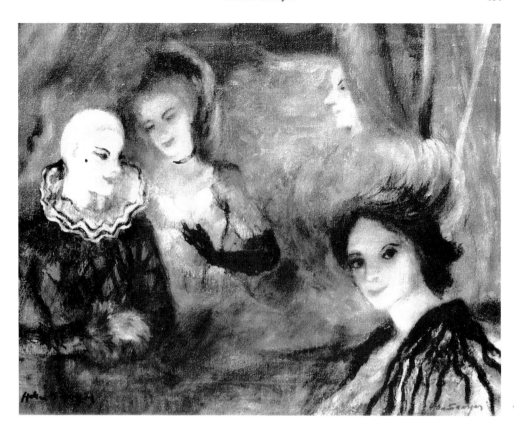

Helen Sawyer. *Carnival.* **Oil on canvas, 16″ × 20″. Courtesy of Corbino Galleries, Sarasota, Florida.**

other earth color and keeping the whole mobile as she worked from one balancing part to another, thus becoming so familiar with the various parts and mood of the whole that it became like a world in itself which the painted inhabited.

She then painted in solid color the richest darks, and next a passage here and there of light and color in small areas, weaving back and forth in working so that the canvas would look unintelligible to anyone but a painter while it was being developed.[7]

The above procedure indicates strongly the abstract expressionist approach. Only the result differs. Even though the process is similar, Sawyer insisted upon a recognizable image.

In *Mardi Gras,* Sawyer has sustained the contours of individual objects, but within those confines restless brushstrokes inhabit the interiors. This is an elegant painting of an elegant subject, a woman "delicious in color, irridescent and piquant."[8]

The ability to establish a highly personal attachment to her subject matter has made Helen Sawyer a

Opposite: **Helen Sawyer.** *Child's Dream of Circus.* **Oil on masonite, 18″ × 36″. Courtesy of Corbino Galleries, Sarasota, Florida.**

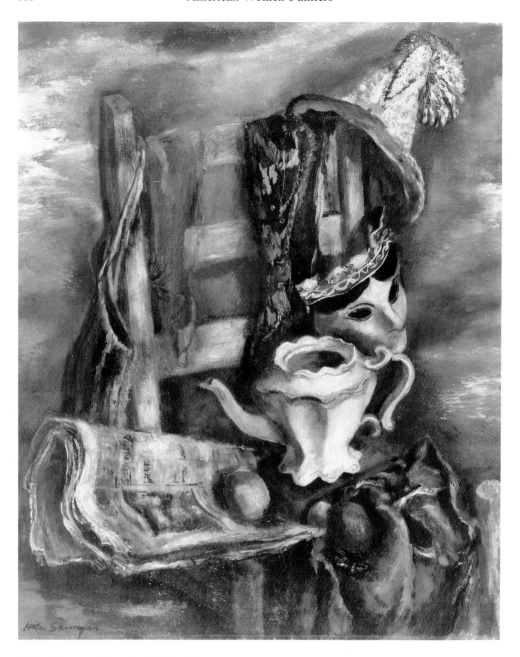

Helen Sawyer. *Clown's Chair.* **Oil on canvas, 30″ × 25″. Courtesy of the Chrysler Museum, Norfolk, Virginia. Gift of the artist.**

foremost recorder of the American scene. Her several devices for blending foreground and background disregarded visual perspective which applied to her circus themes as well as her landscapes and seascapes.

A comparison of devices occurs in the two paintings titled *The Clown* and *Bareback Rider.*[9] In *The Clown,* the close-up view immediately established the subjective approach which is sustained by a technical application

of paint similar in both foreground (figure) and background. Details are forsaken in order to fully appreciate the entire portrait. In *Bareback Rider,* Sawyer has introduced adjoining elements which remain subordinate to the featured subject, the bareback rider. In the case of *Bareback Rider,* the clown, horse, rider and circus tent enhance the presence of the major character. One does not share the presence of secondary figures, but adds their roles to that of the featured role player to endorse a more complete character. In the case of *The Clown,* the background and foreground are compatible because of the technical application of paint. The affectionate dog, sitting in the clown's lap, sustains compositional areas of color similar to those displayed in the clown's oversized costume. In both, visual perspective is translated into frontal planes so that recessive qualities are minimized.

A second version of the bareback rider revealed Sawyer's anatomical prowess. The semi-nude rider's costume has been painted with a "sensitive feeling for texture, while the circus background has been muted in such a manner as to make it of importance to the whole but never obtrusive."[10]

Helen Sawyer has utilized a medium of painting considered by critics and painters as preliminary to permanent paintings, or as a lesser work than the oil on canvas. Called "oil on paper," it has satisfied artists over the decades, even centuries, as a free form of expression. Its natural makeup assumes a lesser degree of success and subsequently lessens the painter's fear, partly because of its perishable nature. It is precisely this reason that Sawyer preferred the medium for on-the-spot scenes and events. No doubt her oils on paper had served immediate needs as well as motivation for future production. Yet, for Sawyer the groundwork was laid for her more permanent works since the dry brush technique and turp wash created emotional moods which were her major concerns.

The work titled *Landscape Mood* is a spontaneous sketch painted in broad strokes which successfully exploited the atmospheric character of the motif.[11] The deliberate approach and casual attitude which accompanied this medium of expression resulted in an exciting and dramatic scene. The mood created by tall trees entangled with clouds and foliage had extended into her more permanent works. Another example, *The Red House,* was objectively conceived and executed. The dry brush technique correctly identified with the vast rugged landscape. The obvious objective positioning of the vertical poles and posts in *The Red House* diminishes its compositional integrity. Removal of the telephone poles which mark the landscape may heighten the emotional impact of the scene by awakening the vast landscape to a state of isolation. The possibility of overwork is always present, and yet, considering the purpose of the sketch, which was to record a scene, *The Red House* serves the intent of the artist.[12]

Saturday Night, Jacksonville, because of its several figurative forms, demanded a slightly different approach. Background areas of sky and land were brushed in first, as the most recessive planes. Buildings were then added, and finally all figures were positioned in appropriate places. However, the consistent subjective sense of completeness is evident. The

inhabitants of *Saturday Night* are compatible with the environment. It is typical of scenes prevalent during the Great Depression years. The favorite spot, the meeting place, the wolf's corner, describe *Saturday Night*. Another work by Sawyer, *Oil on Paper,* became an anticipation of excitement, an inquiry into the future, an example of restlessness, an uncertainty among the participants.[13]

This looseness of pigment is best illustrated in her painting titled *The Mask,*[14] in which turp washes swish within the swirling gowns of three female beauties. The model used for the painting *Mardi Gras* and several versions of *Bareback Rider* is again used in *The Mask.* Particularly intriguing are the nuances of darks and lights and the subtleties of blending that provide graceful circular compositions within the whole.

Her technique of deliberate blending of turpentine and oil pigment with only casual control suggests the approach of an abstract expressionist. The three figures form a conclusive trio, a compositional treat of mystery, detailed and accentuated in appropriate areas. A vase of flowers anchors the rounded table occupying the lower left corner of the painting, adding to the richness of the theme.

An untitled oil on a "thinly painted surface, in a dry brush manner, on a warm-toned paper stock"[15] has resulted in an inventive recording of a commonplace scene. Again, the injection of obvious compositional devices (telephone poles) has developed a visual depth as well as serving as connector of horizontal planes.

The peaceful painting has been transformed into a dynamic expression by virtue of a drybrush technique which allows the artist the option of subscribing to the new version or to the original scene if future production were to be considered.

A similar subjective transformation occurs in the painting *Iruro in Fall,* which is comparatively diminutive in size. A vast expanse of territory is, however, revealed in a dramatic fashion. The quickly exploited landscape has the usual visual devices of recessive qualities. Because the "oil on paper" technique is an intuitive process, errors occur that are nonreversible. Therefore, particular areas may appear disruptive to the unity of the whole. As the artist has so aptly explained, "Painting in oils on paper is difficult because it is almost impossible to alter what has been set down. If the darks are too heavy, or if it has been scraped or scrubbed too much, it is better to discard it and begin again, in order to retain a freshness and a sureness of touch."[16]

The rugged mountainous background could easily overpower the three isolated dwellings in the landscape below, but the careful application of diluted oils sustains an appropriate distribution of grey tones of varying nuances. "These black and whites can have a remarkable range, from delicate greys to brilliant blacks," according to Sawyer.

A handsome drawing, *Basque Bridge,*[17] with its delicate and subtle modeling simulating the character of a fine proof taken from a drypoint engraving, regrettably exists only in

Opposite, top: Helen Sawyer. *Oaks in Spring.* Oil on masonite, 18″ × 24″. Courtesy of Corbino Galleries, Sarasota, Florida. *Bottom:* Helen Sawyer. *Jamaica.* Oil on masonite, 18″ × 24″. Courtesy of Corbino Galleries, Sarasota, Florida.

the unique original. Because several of her "oil on paper" works resembled drypoint engravings, the temptation was strong to imitate the etching appearance as an exciting sideline while recording the event or scene.

According to Sawyer, "there are possibilities of achieving unusual results working in oil on paper, sometimes not obtained in any other way, and sometimes the appearance can be baffling to others."[18]

Although other artists have considered the "oil on paper" approach to painting as an exercise technique, Helen Sawyer has used it with varying intents including as a mature and complete expression of her artistic goal. Frequently the process ends before its anticipated conclusion. This is true especially of the intuitive process when results are not preplanned or precomposed. In other words, an anticipated result may never occur because a more satisfying result may occur at a point during the process prior to the intended completion. Sawyer's "oils on paper" are such examples. The process is to record an impression, but in the process an artistic result may occur.

A *New York Times* critic called her paintings "impressionistic in technique and rococo in flavor," and related "astigmatically blurred contours and the cold but strong color" in relation to Monet. Her name is "Henka," or at least so it appeared on the brochure of the Grand Central Art Galleries of New York on April 19, 1932, where a collection of decorative and romantic themes appeared, of which *Tea Party* is typical.[19] "Henka," an alias for Helen Sawyer, has indeed altered her style reflecting the influences of Degas and Laurencin.

The "Henka" trademark continued for several years. A New York showing at the Milch Galleries in 1940 recorded drawings with the "Henka" label. According to Edward Alden Jewell, it mattered little what label appeared as he considered Helen Sawyer a painter "with communicable relish evincing on the artist's part a fresh, uninhibited eye for color and for bold harmonies."[20]

Margaret Breuning has found "a radiance and profusion, that pours a new content into a well-worn mold of flower painting yet in ordered sequence of design."[21]

The same enthusiasm was shared by Emily Genauer who said that "rarely does one come on an exhibition so deeply satisfying. There can be no hesitancy about her talent. Strongly evident are the warmth of her colors, her poetic approach and the vigor and breadth of her technique."[22]

While her husband, Jerry Farnsworth, served as an artist-in-residence at the University of Illinois in 1943, Helen Sawyer held shows at both the University of Illinois and Illinois State University. Reviewer Gladys Bartle claimed that Helen Sawyer's paintings described "the true worth and depth of feeling of the people through the dominance of vertical tree forms, firmly modeled and decisively outlined." *Back Fields of Illinois* is a painting reflecting the "very essence of the prairie land," according to Bartle. "This painting of infinite expanses of sky above the level land, the rows of corn, plowed fields, a tractor and farm buildings, creates a scene which has been translated very thoughtfully into the minor key ... [and] gives a sense of the very oneness of the earth, its abounding yield, and the farmer who toils through the darkening of the day."[23]

Helen Sawyer. *Plumes and Spangles.* **Oil on canvas, 20″ × 16″. Courtesy of Corbino Galleries, Sarasota, Florida.**

Helen Sawyer. *Dejeuner.* **Oil on masonite, 10″ × 12″. Courtesy of Corbino Galleries, Sarasota, Florida.**

This same oneness is evident in her poetic and charming painting titled *Arrangement with Pitcher and Green Glass.* The atmospheric aroma of her seascapes and landscapes resides in both the background and foreground of this work. The textural nature of the environment echoes the flower arrangement as if positive and negative areas live as one. An almost perfumed quality consumes the canvas, as its initial objective nature succumbs to the personal, intimate qualities of the artist. *Arrangement with Pitcher and Green Glass* displays more than delicately rendered flowers. A symbolic feminine mask and an eruptive table texture recall days past. These personal attachments, seldom identified, become intriguing images for the consumer, but flow effortlessly from the artist's brush. There is a sense of totality in her work, a transformation of objective drawings into subjective paintings.

Notes

1. The quotation is taken from page 33 from *American Artist,* September, 1949.

2. The painting *Fishing Before the Storm* measures 18″ × 30″. It is reproduced on page 34 of the September, 1949, issue of *American Artist.* The quotation appeared on page 36 of the same magazine.

Helen Sawyer. *Arrangement with Pitcher and Green Glass.* **Oil on canvas, 30″ × 25″. Indianapolis Museum of Art. Gift of Mr. and Mrs. Wendell F. Coler in memory of their daughter, Jean Coler. C. 1989.**

3. These quotations appeared in *American Artist,* September, 1949. The painting *Sailors Take Warning* measures 36″ × 42″ and is owned by the Pennsylvania Academy of Fine Arts in Philadelphia.

4. This quotation appears on page 36 of *American Artist,* September, 1949.

5. *Ibid.*

6. The painting *Early American Bowl* measures 25″ × 30″.

7. The quotation appeared on page 37 of the *American Artist,* September, 1949.

8. The painting *Mardi Gras* measures 25″ × 30″ and is owned by a private collector. The quoted phrase are the words of the artist, Helen Sawyer, and appear on page 37 of *American Artist,* September, 1949.

9. The painting *The Clown* measures 30″ × 25″, and the painting *Bareback Rider* measures 30″ × 40″. Both are reproduced on page 36 of *American Artist,* September, 1949.

10. This quotation belongs to Ernest Watson, author of the article "Helen Sawyer," appearing in the September, 1949, issue of *American Artist.*

11. The painting *Landscape Mood* measures 11⅝″ × 14¼″. It is in the collection of the artist and her husband, Jerry Farnsworth.

12. The painting *The Red House* is owned by the Farnsworths, and it measures 11½″ × 13½″.

13. The painting *Saturday Night, Jacksonville* is also owned by the artist and her husband, Jerry Farnsworth, and measures 10″ × 14″.

14. The painting *The Mask* measures 8½″ × 11″. A reproduction of it appears on page 48 of *American Artist,* January, 1964.

15. This quotation appears on page 46 of *American Artist,* January, 1964.

16. *Ibid.,* p. 47.

17. The painting *Basque Bridge* is reproduced on page 49 of *American Artist,* January, 1964. It measures a mere 7¼″ × 9⅝″.

18. This quotation appears on page 49 of *American Artist,* January, 1964.

19. A reproduction of the painting *Tea Party,* under the assumed name of "Henka," appears in the April 15, 1932, issue of *Art Digest.*

20. The quotation appeared in the December 1, 1940, issue of *Art Digest.*

21. *Ibid.*

22. *Ibid.*

23. The quotations by Dr. Gladys Bartle appeared in the March 15, 1943, issue of *Art Digest.*

Bibliography

Reproduction of *Arrangement with Pitcher and Green Glass.* John Herron Art Bulletin. April, 1946.

Critics Highly Approve Sawyer Exhibition. *Art Digest.* December 1, 1940.

Exhibition. Feragil Galleries Review. *Art News.* March 14, 1931.

_____. Feragil Galleries Review. *Studio.* May, 1931.

_____. Grand Central Galleries. *Art News.* April 23, 1932.

Exhibition Review at Milner Gallery. *Art Digest.* March 15, 1943.

Fern, Alan. *American Prints in the Library of Congress.* Baltimore & London: Johns Hopkins University Press, 1970.

Helen Sawyer (Reviews). *International Studio.* May, 1931.

Helen Sawyer Reviews. *American Artist.* September, 1949.

_____. *Art Digest.* March 1, 1940; December 1, 1940; March 15, 1943; October 15, 1943; November 1, 1945.

Mitch Gallery Exhibition Review. *Art Digest.* November 1, 1945.

_____. *Art News.* November 1, 1945.

Portrait Exhibit Review. *Art Digest.* March 15, 1943.

Reproduction of *Sailor Take Warning. Art Digest.* March 1, 1940.

Reproduction of *Spring at Fiddler's Cove. Art Digest.* October 15, 1943.

Sawyer, Helen. *Painting in Oil on Paper. American Artist.* January, 1964, pp. 44–49.

Sawyer Exhibit Critically Acclaimed. *Art News.* November 30, 1940.

Watson, Ernest. "Helen Sawyer." *American Artist.* September, 1949, pp. 33–37.

"Who Is Henke, Who Performs an Art Flip Flop?" *Art Digest.* April 15, 1932.

•─Gladys Rockmore Davis─•

Recognized as America's painter of women and children, Gladys Rockmore Davis' delicate style has fascinated the art world throughout her career. Influenced by the French Impressionists Renoir and Degas, Davis became the queen of the American ballet scene. Although her style was unlike the French masters, Davis succeeded in maintaining their tradition of recording the ballet.

In a series of paintings commissioned by *Life,* Gladys Rockmore Davis transferred the European tradition of the ballet to America. The Impressionist style of the French masters of the late 19th century has been mirrored in the brushwork of Davis. Her subtle yet colorful dabs and streaks of pigment fuse into an array of luminous activity.

The demure grace of the ballerina is seen in Davis' *Les Sylphides.* She painted Alicia Alonso as she posed the fourth position at the end of the "Prelude." The artist has allowed a spacious environment for the single dancer as a silhouette echoes her performance in the background. The simple stance of the ballerina, although dominating the canvas, directs the viewer's attention to other seg-

ments of the painting. Her left foot pointing downward activates the vast space in the forefront, while her right foot activates the space between the two legs. Her arms disrupt the openness of the backdrop while the entire left segment of the canvas is filled with the dancer's silhouette. In addition, the diagonal slant of the stage curtain paralleled similar slants of the dancer's body.

Davis' study of the ballet as a child resulted in an avid lifetime interest in this form of dance, and given her fondness for the female nude, the ballet afforded her a combination of her two loves.

Making Up focuses on the single act of applying eye make-up, and in spite of the sensuous female form and essentials of the theatre world, it is the act of doing to which one is drawn. Davis allows the viewer to witness the act between the doer and the image in the mirror. And yet, Davis further allowed for the appreciation of a lovely body. Although the painting is subjective, Davis encourages the viewer to observe the pertinent apparatus. One is invited to share with the subject those ingredients which seem positioned in a haphazard manner. *Making Up* is an

equal balance of personal and impersonal needs.

The spotlight became a device of isolating the central theme from its environment. It also aided in establishing several vantage points. The onstage/offstage duality seems effective for Davis in establishing a relationship between performer and spectator. In *Swan Lake,* the "spectator" relaxes while awaiting a turn to perform. Life is split between the real world of waiting outside and the realm of the artistic world of the ballet—the actual performance. Davis has succeeded in blending the two worlds into a single pleasure. One inhabits the personality of the Oleko character as the viewer identifies with the "spectator." Davis has used the spotlight as a compositional device of arranging light areas throughout the painting.

However, in the case of *Giselle,* the spotlight focuses on the performers while the oncoming stars reside in the shadows. The "spectators" become like silhouettes. Instead of distributing light areas throughout the painting as in *Swan Lake,* Davis divided her canvas into four triangular shapes. Attention is devoted to the dancers in the spotlight on stage, while the viewer joins the "spectators" in witnessing the performance.

In *Young Man from Ballet,* Davis manipulated the spotlight to incorporate both distant and close-up characters. The focus has shifted from the spotlight to the figure offstage. Although nestled in the shadows, the character, Capulet, dominates the painting. His physical being, strangely overpowering the demure figure of the ballerina, acts as a protector of the meek.

Davis revealed the strange duality of the inside/outside or onstage/off-

stage. In this series of ballet portrayals, she separated within a single expression the worlds of reality and fantasy before blending the two into a single concept. Instead of concentrating on the performance or collaborating with the audience, as many artists have preferred to do, Davis acknowledged the behind-the-scene participants as integral role players.

Only in the painting titled *Waiting for the Curtain* did Davis prefer to omit the performance in favor of preparation. And yet, the artist continued to utilize the distant/close-up theory of portrayal. As the dancers in "Princess Aurora" stand on stage, exercising or chatting before curtain-time, the viewer is treated by the artist to a textural delight, the detailed pattern of color witnessed in the close-up figures occupying the foreground.

Although she had eliminated the spotlight in *Dancer Hugh Laing,* Davis had highlighted the dancer with bright color while diminishing the focus on the onlookers. Gladys Davis continued bridging the performance and audience into a splendid singularity of purpose. The ease and relaxation of those in waiting suggest the secret to great performances. Gladys Davis' approach removed the mystery and artistry of the ballet and replaced it with reality.

Fantasy becomes reality in *Petrouchka* as weird characters parade in dramatic fashion on stage. The street dancer, the blackface, the merry-maker, the coachman and the grotesque animal contribute their individual talents to the Stravinsky work. Concentration on single personalities had given way to a carnival atmosphere in which colors, brushwork, detail, textures and shapes compete.

Gladys Rockmore Davis. *Girl in White.* **Oil on canvas. Courtesy of the National Academy of Design, New York.**

Gladys Davis had focused upon the subordinate role players which, although secondary in stature and performance, maintained integral roles in the ballet. This series of paintings afforded the artist a chance to exploit her profound love of the ballet, although her technique and composition differed from other works of the same period.[1]

Gladys Rockmore Davis was born in New York City in 1901. At age 16 she attended the Art Institute of Chicago. In 1925 she married, moved to New York and succeeded as a commercial artist. However, in 1932, after a stay in Europe, and influenced by the works of Renoir and Degas, she returned to New York as a serious artist.

The posed model altered Davis' style considerably from that used for the New York City ballet on-the-spot scenes. *Emma* is an example of a tighter technique without the loss of a relaxed subject. The artist spoke of the smiling innocence of youth, in *Emma*. She used the direct approach to painting without preliminary sketches in order to avoid change— not in the subject but that which may have occurred within herself. Instead, she posed her subject and dealt with it directly. She set the composition in the studio and transferred it onto her canvas. *Emma* is a classical picture. The youthful innocence peers at the viewer with contentment and a hidden desire to please. Meticulously detailed, Emma sits in an equally lavishly rendered chair. Each brushstroke was deliberate but painstakingly applied and neatly tucked in its proper place. Such details as the diligently woven pigtails paralleling the curved chair legs and the laced petticoat balancing the upper laced portion of the apron,

are earmarks of Davis' classic approach.

Two of Davis' favorite models were her children, Tuffy and Sissy. A highly subjective work titled, simply, *Tuffy* is sensitively rendered in subdued color. Occupying almost the entire canvas, the head sets a poetic mood: piercing eyes, mellowed with soft brushstrokes, set into a perfectly modeled head. The circular neckline parallels the curved arch of the hairline, the lower eyelids and the chin.

Of a more formal appearance is the portrait of *Sissy*. Seated onto a wicker chair, the young girl of ten years poses obediently with folded hands. An animal statue, book and vase of flowers act as background props. This classical style hoisted Gladys Rockmore Davis to a high achievement level among American painters.

Not unlike the photographer who sets the pose in an appropriate environment, Gladys Davis performed an intimate arrangement of stimuli before painting. Although tightly knit, the composition appears relaxed and casual. Shadows create a pensive mood while highlights are carefully distributed to sustain the composition. This is a quiet, precious moment which Davis achieves in *The Music Lesson*. Although Davis has allowed ample negative space to warrant a full appreciation of the music lesson, the painting remains a compact arrangement of overlapping figures and objects. Each detail is diligently rendered. There is a devotion, a love engendered between what appears to be a mother and child. In spite of seemingly objective interferences, one imagines a visual dialogue between the two models as well as an emotional interchange of thought.

Gladys Rockmore Davis. *Noel.* **Pastel on paper, 17¼″ × 16″, 1941. Sheldon Memorial Art Gallery, University of Nebraska–Lincoln. F.M. Hall Collection.**

Flowers was painted as an experiment to get pure color vibrations by not mixing the colors but placing them on the canvas just as they come from the tubes. Yet, the colors are refined, not at all resembling the works of the Impressionists whose techniques followed the theory of adjacently placed pure colors. One senses a poetic charm in *Flowers*.

Seated Figure, one of several nudes painted by Davis, has a sensuous tone to it and relates the artist's fondness for the human body. There is an intimate, feminine mood which helps bring *Seated Figure* into a high level of artistry. This is a direct, honest statement of a woman in profound thought. Davis contrasts the smooth flesh tones against the soft textural

clothing of the lower torso. The background is subdued to enable one to absorb the female form.

The thirties and forties were years of fruition for the American artist. Corporations became patrons of the arts. One development of interest was the commissioning of Christmas cards initiated by American greeting card companies. Gladys Rockmore Davis was no exception to this introduction of the fine arts to the commerical field. The strange paradox resulting was the neglect of the Christian birth. Few artists, in fact, created religious thought. Most thrived on personal life situations — outdoor winter scenes and mother and child themes. Gladys Davis repeated her familiar and popular portrait of her daughter accompanied by her mother. It is a beautiful moment of sharing. Love permeates the entire work. The delicate arm embracing Deborah and the relaxed couple engaged in mutual dialogue do not convey a religious message, but do reveal the deep love of mother and child which, of course, does relate to the birth of Christ. Davis accompanies her charming mother and child concept with the ever-present still-life of fruit and flowers.

Gladys Rockmore Davis was a classicist, an adherent of the past and an artistic fundamentalist who rejected the notion of self-expression which ignored the basics of composition and technique. She related the art of painting to that of life, to the duties and responsibilities of a wife, mother, and housekeeper. In 1953 Gladys Davis made a plea for standards in art much in the way she would have pleaded for criteria for life. She objected to the cults and "isms" of the forties and fifties.[2]

The basics of life are the principles of painting — discipline, mortality, love, tenacity, ability and intelligence, and an inner peace that can be gained only through a being greater than oneself. It was not that Davis objected to the Abstract Expressionist movement which was so prevalent during the fifties; it was student apathy toward the underlying strength of any painting, solid composition and reliable technique, that upset her. Although her words would still ring true today in light of the scientific advances, her plea would be less effective.

In the summer of 1948, Davis herself experienced the joy of Expressionism. It became a raging intuitive response to a gnawing sense of need. In describing her reaction to this need and the ensuing artistic expression, Gladys Davis confessed to the thrill of the artistic, intuitive act. She described the central incident of her formidable work titled *The Kiss* as follows:

> One morning as I was sitting in the little cafe across the street from my hotel having coffee with my daughter, we both saw a woman coming toward us. She was quite tall and very beautiful, and carried a young baby on each arm. Another child clung to her skirts. At one point as she walked, she looked down at one of the babies with an expression of such ineffable tenderness that I had a feeling of seeing something too personal to see — of almost the sense of peering through a keyhole. It was all of Mother-love — in that brief instant; and I knew I would have to paint it some day. I thought about it very often, and tried it many times, never getting close enough to the memory of that

Gladys Rockmore Davis. *The Shell.* **Oil on canvas, 26″ × 16″. The McBride Galleries, New Orleans.**

Gladys Rockmore Davis. *Maternity* **(also called** *Nursing***). Oil on canvas, 24″ × 30″. Courtesy of the McBride Galleries, New Orleans.**

moment. When finally it was painted, it went very quickly in a feverish excitement of work. I remember not being able to get the paint on fast enough with either brushes or palette knife. Many parts of the canvas are painted with my hands and with rags. I believe I came fairly close to the sensation I wanted to put down, but the artist is always dissatisfied in his constant search for the essence.[3]

Explained in shorter terms, Davis reflects the process of intuitive creativity:

At the start of a canvas there was a feverish sense of excitement, then at a certain point a feeling of exhilaration, and of having achieved completely my original conception. This brief and happy period is always followed by an irresistible desire to go on to the next painting.[4]

Davis' creative process consists of a blend of the visual, intellectual and emotional facets of the artist's make-up, and generally a brief period of time to execute. In *The Kiss* the inner strength of the mother is reflected

Opposite: **Gladys Rockmore Davis.** *The Kiss.* **Oil on canvas, 1948. Courtesy of McBride Galleries, New Orleans.**

in the powerfully structured body. The massive feet and hands further exemplify the strength of Motherlove, especially when compared to the tiny segments of the child's body. *The Kiss* is an emotional event and a tribute to the artistry of Davis, whose classic portrayals generally incorporated objective elements. The painting of *The Kiss* is one of those rare experiences which is sacred in its intimacy and innocence, but which is enhanced by the artist's need to echo the incident.

Gladys Davis' classical works were not limited to painting. Her pastel drawings revealed the sculptoresque form and glowing color found in her lush, richly decorative paintings. Her drawings were conceived in color and mass rather than in line. Once compositional needs are met, colors and tones are applied after lightly indicating in line the positioning of figures. The result is a completed drawing closely resembling that of her paintings. An excellent example is *Girl Arranging Flowers,*[5] a pastel drawing of 1940. This classical portrayal is vibrant and sustains a freshness seldom found in a temporary medium. Its delicacy is afforded through a fundamentally strong inner structure. *Girl Arranging Flowers* is a simple activity which succeeds as a provocative, sensitive portrayal, an expression of love and affection toward the subject.

The somber tones of the face are offset by the sprightly, lacy character of the sleeves. The pensive nature of the event, the anticipation created by the distance between the young woman's face and her hands arranging the flowers, remains a subtle experience. There is a liveliness that reigns within a calm atmosphere.

Davis' showing of pastel drawings in 1941 was her only major exhibit of drawings, but critical raves compared her works with that of Renoir and Cassatt. Her fleshy nudes and beautiful children compare favorably with Renoir's flair for life.

Not only was Davis the creator of lovable paintings, but her choice of subjects and the arrangement of those subjects evinced a high degree of creativity. She exceeded the expectations raised by most creative photographs. Her subjects became communicators, not merely models.

Success as a pastel artist came because her drawings were complete emotional expressions, not merely preliminary sketches for her more permanent oils. They had a haunting reverie about them, a total commitment to human love. One could sense a loneliness that only a child could bear, and yet a yearning exists on the part of the viewer to embrace her lovable creatures.

One of her most famous works, *August Afternoon,*[6] is a classical portrayal which exhibits the usual Davis charm. The concept of the opened letter and its effects upon the concerned reader is a commonplace adventure, but Davis injected into it a sense of reverie. The usual became the unusual; the general, the intimate. And again, her ability to communicate a message within a brief distance between the cause and effect of the subject's action, places her high among America's artists. *August Afternoon* lacks the preciseness of detail of an *Emma,* but has instead the qualities of a freer and suggestive surface texture.

Two Girls,[7] executed in the same year as *August Afternoon,* is an intimate duality of two figures occupied in a reading exercise. A similar free

Gladys Rockmore Davis. *Robin's World.* **Oil on canvas, 30″ × 40″. Courtesy of the McBride Galleries, New Orleans.**

style is utilized. The light source occurs outside the picture plane and focuses on the activity and adjoining areas. The glow of light is more than a compositional necessity, for it sets the stage, so to speak, for an act, however commonplace, which swells with a haunting sense of mystery. It is not the contents being read that matters, but rather the concentration essential to sustain the act. The bowl of fruit or vase of flowers generally associated with Davis' paintings is frequently an effort to enhance the primary subject matter with a similar note of grace.

Gladys Rockmore Davis' approach to painting is similar to that of the creative photographer who sets his pose until he achieves the ideal look, stance, lighting, or whatever it takes to provoke that one fleeting moment that translates into a personality heretofore unknown. Her claim is that the establishment of the pose is the most difficult task, exceeding even the painting process itself. Once the positioning of her subject matter is complete, the painting is then begun and finished within a single time period. Thus, it seems that the character of the brushstrokes will rely greatly upon the temperament of the artist as well as the personality of the sitters.

This diligent search for the appropriate pose that illustrates the psychological and emotional environment for her work ends with such works as *Girl with Fruit* and *Deborah*. Painted in 1937, *Girl with Fruit* was completed after several versions were drawn regarding placement of the girl's hands. The presence of the fruit bowl is a mere convenience, since it is disregarded by the girl. Her glance is aimed at the viewer as a technical and psychological device by the artist. The viewer relates to the surface distance of the canvas and that between the visual glance of the subject and the hand grasping the bowl of fruit as well. The viewer is also, however, called upon to examine the distance between the visual glance of the subject the viewer himself. This distance is illusive since it occurs outside the picture plane and differs with individual observers. Yet, there remains a haunting sense of yearning, a seeking of companionship.

Psychologically, the visual distance in *Deborah,* also painted in 1937, differs from *Girl with Fruit,* because the subject, Deborah, is content with the engagement of the activity. Here the bowl of fruit becomes an integral part of the painting as it overlaps the book, which in turn, is overlapped by the subject's arms. In this case, the bowl of fruit forces the viewer's concentration onto the book's pages to which the subject's eyes are directed. Again, the artist has adjusted the light source to concentrate on the child's face, thus creating a nostalgic sense of need. There is always doubt, or a wonderment. Davis did not resign her subjects to fate. There is always a continuance, a need to reconsider or reevaluate, a spirituality that suits each subject. It is this questioning, augmented by her classical style, that placed Davis among the finest American artists during the era of the Great Depression.

The Letter,[8] one of her finest works, also appeals to the viewer. A beautiful woman reflects upon the contents of a letter. The deliberate placement of the stimuli upon the table and the delicate overlap of letter and envelope have met the precise discipline of composition devised by the artist herself. The precise angle of the envelope nearing the rounded edge

Gladys Rockmore Davis. *Procession of the Penitentes.* **Oil on canvas, 27⅛″ × 36¼″. University Art Collections, Arizona State University, Mr. and Mrs. Lewis Rushkin. 12/31/80.**

of the table quietly urges the viewer's attention to the wistful glance of the subject. Davis' obsession with bowls of fruit as companion pieces for her universal portraits may at first glance appear to be a descriptive force to her diligent arrangement for *The Letter* until one realizes that its counterpart is the similarly shaped bodice of the lovely subject.

The viewer reacts not only to the painting itself, but to the message it brings to the viewer. One is bound to contemplation. One wonders. There is more to a painting than color, brushstrokes and composition so that the visual senses are satisfied. There is the message beyond the physical structure of the painting. The aura of mystery prevails. The contents of the letter re-

main unknown, and it is this illusive quality that positions Gladys Rockmore Davis' portraits into the class of fine art. The composition is classic. The circular area of concentration is the immediate action prevailing between the subject's eyes and the written words of the letter. *The Letter* is an honest, direct statement of a commonplace experience, but one of a personal and sometimes provocative nature.

Also executed in the year 1940 is an astonishingly classic painting titled *Odalisque.* The position of the reposed form differs from succeeding nude paintings, and yet it was a continuation of her search for color. Residence near the home of Monet in France and general travel throughout

Europe became part of that search. And Davis' continued reliance upon the posed form kept her from the exciting journey soon to follow. She continued the study of the works of the Renaissance painters, particularly those of Peter Paul Rubens, El Greco and Titian. Her portrayal of an *Odalisque* was a summation of such influences. This monumental painting reveals "the classic calm of tradition that, reaching back through the centuries, has its source in the monumental reclining nudes of the Renaissance Italians."[9]

Her use of a landscape background to introduce visual perspective presents a concern for the objective world and a visual depth heretofore absent in her other nude portrayals. *Odalisque* becomes a prerequisite to a modern abstract work in a fashion reminiscent of Picasso's early nudes. There exists a buxom nature similar to the fleshy nudes of a Renoir or a Titian. "Key areas are carried through to an exquisite state of glowing life. Edges, which are sometimes lost in delicate equilibriums of tonal values, are at other times stressed to mold form and provide accents."[10]

The back view of a seated female form titled *Nude in Interior* reveals the same sensuous flesh tones as seen in *Odalisque*.[11] Although it sustains a bit of European influence, this painting emerges with an American tone—the upswing hairdo, delicate body features and interior background. Davis has succeeded in promoting a sensuous form into a provocative event, thus creating a dialogue between the painting's subject and the viewer. Therefore Davis has succeeded in establishing a communicative link between the inside of the painting and the outside. Then, the painter has used the painting as an

intermediary to transfer her message from herself to the witness outside the painting. Thus the painter has sent the message via the painting and at the opposite end of the transaction the viewer has received the painting.

Venus, Renee and *Pink Skirt,* three of Davis' several paintings of semi-nudes which reflect the influence of such European masters as Renoir and Rubens, satisfy the visual appetite of the viewer, but lack the dialogue which transpires outside the picture plane.[12] Gladys Rockmore Davis was noted for her love of painting flesh imbued with the glow of life, and would have pleased art critic Thomas Craven with her nude portraits since they indeed were "pleasant enough to put between two sheets."[13]

Although noted for her classical style in which a tight, pre-conceived arrangement of her stimuli dominated her work, such expressionistic paintings as *The Kiss* projected an emotional force which superseded her earlier classical works. Thus, it is no wonder that her paintings of Paris after World War II that were commissioned by *Life* held a special esteem for the art world.

Life in Paris during the aftermath of World War II was extremely difficult. In a series of paintings by Davis, the suffering, frustration and misery were registered on canvas.[14] *Montmartre* depicted a people in despair. Depression and starvation seemed inevitable. Davis pictured a French woman caressing her starving child as other women sold their wares from a pushcart. Faces are expressionless. Bodies stand in motionless postures because of despair, the cold, damp weather, starvation or sickness. Different from her meticulous

Gladys Rockmore Davis. *Christmas.* **Oil on canvas, 29½″ × 39¼″. The McBride Galleries, New Orleans.**

arrangement of stimuli for her classical portraits and still lifes, the Paris paintings are direct recordings from the scene. Davis had to merely observe and record, but in recording, her emotional reactions were restrained in order to fully honor the profound nature of the scene.

Despair is further propagated in the painting titled *Execution Wall,* where patriots were shot by Nazis. It revealed a widow placing a wreath under a plaque bearing her dead husband's name. The woman, dressed in black, is a stark contrast to the colorful flowers lining the base of the wall. The pathos is heightened by the presence of the unhappy child clutching the mother's neck. This is an intimate

scene that Davis has treated with respect and devotion.

Particularly noteworthy is the compassionate display of the child's plight which diverts the viewer's attention from the anguished mother's mission of prayer. A similar event occurred in *Montmartre* as the mother and child approach the viewer in the forefront of the painting.

There is a loneliness within the hearts of the characters in *The Street of the Fishing Cat,* a painting which represents the narrow alley leading to the left bank of the Seine River. Each of the six figures lining the street exhibits its own peculiar needs, and although discreetly hidden, frustration, confusion and misery are reflected

in their postures. Compositionally Davis has positioned each role player to present a unique message. The female figure to the far left is facing left in order to avoid an obvious turning-in to the composition. This slight alteration expands the scene to embrace several eventful possibilities. It also releases any confinement the scene may suggest other than the personal.

The economic atmosphere of Paris had dampened the spiritual and intellectual climate as witnessed in the painting *Bookstalls.* The normal overflow had dwindled to a few customers, including G.I.'s. Facial gestures identify the mood. It is not a joyous occasion. The ponderous trees divide the painting in an effort to decrease the rate at which one completes a viewing of it. Following the visual glances and head positions of the figures, one soon realizes the artist's compositional intent. Davis had carefully arranged the directional movements of each role player so that the viewer experiences a reaction from each. The figures are conveniently confined to a horizontal rectangular shape sandwiched between similar planes representing the sky and street.

The painting *Flower Stalls* reveals the ever popular stalls which Parisians frequent in spite of economically hard times. Davis had arranged a dialogue between the buyer and seller, but perhaps more significant is the mood created by the lone bystander. The background which exhibits the Arc de Triomphe is filled with cyclists partly because of gas rationing. Parisians await the day of the armistice, the official end of the war. The usual architectural structures confirm the freedom which is psychologically contained.

In *Joan of Arc Statue,* the artist had utilized an arch to contain a triumphant scene symbolized by hats and flags, and yet, facial expressions relate the true emotions of weariness, frustration and uncertainty. Davis' characters are not engaged in conversation. Each responds only to inner promptings. Each contemplates the future. The newly gilded statue of France's glorious heroine is a lone reminder of the joyful days before the German invasion.

Gladys Rockmore Davis became captivated by children. The simple pleasure of riding one's favorite animal is heightened by the colorful apparatus of the *Merry-Go-Round,* the focal point of the painting, of that title, and in spite of its presence, the same gloom enveloped the Parisian populace. The vendor and his pushcart, the window shoppers, the cyclists, the widow and her child and other fatherless children play the game of life. It is a pathetic picture, but it is real. The usual gaiety of Paris had waned considerably but is bolstered slightly by the children at play. The artist leads the viewer directly to the merry-go-round, first by its central location and secondly by the figures positioned in adjoining areas. Even though *Merry-Go-Round* is objectively composed, intimate renderings still prevail. One is emotionally aroused by the presence of the forlorn widow and child awaiting their turn for a joyride.

Because Davis was free to experiment with several preliminary sketches and compositions, her paintings of recently German-occupied Paris were more expressive than her posed portraits or still-life set-ups. The need to adhere to the details of a diligently arranged posed portrait is understand-

able, and to veer from the disciplined nature of the project would have been folly. Perhaps that is why, in spite of dreary circumstances, *Luxembourg Garden* reflects a bittersweet approach. The children seem naturally curious and optimistic compared to the anxious and futile outlook of the parents. *Luxembourg Garden* is a complex design established by nature rather than the artist. Visual glances of the participants coincide with those of the viewer in establishing a unique composition. It deals with lateral as well as recessive communication. The advancing and receding figures create a visual depth seldom encountered in her accommodating portraits and nudes.

Swinging to adult entertainment, Gladys Rockmore Davis portrayed the intimacy of the Chez Suzy, a nightclub near Montmartre where patrons kept warm from the body heat of the crowd, if of course, they could afford the price of a cognac. The artist has featured Suzy, the proprietor, chief entertainer and possessor of a reputation for having been a considerable "femme fatale" during the German occupation. The garish coloring of the painting is offset only by splashes of flesh of the sensuous entertainer.

The final painting of the Paris series brought the artist to the steep steps leading to the narrow alleys in Montmartre. Again, the fatherless child and widow supersede other elements. An extensive outdoor stairway anchors the fears and anxieties of an uncertain people. The viewer is not allowed to exit, for Davis had positioned figures with dramatic gestures in appropriate locations on the staircase.

The magic of Gladys Rockmore

Davis is witnessed in her painting titled *The Nativity*.[15] The Star of Bethlehem shines from on high onto the three Wise Men who are seen journeying to the stable in Bethlehem to honor and adore the Christ child. A gigantic mountain acting as a backdrop to the humble abode of the new birth simultaneously contrasts to the brilliant glow of the angel summoning the Wise Men.

The opportunity to envision a composition with limited characterization has freed the artist, in *The Nativity,* from her usual classical style and therefore allowed a creation of imaginative and spiritual innocence.

The French influence (Degas and Renoir) is seen in such portraits as *Old Lady with Bonnet*. The artist's new adventure into color is also evident. There is happiness in the subject's face; eyes glisten with hope and contentment and a smile befitting that of a satisfying life graces her countenance. But it is the delicate intricacy within a simplistic theme that greets the viewer. It was a breakthrough into a subjective experience which followed that raised her rigid classical style to a provocative, heart rending, soul-searching experience.

Although her pastel drawings of the forties have been discussed earlier in this chapter, there is need to review other significant works which contributed to her change of style. Even the simplest of flower arrangements glow with strokes of life as nuances of color smother the surface in *Pink Roses*. This direct frontal statement strays from the diligently prearranged still-lifes and breathes life into each rose. Even the fallen petals upon the table surface glow with shimmering life.

Gladys Rockmore Davis. *Pink Roses.* **Pastel, 25″ × 18″. The Butler Institute of American Art, Youngstown, Ohio.**

The pastel technique is equally effective in a charming portrait known as *Debbie with a Hat*. Strokes of color texturally applied to the young girl's blouse contrast with the smoothly applied flesh tones of the arms and face. The summer hat hinged with a pink flower surrounds the provocative facial expression of the young lass. The background remains subdued and

subordinate to its subject. Davis has sustained the character of the gesture style in order to retain a sense of incompleteness, an uncertainty, an anticipation of life to follow.

Advancing the pastel technique to a fuller figure form and a background environment is a move seen in *Deborah Reading.* A wider range of techniques is evident as adjacent contrasting forms necessitate choices. Smooth flesh tones underlying a soft, fluffy dress is set against a variety of environmental textures. Several geometric shapes interplay as horizontal, vertical and diagonal lines occupy the background. In spite of the central positioning of the subject, the viewer is compelled to associate each item with others placed throughout the painting.

Of lesser objective concern is the pastel drawing titled *Tea Time,* in which two lovely ladies are engaged in intimate conversation. The background is negated because of the largeness of the two female forms. Having destroyed the visual distance ordinarily associated with two figures positioned opposite each other, Davis has ignored the objectivity of visual recession by enlarging the figure positioned furthest back in the picture plane. Foremost, however, is the mystery created by the secrets hidden within the quiet dialogue.

Other pastel drawings include such titles as *Noel, Yellow Roses, Fish and Shrimp* and *Farm House.* Davis' *Yellow Roses* compares equally with *Pink Roses,* while *Fish and Shrimp* presents an unusual theme in an intriguing and colorful manner. The horizontal drawing depicts two fish seemingly "swimming upstream" as the paper in which the fish were wrapped serves as the environment.

The pastel technique has allowed for a free flowing expression in which color, texture and line blend into single movements.

This freedom in space is even more obvious in *Farm House* which records horizontal strokes of color in a staccato fashion due to the interruption of the vertical window panels of the farm house. A reversal of strokes has also occurred in the make-up of upright trees which appear both in front and behind the farm house.

The limitation of the horizontal movement caused by the vertical definitions of the rectangular shape of the farm house created a difficulty in rendering a continuity. It is a hampering device which arrests the natural flow of the pastel technique. The technique considered for *Farm House* differs from that used in *Pink Roses,* for example, since the latter subject matter seems unending; that is, deletions or additions can be readily experienced.

In *Farm House,* the adjoining trees are more conducive to pastel color blending and consequently appear more natural than the house itself. Ducking the house between the two trees adds to the pastel rendering. The farm house theme is a rarity in Davis' productivity which consisted mainly of portraits, figures and still lifes.

The Story, painted in 1943 by Gladys Rockmore Davis, is one of several such themes. The dual portrait was carefully conceived and arranged. A V-shaped triangular composition dominates the action as a dynamic, yet contemplative shape is formed by the visual process of the two subjects reading from a single stimulus, even though *The Story* is basically a series

of circular compositions. Adhering to the classical charm of her paintings, *The Story* is enhanced with subordinate features such as the textural table laden with fruit and flowers and the unusually designed carpet tucked under the bare feet of the young child. However, it is the quiet and serene communication between the two subjects that monopolizes the canvas.

Although Gladys Rockmore Davis is noted for her classical portraits such as *Deborah* and *Nietzsche,* her artistic talents are fully realized more in such works as *The Kiss* and other more intuitive works including the 1945 *Paris* series. Her classical works are poetic due partly to her love of her subjects and partly to the disciplined and detailed arrangement of her stimuli. Deborah, her subject, affectionately named, Sissy, and her companion, Nietzsche, share the spotlight. The slight overlap of these two subjects is enough to form a single unit, and coupled with a mute background suggest a subjective reaction to the posed situation.

The emotional impact of her painting *Man's Inhumanity to Man* is eerie. In fact, it is downright scary. Unaware of the motivation, one can only assume the artist's motive. The style rather closely relates to that applied to the *Paris of 1945* theme. The roughly textured pigment coincides with the terror witnessed in the child's eyes. The Nazi invasion of Europe was terrifying and the painting *Man's Inhumanity to Man* could well be symbolic of Nazi executions.

Davis has focused on the child's bewildered face and active hands, which serve a destructive event. This expressive moment of terror illustrates Davis' versatility, but more significantly, captures a fleeting dramatic moment while sustaining the full capacity of fear and terror.

This expressive technique is duplicated in her painting titled *Blue Bonnet,* a capsule account of an awesome experience. The same sweeping swatches of paint cover the canvas as are seen in her fabulous painting *The Kiss* and her ballet series. This quickly executed painting is rare within an artist's agenda because of the unusual blend of emotion and intellect, the mental decision to let loose a sustained agony or emotional hype. Because of its simplicity of composition, *Blue Bonnet* is a highly concentrated effort on a single notion, thus a limited thrust of brushstrokes cover an area subjected to a single stimulus. The blue bonnet attached to a small child is a simple concept created with an emotional approach. The canvas is completely consumed by a single notion, thus eliminating extraneous interruptions.

In contrast to *Blue Bonnet* is Davis' painting titled *Carousel.* The conglomeration of figures riding the carousel propels this painting into the objective realm. The viewer is compelled to assume the role of reviewing several role players. Subjectively positioned, however, are the rather large, playful girls and their French poodle, who by themselves would assume subjective roles. And *Carousel* was delicately rendered with details articulately executed. The intricately designed decoration of the carousel, the lacy blouses of the two girls and the furry texture of the French poodle remind one of Davis' earlier classical approach.

And along similar lines is her heartwarming portrait of *Old Woman*

Sewing. The artist has projected the role of the elderly, the worn, but determined hands of the aged contrasted to the intricate design already executed in the image of the sewn material. Again, Davis relied upon a single activity to portray a universal theme. The background is muted, thus sustaining the intimate and personal reaction.

The Mandolin Lesson captures a nostalgic moment. Two attractive women combined to form a single activity. This technique has appeared in several of Davis' works such as *The Story, The Music Lesson* and *Two Girls.* The bowl of fruit which sits precariously at the edge of the canvas seems to add little to the full composition.

Dummy Backstage, a segment of the ballet series originally prompted by the *Life* commission, translates into a blend of the real and the unreal by virtue of her two favorite stimuli—the ballet and the still life.

The year 1948 saw the advent of several of Davis' strongest canvases. Accompanying such great works as *The Kiss, Man's Inhumanity to Man* and *Blue Bonnet* are her emotional paintings of *Baptism, The Hair Ribbon* and *Happy Birthday.*

Executed in a similar style to *The Kiss,* her painting *Baptism* extended the mother and child theme. Davis again diminished background areas so that the full force of the event confronts the viewer. *Baptism* was not pre-arranged, but adjusted on canvas to parallel the emotional tone of the experience itself. Davis avoided the conclusive act of submersion. Rather, the artist pictured the process of the act so that the viewer is treated to the anticipation of it. This has allowed a full view of the child before

submersion (or perhaps immediately following it).

Davis deliberately avoided personal identities with her subjects, thus creating a universal concept which transcended cultural, economic and religious classifications. The intuitive process blended with an objective concept in which the artist called for recognizable images in conjunction with instinctive responses to an emotional charged event.

In a more light-hearted vein, *The Hair Ribbon,* which also focused on the mother and child image, refused identification. The faces of both figures are partially hidden. Davis had combined detailed realism with suggestive expressionism, and had exploited the theory of tactual experience—the deliberate focus on the act of doing. While bodily features were subordinated to the whole, the emphasis was placed upon the mother's hands and the hair ribbon.

Davis felt a definite need for emotionalizing because these paintings record acts of doing, and such emotionalism relies upon instinctive responses to events.

Adding to her list of 1948 accomplishments is a painting titled *Happy Birthday,* a charming depiction of a young boy in party hat and bib engaged in the simple act of whistle blowing. Davis has intensified the space between the child's mouth (the act), and the end of the whistle swirl (result of the act), and has utilized the full canvas to do so. This extension of the activity into an open space, particularly to the edge of the canvas, enabled a fuller view and study of a child at play. It also draws attention away from the subject momentarily to permit a stronger and more appreciative

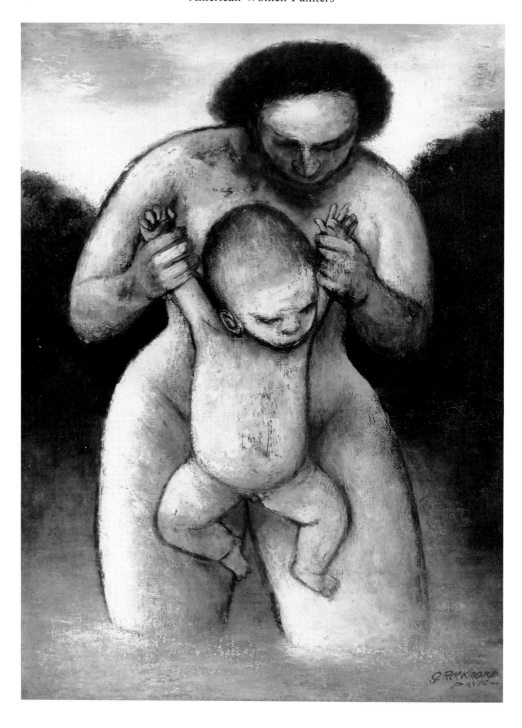

Gladys Rockmore Davis. *Baptism.* **Oil on canvas, 28½″ × 38″, 1948. Courtesy of the McBride Galleries, New Orleans.**

approach. In other words, the extension of the whistle gadget to the appropriate degree determines the degree of emotionalism attributed to the subject matter. Had Davis recorded the swirl closer to the subject, the confusion resulting from the combination of the two would have deemotionalized the portrayal of the painting's subject. And extending the swirl (end of the act) beyond the appropriate location would have caused two separate subjects demanding equal attention, which in turn, would have weakened the painting considerably.

The *Life* commission of the *Paris of 1945* paintings strongly influenced Davis' concern for children. The thousands of fatherless children influenced the imaginative powers of the artist and subsequent paintings of children revealed "affirmations of faith in the joy that still remains on this troubled planet." *First Love,* a single painting of an exhibition called *Children's Moods* is a vision rather than an observation. Further remarks by Judith Kaye Reed regarding Davis' paintings of children relate that the subjects

> are partly dream children, not because the artist has retreated into a self-centered world of imagination but because she had idealized the beauty and tenderness she felt. And if at times her characterizations change from the exquisite expression of *First Love* to more sweet representation, there is always the element of rewarding paint passages.[16]

Back in 1943 several of Davis' widely publicized paintings were brought together in a showing at the Midtown Galleries of New York. Included was her appealing work titled *End of Summer* which reflected a nostalgic retreat for two youngsters from a bustling summer schedule.[17] One of Davis' favorite pastimes, reading, dictates the emotional tone. Both figurative images seem lost to the written word while the artist's popular fruit bowl graces the foreground. The artist's diligent arrangement creates a oneness in spite of singular images which suffice as important singular compositions. The artist has again used her own children as subjects for *End of Summer.*

Similar to such works as *August Afternoon, Woman with Flowers* and *The Letter* is the painting *Morning Papers.* Although prearranged in meticulous fashion, *Morning Papers* exemplifies a casual, daily experience typical of the pre–1945 style. Served with a light breakfast, a timely reading of the latest news makes for a traditional event on the Davis agenda. The viewer's attention sways between the action and the cause of the action; that is, the distance existing between the subject's eyes and the written word becomes the activated space as surrounding stimuli act in a supplementary manner.

The partially hidden table guides the composition into perfect order. The visual aspects of the registered parallelogram coincide with the images of the outstretched arms and the slumped spinal cord, thus creating a perfect union of subject and its environment. One is reminded of Isabel Bishop's works as one studies *Morning Papers,* even though Bishop's subjects were recorded from actual events.

Notes

1. All of the aforementioned paintings were commissioned by *Life* and appeared in that magazine in 1944.

2. This plea for art standards appeared as an editorial in the 1953 issue of *American Artist*.

3. The quote describing the painting *The Kiss* appeared in a 1950 issue of *American Artist*.

4. *Ibid.*

5. A reproduction of the pastel by Davis appeared in the February, 1942, issue of *American Artist*.

6. The painting *August Afternoon* was painted in 1936 and purchased by the Metropolitan Museum of Art in 1937.

7. The painting *Two Girls* was painted in 1937 and measures 20″ × 30″.

8. A reproduction of the painting *The Letter* appeared in the January, 1940, issue of the *Magazine of Art*.

9. The painting *Odalisque* was done in 1940. The quotation refers to the words written by Margaret Breuning in the October 16, 1940, issue of *Art Digest*.

10. *Ibid.*

11. The painting *Nude in Interior* is owned by the Swope Art Gallery.

12. *Renee,* one of several paintings of nudes by Davis, was painted in 1937 and measured 30″ × 40″; *Venus* measures 25″ × 40″ and appeared in the Whitney's Museum of American Art's Annual.

13. "Pleasant enough to put between two sheets" was a reference made by critic Thomas Craven to Amedeo Modigliani in his book *Modern Art*.

14. This series of paintings by Gladys Rockmore Davis appeared on pages 46–49, 54 and 55 of *Life,* July 15, 1945. The title of the article was "*Life's* Artists Show How the Freed City Has Fared." The text was reported by Charles Christian Wertenbaker, chief of *Time* and *Life's* European staff.

15. The painting *The Nativity* appeared reproduced in color in a series of Christmas card designs for *Life*. Other artists included in the series were Doris Lee, Doris Rosenthal and Lauren Ford.

16. The reproduction of *First Love* appeared in the November 1, 1946, issue of *American Artist,* and the painting appeared at the Midtown Galleries in New York.

17. A reproduction of *End of Summer* appears on the cover of the May 3, 1943, issue of *Art Digest*.

Bibliography

"Babcock Gallery of Recent Figure Paintings." *Arts.* November, 1957.

"Ballet and Backstage at the Midtown Galleries." Review. *Art Digest.* April 1, 1944.

Baur, John. *New Art in America.* New York Graphic Society. New York: Frederick Praeger, 1957.

Boswell, Peyton. *Modern American Painting.* New York: Dodd, Mead, 1940.

Bovio, M. "Gladys Rockmore Davis." *London Studio.* November, 1942.

"Brilliant Pastels." *Pictures.* November, 1941.

"The Charms of Childhood." Exhibition Review. *Art Digest.* November 1, 1946.

"Cleveland Picks *Noel* with Violin." *Art Digest.* May 1, 1945.

"Continues Progress." Review. Exhibit at Midtown. *Art Digest.* May 1, 1943.

"Deborah Goes to Terre Haute." *Art Digest.* December 1, 1942.

"Discussion of the Painting, *The Kiss.*" *American Artist.* September, 1951.

Editorial, "Plea for Standards." *American Artist.* December, 1953.

Eliot, Alexander. *300 Years of American Painting.* Time Books. New York: Random House, 1957.

"Exhibition at Midtown." Review. *Art News.* April 1, 1944.

"Exhibition of *Haitian Dances* Paintings." *Arts.* December, 1956.

"Exhibition of Paintings of Balinese Dances." *Art News.* December, 1956.

Exhibition of Spanish Scenes. *Art Digest.* April 15, 1953.

"Figures in Luminous Paint." *Art News.* October 26, 1940.

"Gladys Rockmore Davis." *Magazine of Art.* January, 1940.

"Gladys Rockmore Davis." *Studio.* November, 1942.

"Gladys Rockmore Davis: Discusses a Recent Canvas." *American Artist.* 1950.

"Gladys Rockmore Davis: Her Adventure in Pastel." *American Artist.* February, 1941.

"Gladys Rockmore Davis: Her Adventure in Pastel." *American Artist.* February, 1942.

"Gladys Rockmore Davis: Pastels." Catalogue. New York: Midtown Galleries, November, 1941.

"Gladys Rockmore Davis Hits High Note." *Art Digest.* October 15, 1940.

"Gladys Rockmore Davis Reviews." *Art Digest.* May 3, 1943; October 15, 1948; October 15, 1940; August 1, 1941; October 15, 1948.

Gruskin, Alan. *Painting in the U.S.A.* New York: Doubleday, 1946.

High Museum of Art Exhibition Review. *Art Digest.* April 15, 1949.

"Life's Artists Show How the Freed City Has Fared," written by Charles Christian Wertenbaker. *Life.* July 15, 1945, pp. 46–49, 54 and 55.

Midtown Gallery Exhibition. *Art Digest.* November 1, 1949.

————. *Art News.* November, 1949.

————. Review. *Art News.* October, 1946.

————. Review. *Art News.* April, 1953.

———— by B. Holme. *Studio.* September, 1944.

"My Desire to Paint." *Magazine of Art.* January, 1940.

"Paintings of Liberated Paris Exhibition." *Minneapolis Institute Bulletin.* February 9–16, 1946.

"Paintings of Post War Paris Exhibition at *Time* & *Life* Bldg." *Art News.* August, 1945, and *Art Digest.* August, 1945.

"Passionate Colorist." *Art News.* May 1, 1943.

"Pastel Painting." *Art Digest.* February 1, 1944.

"Pastel Painting." Review. *Art News.* February 15, 1945.

"Pastels: Gladys Rockmore Davis." Catalogue. New York: Babcock Galleries, October 13–November 1, 1958.

"Plaster Splendor." *Art Digest.* November 1, 1940.

"Portrait." *Art Digest.* December 1, 1941, and *American Artist.* February, 1942.

"Prize Winner in Pepsi-Cola Competition." *Art Digest.* September, 1945.

Reproduction of *After Christmas. London Studio.* December, 1943.

Reproduction of *August Afternoon. Art Digest.* April 1, 1940, and *Parnassus.* May, 1940.

Reproduction of *Baby. House Beautiful.* January, 1957.

Reproduction of *Baptism. Art Digest.* October 15, 1948.

Reproduction of *Carousel. Art Digest.* July, 1946.

Reproduction of *Child with Doll. Art Digest.* January 1, 1948.

Reproduction of *Debbie with Hat. Art News.* November 1, 1941.

Reproduction of *Deborah. Art Digest.* June, 1941.

Reproduction of *Deborah. Art Digest.* April 1, 1942, and *Art News.* March 15, 1942.

Reproduction of *Dressing. Artist.* September, 1957.

Reproduction of *Dummy Backstage. St. Louis Museum Bulletin.* February, 1946.

Reproduction of *Emma. Art Digest.* April 1, 1945.

Reproduction of *End of Summer. Toledo Museum Bulletin.* December, 1943.

Reproduction of *Girl Braiding Her Hair. American Artist.* June, 1947.

Reproduction of *Happy Birthday. Art Digest.* September, 1949.

Reproduction of *In the Wings, Ballet Aleko. Art News.* February 15, 1945, and *St. Louis Museum Bulletin,* February, 1945.

Reproduction of *Letter. Art Digest.* March 1, 1945.

Reproduction of *Morning Papers. Art Digest.* April 1, 1939, and *Magazine of Art.* May, 1939.

Reproduction of *Music Lesson. Art Digest.* January 1, 1951.

Reproduction of *Noel. Art News.* May 1, 1942, and *Magazine of Art.* May, 1942.

Reproduction of *Old Woman with Bonnet. Art Digest.* November 15, 1945.

Reproduction of *Old Woman with Bonnet. Design.* May, 1949.

Reproduction of *Pastorale. Design.* February, 1948.

Reproduction of *Petrouchka. Art News.* August, 1945.

Reproduction of *Pink Skirt. Magazine of Art.* November, 1938.

Reproduction of *Pink Tights. Art Digest.* October 1, 1946.

Reproduction of *Portrait of a Child. Art News.* November, 1947.

Reproduction of *Portrait of a Woman. House Beautiful.* January, 1957.

Reproduction of *Reclining Figure. Art Digest.* November, 1938.

Reproduction of *Still Life. London Studio.* April, 1942.

Reproduction of *Story. London Studio.* December, 1940.

Reproduction of *Venus. Art Digest.* January 15, 1940.

Reproduction of *White Petticoat. Studio.* September, 1955.

Edna Reindel

Born in Detroit, Michigan, in the year 1900, Edna Reindel has been recognized for her flower and still-life studies, and has gained further fame for her New England scenes. After graduation from Pratt Institute and a career of five years as a book illustrator, Reindel began painting seriously as a lifetime profession. Although critics have labeled her an "intellectual poet" because of the abstract nature of her work, her still-life paintings verge on surrealism. Her interest in the profound nature of things has led Reindel to produce paintings that transcend reality. The ultra-real becomes the unreal. Furthermore, her still-life paintings take on ideologies which explain the label of intellectual "poetry." Instead of words, Reindel used color and shape and line.

Hidden meaning, personal fantasies and the recollection of childhood memories invade Reindel's still-life paintings. *Souvenir,* executed in 1942, thrives on richly colored objects of meticulously textured detail. One is further fascinated by the numerous symbolic notions. The red glow of the lit cigarette held by a lifeless glove, the key nestled in the companion glove which relaxes on a delicately textured table, the red card

slipped into the lavender-blue envelope — all call for explanations.[1]

However, trickier puzzles prevail. For example, the pair of hands seemingly severed at the wrists, the mysterious sheet of paper caressing the lively glove and the pair of shapely legs which protrude from an opened envelope — all add to the excitement. Each mysterious symbol is carefully positioned, allowing the viewer to absorb the bits of delicate colors and exquisite overlap.

New England Theme holds the same fascination. More of an echoing of the past than an extension into the unknown, these remnants of Martha's Vineyard nevertheless verge on the surreal. The painting incorporates such reminiscent elements as a doorway, sea and sail, a bit of weathered wood, Victorian interior and sea shells. These recollections of past experiences fade and emerge in dynamic fashion.

Segments of the painting erupt as if new life were about to occur. The background is composed of bits and pieces, parts of objects seem to disappear and then emerge elsewhere on the picture plane. This broken imagery reflects the infinite aspect of space and depth

Edna Reindel. *Republicans Are Not Always Ungrateful,* **1936. Oil on canvas. Courtesy of the Estate of Edna Reindel.**

generally evident in surrealistic works.[2]

 Regarding political ideology, her painting titled *Republicans Are Not Always Ungrateful* sustains the ab-

stract/surrealistic combination as well as forwarding a political statement. The title was taken from the inscription on the pitcher which was found in an antique shop. The design on the

pitcher is the emblem of the 13 colonial states. The trumpeting angel is from the certificate of membership of the Society of the Cincinnati, a veteran organization of officers of the American Revolution. The colonial mirror and the weather vane were purchased from the Metropolitan Museum of Art.

A bow shaped like an arrow hugs the left of the canvas while the American eagle roosts above the colonial mirror. Even though the trumpeting angel is a replica of a political document, its presence reflects a surreal exhibit. Its removal would merely result in a realistic still-life painting. Again, Reindel's overlap is prudently applied.

Not as meticulously rendered as *Souvenir* or *New England Theme* is *Magnolias by the Sea*,[3] which introduces a looser technique. However, Reindel continued to adhere to the somewhat surrealistic concept. The entire forefront of the painting illustrates the school of realism, while the background is structured in an abstract fashion which again suggests surrealism. The tall rectangular shapes which seem more a compositional device than a conceptual intent lend themselves to a surreal scheme. Fiery shaped clouds advance and recede amid the giant pillars, thus furthering and deepening the notion of surrealism. These spiral clouds also further the notion of infinity.

A different Edna Reindel is seen in the works of the *Women at War* series commissioned by *Life* during the summer of 1943. She avoided the surreal technique in favor of realistic recordings. Furthermore, instead of treating the viewer to a full scale use of the canvas, Reindel preferred to focus on a single activity. Detailed

authenticity became essential, though it lessened her freedom of expression. The recording of the event superseded individual freedom because there was a client involved. Reindel worked with a single figure as the focal point, while subordinating other figures to secondary roles. Such paintings as *Lockheed Welder, Riveter* and *High Speed Router* focus on the role players in the act. In *Lockheed Welder,* the single activity of welding an intake duct for a P-38 involves the doer and the object of the doer. Environmental apparatus coincides with the task at hand. Similar descriptions relate to *Riveter* and *High Speed Router.* In spite of authentic recording of details, a surreal atmosphere prevails in such works as *Electrician, Drilling Holes* and *Shipyard Welders.*

In *Electrician,* Reindel introduced an environmental landscape resembling an inside/outside picture as the female form makes a final check-up on the tail of a PV-1 Ventura bomber.

Drilling Holes (see page 200) represents a straitjacket of life, a routine relying upon the need more than the desire. Each of the four occupants seem destined to go nowhere, while crammed into limited spaces over long periods of time. Even though recording daily events in such a fashion reflects the reality of the monotonous chore, Reindel nevertheless arranged an authentic composition without the loss of a surreal image. The protective face masks used throughout the series further suggest the surreal atmosphere of the otherwise realistic portrayals of daily events.

Even though Reindel satisfied *Life*'s commissioners, she still was able to adhere to symbolic images, with the painting of helmets, blow torches and beach umbrellas which created an eerie

Edna Reindel. *Recollections of an Apple,* **1945. Oil on canvas. Courtesy of the Estate of Edna Reindel.**

atmosphere. It is likely that Reindel was innocent of surreal expressions in this series of paintings, but it is also likely that artists sustain veins of the unreal in the subconscious which frequently emerge as normal realities.

In Plate Shop reveals a woman welding beams that support a link table for moving long slabs of steel. The supervisor to the right holds his gloved hand between his face and the dazzling flame to protect his eyes. The protective covering (helmet, eyeglasses, gloves) creates an eerie dialogue between two humans. Reindel's close-up views relay a subjective experience between artist and viewer.

In *On Assembly Line,* the nose of the unfinished plane becomes the focal point while four human figures offer supporting roles. Even the plane's nose reflects a robot-like appearance. So, in spite of a commercial assignment, the artist is perhaps obligated to personal integrity while serving the purpose of the commission. The series titled *Women at War* served both obligations, and Edna Reindel continued to arouse the viewer toward a deeper and more secure understanding of the visual arts.[4]

Critics have compared Reindel's paintings of Martha's Vineyard with those of the detailed, rustic depictions of Luigi Lucioni. Indeed, a similarity exists, but also a difference in the stillness and quietude that settles over their scenes. Reindel manages an emotional serenity, as in *Storm Over Menemsha,* which translates into a contemplative experience. There reigns a spiritual sense of infinity, an emotional obligation to a life beyond oneself. *Storm Over Menemsha* makes the viewer a part of the painting and

provides a sense of belonging to an ever-present mystery of life and death.

The gathering clouds set the stage for an approaching storm, and Reindel recorded the anticipation of the event. Not only did she set down the scene with factual accuracy, but allowed for a bit of the surreal with the vanishing horizon line. The high, naked sail masts assist in the combination of the foreground and the background while adding to the suspense of the oncoming event.[5]

New England Harbor reflects the same degree of anticipation as *Storm Over Menemsha,* with a stillness that feels eternal. The quiet overlapping of vertical and horizontal structures combined with the empty boats creates an eerie sense of frustration. And yet, Reindel did not forsake the human element. Perched quietly on the dock's edge is a fisherman whose thoughts remain his own.[6]

In *Net Menders,* Reindel increased the human element. Nets sprawled onto the landscape are tended by male menders whose figures are enveloped by the huge nets. There is a prevailing loneliness reflecting the hardships of the seafaring fishermen. A sense of isolation prevails, a sense that the fishermen are hostages to a demanding task. They have become slaves to the stubborn nets. Compositionally, Reindel used the nets as the stimulus for action. The stillness of the figures are offset by the wavering nets caught in the windswept plains.[7]

Woman Dancing to a Harp, a precursor to her more dramatic painting *Praying Mothers,* is a drastic departure from her earlier wartime versions of women at work, which were not only singly identified but which were cemented in space as well. This whirling dervish approach

Edna Reindel. *Drilling Holes* **("Women at War" Series), 1943. Courtesy of the Estate of Edna Reindel.**

removes the stillness and peace which accompanied her still-lifes and boat scenes of yesteryear.

Even though *Praying Mothers,* by the nature of its title, should evoke a quietude, it, however, disperses an excitement, an anxiety, a moving stillness which seems to contradict both approaches. Faces are hidden by prayerful hands, which are enlarged because of the psychological significance of accentuating the positive aspect of the action, thus recalling the tactual experience of a childlike expression. Bodies are wrapped with sweeping brushstrokes while the union of

Edna Reindel. *Praying Mothers,* **1949. Oil on canvas. Courtesy of the Estate of Edna Reindel.**

several figures amplifies the plea for mercy.[8]

The plea of urgency is intensified by the repeated pattern of anguished gestures. A single aspect of nature collaborating with similar aspects form a kind of team. Thus, the viewer shares not the anguish of each praying mother, but the amplification of a whole universe. There has always been a subjectivity about Reindel's work, but it is of a controlled nature, and always quiet and subdued. Her switch to the depiction of gesture suggests a commit-

Edna Reindel. *Angels Weep at Los Alamos.* **Casein and India ink on paper, 32″ × 22½″, 1947. Courtesy of the Estate of Edna Reindel.**

ment to the seriousness of life, a dedication to a calling, to a responsibility, to a conscience.

Figures remain unidentified, thus creating a universality of appeal, as the date of the painting (1949) strongly suggests that the figures represent the widows of World War II victims. The anguish of uncertainty caused by the anticipation of death precludes any hope. In spite of the title, the victims seem hopelessly enmeshed in a tragedy already past. The frenzied brushstrokes, although defining singular figures, overlap so that an abstract nature prevails. Thus, *Praying Mothers* becomes a symbol of despair rather than a recorded event.

The nuances of color which identify the figure, *Linda,* are the same which typify the surreal, ghostlike appearances of her *Women at War* series of the forties. The subjective positioning of Linda, the artist's subject, forces the viewer into serious consideration of the nature of the title figure. The pensive mood of *Linda* also parallels the quietness of the artist's New England landscapes and her somewhat satirical still-lifes.[9]

Reindel's still-life paintings have received acclaim from several critics. Arthur Millier of the *Los Angeles Times* has written:

> Realism, some sage has said, is the bane of art, and when practiced for its own sake this is true. Yet, using the most precisely realistic depiction of objects, a very beautiful art can be made. Edna Reindel does this magnificently. Here, if ever, is a painting which everyone can admire. Everyone, that is, except the artistic snobs who dislike what is popular even when it happens to be good. Miss Reindel goes much further into the nature of each object than would a coarser artist; finds what is its basic shape, its essential texture. It's the sort of realism which would scarcely exist had there been no cubists.[10]

Henry McBride of the *New York Sun* also has written of Reindel's still-life paintings:

> In these works the lover of things as they are may revel to his heart's content, for when it comes to marking the subtle differences of textures in fruit and flowers and what not, Miss Reindel has few lessons to learn from anyone. And with it all, her things, particularly her still life and flower subjects, hold together beautifully as compositions and are satisfying rich in color.[11]

And the interpretations of Margaret Breuning have added to the success of Edna Reindel. Breuning has commented on her still-life paintings as follows:

> Aside from her ususal technical equipment, which has a kinship with the Italian and Flemish primitives, Miss Reindel has shown an interesting inventive side, especially in her still life compositions in which she placed a vase over a red chalk drawing, a dwarf-like image in the catalogue of Toulouse-Lautrec's circus scenes, or a wooden torso resting on broken egg shells. Her *Pierrot,* however, looks more like a serious young American watching a polo match or a catch in the outfield. A strong plastic quality distinguishes the full-checked portrait of Olga. Grapes, flower forms, doves, a reclining cat, masks and various mid–Victorian

Edna Reindel. *Contemplation.* **Oil on canvas, 32″ × 26⅛″, 1937. Metropolitan Museum of Art. Arthur H. Hearn Fund, 1939. (39.44)**

objects are favorite items used by Miss Reindel in decorative compositions. One of her best still lifes is the arrangement of lilies in an early American setting with a floating angel reflected in a mirror. This charming bit of satire is called *Republicans Are Not Always Ungrateful.*[12]

Edna Reindel. *At Night We Dream.* **Oil on canvas, 15″ × 18″, 1942. Courtesy of the Estate of Edna Reindel.**

Edna Reindel first introduced the figure into her work while doing the World War II *Life* series titled *Women at War,* even though the majority of her work focused on the quiet New England landscape and intriguing still-lifes.

Her works of 1949 like *Dancing to a Harp* and *Praying Mothers* may have been experimental pieces, but they altered Reindel's approach considerably. Her new approach featured such figure paintings as *Cafe Girl, Good Earth* and *Victorian Burlesque. Cafe Girl* resembles a snapshot taken from Hopper's restaurant series and pushed forward to avoid the isola-

tionist theory which made Hopper famous. One is reminded of her magical still-lifes with their meticulous renderings and symbolic images. The flaming red rose held by a pair of sensuous fingers, the cocked hat partially blocking an enticing facial expression and the invitational lilting gloved hand reflect a symbolic idiom of the surrealist movement. Reindel's approach to the figure image is also an extension of her still-life composition.

Margaret Breuning has written of her "new" still-life as follows:

Miss Reindel in her flower
pieces proves that this much

Edna Reindel. *Memories.* **Oil on canvas. Courtesy of the Estate of Edna Reindel.**

maligned subject can, with the proper approach, yield strongly designed, vibrantly alive canvases. Her blossoms, many of which are seen almost as close-ups, are bursts of vivid color, deftly controlled. The artist surrounded her blossoms with air, and manipulates light to help unify the composition and to supply variety of texture by giving a translucent glow to some of the petals and by subduing in shadow some of the others.

The painting *Mayan Mask* is such an example.[13]

Notes

1. The painting *Souvenir* is reproduced in an article titled "Edna Reindel," which appeared in the May, 1944, issue of *American Artist*. The painting measures 14″×18″. The magazine's editor had written: "This canvas is a colorful picture, the cherry red slipper with white, lavender and deep red petunias affording the dominant note. A red card is slipped in the lavender-blue envelope and an effective touch is added by the small red glow of the lighted cigarette."

2. The painting *New England Theme* is reproduced in an article titled "Edna Reindel," which appeared in the May, 1944, issue of *American Artist*. The magazine's editor wrote: "This canvas typifies Miss Reindel's practice of assemblage, for her still lifes, objects that have a definite subject association. Painted during one of several summers spent on Martha's Vineyard, it incorporates such reminiscent elements as a doorway, sea and sail, a bit of weathered wood, Victorian interior and sea shells. The bright notes are the red-orange of the lilies and the yellow-green table cloth repeated in the tones of the shells. Blue-greys and off-whites counterbalance the warm tones of the pictures."

3. The painting *Magnolias by the Sea* was painted in 1942 and measures 22″×26″.

4. All of the paintings discussed in the series titled *Women at War* were commissioned by *Life* and were reproduced in a 1943 issue.

5. The painting *Storm Over Menemsha* is owned by the MacBeth Gallery of New York. It is reproduced in the May 10, 1937, issue of *Life*.

6. The painting *New England Harbor* is in a private collection.

7. The painting *Net Menders* is owned by Ball State University of Muncie, Indiana.

8. Reproductions of the two paintings, *Woman Dancing to a Harp* and *Praying Mothers,* appeared in the February 1, 1949, issue of *American Artist*.

9. A reproduction of the painting *Linda* appears in the January 1, 1934, issue of *Art Digest*.

10. The quotation appeared in the February 1, 1949, issue of *Art Digest*.

11. *Ibid.*

12. *Ibid.*

13. The quotation by Margaret Breuning appeared in the February 1, 1949, issue of *Art Digest*. A reproduction of the painting *Mayan Mask* appeared in the same issue. The works *Linda* and *Mayan Mask* appeared in the March showing at the MacBeth Galleries in New York, 1949.

Bibliography

Cover of *American Artist*. October, 1952.
"Edna Reindel." *American Artist*. May, 1944, pp. 10–12.
"Edna Reindel Reviews." *Art Digest*. January 1, 1934; May 15, 1937; May 15, 1938; May 1, 1939; March 5, 1940; March 15, 1940; June, 1944; February 1, 1949.
"Edna Reindel Reviews." *Art News*. May 8, 1937; March 16, 1940; June, 1944; February, 1949.
"Edna Reindel Reviews." *Magazine of Art*. November, 1936; June, 1937.
"Edna Reindel Reviews." *Parnassus*. January, 1934; May, 1940.
"Edna Reindel Reviews." *Studio*. December, 1933.
"Reindel Paints Fishermen." *Life*. May 10, 1937.
Reproduction of *Cafe Girl*. *Art Digest*. February 1, 1949.
Reproduction of *Cafe Girl*. *Parnassus*. May, 1940.
Reproduction of *Contemplation*. *Art Digest*. May 1, 1939.
Reproduction of *Magnolias by the Sea*. *American Artist*. May, 1944.

Reproduction of *Mayan Mask. Art Digest.* March 15, 1940.
Reproduction of *Mayan Mask. Art Digest.* February 1, 1949.
Reproduction of *New England Harbor. Architectural Forum.* December, 1939.
Reproduction of *Praying Mothers. Art Digest.* February 1, 1949.
Reproduction of *Republicans Are Not Always Ungrateful. American Artist.* May, 1944.
Reproduction of *Victorian Burlesque. Art News.* March 16, 1940.
"Still Life & Women in War Factories." Exhibition Review. *Art News.* July, 1944.
"Women at War." *Life.* 1943.

Lauren Ford

Lauren Ford was born in 1891, resided on a Connecticut farm, studied at the Art Students' League and held her first showing at the age of 37. She was a precursor to Doris Lee. Both excelled at panoramic views and both depicted nature in a primitive and charming manner. Both in their expansive vistas executed numerous singular compositions within a single canvas, and both utilized hometown surroundings.

The two differed only in motivation. Lee was stimulated by the commonplace, daily occurrences within the typical urban and rural landscape. Ford's stimuli came from a similar environment but were freighted with a religious fervor, an innocent, childlike zeal which resulted in paintings appealing to both children and adults. Ford would establish a rural community on canvas, then insert the appropriate characters in order to be able to label the painting religious. Lauren Ford did not push religious faith back in time. Rather, she brought Christianity into the 20th century. Christ was not born in Bethlehem, but in the rural countryside of her own childhood.

In the case of *Epiphany in Bethlehem, Connecticut,* a superb panoramic view, bands of Christian admirers flee personal habitats and workplaces to pay homage to the child, Jesus, whom Lauren Ford has sheltered within her own community. The excitement generated by the sheer multitude of adorers makes *Epiphany* a remarkable masterpiece. It has a taste of Peter Brueghel and Hieronymus Bosch in terms of numbers of characters. But there is also a primitive charm, a simplicity and humility that supersedes the panoramic view itself.

The viewer is led on a parade of visits to local establishments—post office, bank, church, Minor's variety store, town hall and several homes—all emptied of patrons who have hurried to the scene and are staring in amazement at the camels and the rich trappings of the caravan.[1]

Star of Bethlehem could well be a single expression pulled from the panoramic composition of *Epiphany.* In *Star of Bethlehem,* Ford represented the birthplace of Christ by painting her own farm in Bethlehem, Connecticut, with an inn sign above the fence to the left. Toward the barn with glowing windows, four shepherds, each with a sheep or two, cross the snowy hillside, led by the blazing

Lauren Ford. *Annunication to the Shepherds.* **Etching, $3\frac{7}{8}'' \times 3\frac{3}{8}''$ (plate), $7'' \times 6\frac{1}{4}''$ (paper). The Dayton Art Institute. Gift of Mr. Frederic Newlin Price. (54.6.23)**

star which glistens brightly in the darkened skies. The glow of the star casts shadows upon the snowy landscape as all movement tends toward the Blessed Child in the barn. The same brilliance of light witnessed in the star has filtered through the windows and door of the barn in which the Savior has been born.[2]

Ford formed an enclosure with the two trees at the edges of the canvas in fulfillment of a psychological need as well as compositional one. The nightfall adds to the prayerful mood, for one painting does cause one to meditate and wonder. Ford has purposely avoided the culture and custom of yesteryear. Instead, Christ is among us, not only in spirit, but in body as well. The artist has celebrated not the original birth as an anniversary event or memorial remembrance, but the annual event. Ford made it appear as if Christ had been born for the first time and not only in Bethlehem, Connecticut, but in every hamlet, town, city and nation throughout the world. And although *Bethlehem* and *Epiphany* were painted during the 1940s, their subject matter remains as fresh today.

The celebration should not be reserved for a single day of each year, but rather should restore the practice of love for all people all days of the year. The masters of the Renaissance diligently researched the artifacts symbolic of the time of the birth. Lauren Ford looked only to the Biblical passage and replaced the centuries past with a single moment within a single place—her farm in Connecticut in the year of 1943.

Using exactly the same scene as in *Star of Bethlehem,* Ford, in *No Room in the Inn,* shows a Connecticut inn at sunset. Unaware of the

coming event, children play and farmers labor as Mary and Joseph head toward the barn. Ford had attached a wooden cross to the side of the barn changing the scene slightly from that in *Star of Bethlehem.* The symbolic cross forewarned Christians that sorrow accompanied the birth of Christ. Compositionally, *No Room in the Inn* sought to utilize the smallest area of sheltered space for human activity. Ford did well in the relationship of diminutive forms and open spaces. She sustained the panoramic view while forwarding personal charm for individual figures in spite of their anonymity.[3]

Before World War II Lauren Ford had spent months each year in France. She shunned the habitual haunts of the French artists and lived instead in remote villages learning the customs and culture of the people. In a series of paintings commissioned by *Life,* she re-created the tales of saints, miracles and visions which are still close to the hearts of the French people. Therefore, the settings or habitats in which Ford's characters are situated are foreign to her native farmland of Connecticut, but nonetheless appropriate for her expressions. In describing this series of paintings, one is compelled to relate the urgency of Ford's message. She had transported the life of Christ and related episodes into a 20th century European environment only during her stay in France and Italy.

Although subtle in its location, the death of Christ is symbolically apparent in the Ford painting titled *The First Communion Dress.* In spite of the untouched beauty of the recipient and the purpose for which the white dress was donned, the symbolic cross is there to remind one that

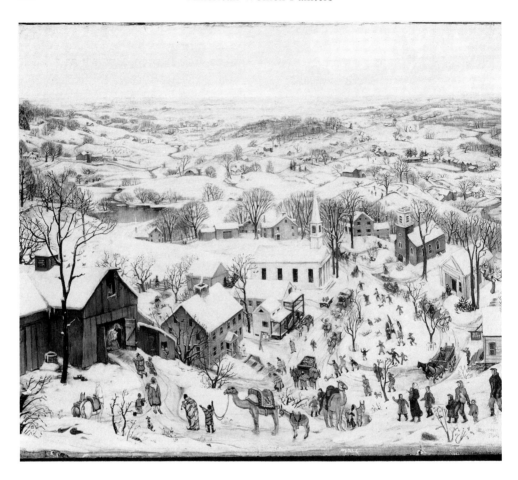

Lauren Ford. *Bethlehem.* **Oil on masonite, 20″ × 24½″, 1942. Collection of the Indianapolis Museum of Art. Delavan Smith Fund. Photograph by Robert Wallace. (43.41)**

death is inevitable and that sorrow and tragedy are segments of life. The delicate cross surrounds the neck of the first communicant, and is perhaps less obvious as a design in the decorative paper adorning the background wall. The relationship of the two symbols is obvious—the crucifix and the first communion dress. Catherine, the nervous young girl, will receive for the first time in her heart the precious body and blood of her Savior which was offered to the world at the Lord's Last Supper.

Although Ford had presented this family closely to the viewer, one is forced to share this precious moment with Catherine's godmother and her brother and sister. (Catherine was ordained a saint as Catherine Laboure in the year 1933.) Ford's characters seldom appeared happy, as if a journey had been prescribed for them. There is a resignation to life, to a life of acceptance and discipline.

In *The First Communion Dress,* Ford had presented a dual composition, one portraying Catherine and her godmother, and the other depicting Catherine's brother and sister. The two compositions are united by the ornate window frame in the

background. The delicate environment is offset by the purity of the communion dress which in later years became a symbol of sainthood for Catherine Laboure.

The Celestial Mother becomes a vivid gesture by the Blessed Catherine Laboure who was the bearer of *The First Communion Dress.* The scene pictures the motherless child standing upon a wicker chair and, while holding the statue of the Virgin Mary, the Mother of God, asking that she become her adopted mother. The painting has the French environment, a van Gogh interior, a simple corner of a room which appropriately suits the role of the subject. The young girl looks fervently at the image of the Blessed Mother and the child, Jesus. In fact, Catherine Laboure is seeking a position as a family member which in essence is the purpose of all devout Christians.

Ford has positioned her subject left of center and created an anxious distance between the subject's face and that of the Blessed Mother. The gigantic fireplace and china cabinet serve as a vertical, compositional balance to the upright chair and figure of Catherine. Again, Lauren Ford's simplicity and charm emerge and her message remains personal, and unless the viewer is aware of the story behind the scene, the message may lack universal acceptance.

The painting titled *Vision of La Salette* presents a more obvious message than *The Celestial Mother.* The painting pictures a young girl and boy and their pet dog witnessing a glowing vision of the Virgin Mother. The vision wears a startling white gown sewn with pearls that looked like tears. A crucifix is conspicuous near her neckline. The French chil-

dren, dressed in peasant clothing, stare in wonderment at the bewitching image. The French Alps act as a backdrop for this miraculous vision.

St. Germaine depicts the saint as a child of a poor farm laborer of southern France. The artist has shown her as a shepherdess who was accused by neighbors of stealing food for a starving stranger. Forced to reveal the "stolen food" hidden in her apron, the child miraculously revealed fresh roses even though it was late autumn and out of season. The child, who was canonized after her death in 1601, occupies center stage surrounded by her flock of sheep. She is attired in a simple country dress with apron and a full head bonnet and wooden shoes. Behind her spreads a panoramic vista of rural excitement—girl and dog frolicking in the meadow, horse and carriage strutting down the lane, cows in the meadows and birds flying in the distant skies (similar to a Doris Lee farmscape). Removing the figure of Saint Germaine from the scene would result in a panoramic view of rural life in southern France. Ford had painted the saint atop a hill overlooking a vast acreage of farmland not unlike that of her Connecticut meadowlands.

The Vision at Dusk relates an evening in 1871 in which the villagers of Pont Main in Brittany offered prayers for safety from Prussian invaders. Also revealed are six children who witnessed a vision of the Virgin Mary surrounded by a halo of light. Evidently, the prayers were answered as the Prussians were turned back. The anticipated space is a long range distance between the children and the vision of the Blessed Mother. However, there are objective disruptions such as images of the villagers'

Lauren Ford. *Christmas, 1929.* **Etching, 5⅞″ × 4⅞″ (plate), 9⅜″ × 8″ (paper). The Dayton Art Institute. Gift of Mr. Frederic Newlin Price. (54.6.20)**

Lauren Ford. *The Nativity.* **Etching, 3⅞″ × 3″ (plate), 6¾″ × 5½″ (paper). The Dayton Art Institute. Gift of Mr. Frederic Newlin Price. (54.6.24)**

homes. Thus, the vision is not immediately acknowledged as the viewer encounters several stimuli enroute. And yet, the excitement is there. The Blessed Mother hovers over the village like a lioness protecting her cubs. The entire sky is illuminated with countless stars, making the spacious skyline a magic land.

Lauren Ford painted several

versions of the guardian angel theme. *Guardian Angel* reveals God in the person of an angel with arms raised in a protective manner over a small child named Melanie de La Salette. The girl lived during the middle of the 19th century in southeastern France. The angel image dominates the scene, overpowering the tiny creature as towering trees become the environment. Small forest animals frolic as if rejoicing in her presence.

Ford's choice of subject matter hinged on the miraculous and the unfortunate, those creatures whose suffering upon earth resulted in heavenly joy. The real-life child endured maternal brutality, but tenderly cared for her mother until her death.

Compositionally, the angel seems to have sprung from the earth, brushing aside the gigantic trees and swinging wide her arms in a gesture of peace. Her brilliant gown excites the forest animals as they flutter about in amazement.

Another version titled *A Childhood World* reveals a transparent angel competing for dominance over the towering pines. The angel differs from the *Guardian Angel* in the arm positions. Open arms await an errant move. The young child walks innocently through the wooded forest. Towering trees, rendered exquisitely with textural accuracy, psychologically diminish in size the already diminutive child. The usually friendly forest creatures play hide and seek amid the tall pines. Remove the religious aspect and a remarkable portrayal of a young girl innocently positioned in a natural environment emerges.

Five paintings form a mural or multi-panel arrangement in *Baptism of Arnauld,* which unites the past with the present. The traditional guardian angels and dove representing the Holy Spirit hover over the baptismal sight, while the French families participate in the religious ceremony and celebration. The upper central panel shows the priest presiding over the baptismal font with the godmother and newly christened child to his right and the several family members surrounding the font.

The outdoors is the scene of the lower middle panel, which is jammed with family celebrants relishing in the feast. Even the chickens partake while the new member of God's kingdom sleeps peacefully in a fanciful crib under a sheltering tree. The three remaining panels reveal other episodes of the baptismal sacrament with both the clergy and laity as participants.

Ford utilized a single environmental backdrop for the three top panels, that of a concrete block church interior wall. Each panel has its own central event, but all unite into a complete sequential oneness.

Perhaps one of her greatest paintings is *Resurrection,*[4] in which an amazing aggregation of souls, once dead now reeking with life, praise God. Lauren Ford had painted a little churchyard in southwestern France with masses of joyous souls celebrating the resurrection of Christ. The graves had opened and bodies emerged to be judged by Christ in the name of God. An endless array of human flesh dominates the scene, a tribute to Bosch and Brueghel who seem definitely to have been influences, especially in the compositional display of groupings of intimate prayers of thanksgiving. The cemetery of tombstones no longer lies quietly and peacefully, but shouts with cries of penance, thanksgiving, forgiveness and regrets. Ford had revealed Christ's triumph over

death. Crucifixes are scattered throughout the terrain as reminders of His suffering and death. The viewer is treated to a parade of emotions, each a personal family affair. High above the church yard in the heavens, the figure of Christ, crowned in triumph, reigns over the proceedings. Spring flowers spot the landscape between gravesites. Highly objective in nature because of the viewer's need to share individual experiences, each emerging soul becomes a deeply subjective episode which transcends the mere notion of compositional achievement. This is not unlike her panoramic views of the Connecticut landscapes in which several individual compositions constitute the whole.

While in Europe, Lauren Ford traveled from France to the hilltown of Assisi in central Italy, the birthplace of Saint Francis. There she painted *Saint Francis* to symbolize the founding of the Third Order of Saint Francis. The stage was set on the streets of the little town against a backdrop of ancient Italian architecture. Saint Francis stands upon what appears to be a baptismal font or birdbath. He is surrounded by entire families, children perched upon their mothers' shoulders. A Franciscan monk kisses the foot of Saint Francis while a mother's child touches the saint's robe.

Ford's audience seems to be in search of guidance from St. Francis rather than engaged in the practice of his teachings. There are needs evidenced in the faces of the devout audience. Some bow their heads in adoration. Others look beseechingly at the revered saint.[5]

After her stay in Europe, Ford returned to her home in Connecticut where she painted *Adoration.* Here she depicted her neighbors gazing in awe at the child, Jesus. The Blessed Mother kneels in devout prayer alongside the Savior as Saint Joseph stands in the doorway awaiting the coming of the three wise men. The barn interior shows the star of Bethlehem shining through the hayloft window. Once again, Lauren Ford has drawn the viewer into a subjective situation.

Ford set the stage for several intimate relationships within a given expression while sustaining an objective viewpoint on a panoramic scale. In *The Nativity,* the artist again acquaints the viewer with the Connecticut landscape as neighbors and animals hail the newly-born King. In her etching the blessed trio are sheltered in the Ford barn, as tracks in the snow identify Saint Joseph's footsteps to the water pump and back. The traditional angels identify the scene and protect them from on high.

The trio again appear in the hayloft of Ford's barn. Starlight shines upon them as two love birds perch on the window sill observing the quiet evening. According to Ford, these two etchings commissioned by *Life* were created to bring home the beauty of Christ and His teaching to the modern world. Although conceived and executed more than fifty years ago, their appearance today would have been warranted through perhaps less appreciated. By adhering to current scenes and landscapes, Ford had brought new truth and universality to the immortal story.[6]

A final series of paintings of the life of Christ commissioned by *Life* were executed by Lauren Ford according to Bible passages. Although painted during the late thirties, Ford's

Lauren Ford. *Child.* **Etching, 6″ × 4″ (plate), 8⅞″ × 6¼″ (paper). The Dayton Art Institute. Gift of Mr. Frederic Newlin Price. (54.6.21)**

Lauren Ford. *The Holy Family.* **Etching, 5″ × 7″ (plate), 9⅝″ × 10½″ (paper). The Dayton Art Institute. Gift of Mr. Frederic Newlin Price. (54.6.25)**

portrayal did bring Christ into the 20th century and into surroundings familiar to the American populace. Throughout the series of eight paintings, Ford inserted the faithful dog as an image of protection.[7]

In the first painting, the angel Gabriel approached Mary to be the mother of a child to be called Jesus. The scene occurs on the front porch of the artist's home. Shutters and laced curtains dress the window frames. The angel and Mary were enclosed into separate rectangular shapes, thus preserving the untouchability of the now Blessed Mother. Titled *The Annunciation,* Ford inserted an Easter lily between the two figures, thereby

predestining the death and resurrection of Christ.

The star of Bethlehem has guided the shepherds and their flocks to the *Birth of Christ,* which transpired in the Ford barn. A dual composition known as an inside/outside arrangement became important to relate the idea. The Blessed Mother and the child, Jesus, appear to glisten in light from an unusual source, perhaps a miraculous source. It could not radiate from the kerosene lamp which sits upon a clump of hay perilously close to the Savior. The trio of saintly characters is accompanied by the faithful dog and two cows.

The third painting, titled *Wise*

Men, reveals the trio on the porch of Ford's home, having moved from the barn. A visit from the Wise Men completes the composition. A second painting exists as an environmental landscape, a panoramic vista which lies behind the featured characters.

The Flight into Egypt reveals the event during a snowstorm. Flanked by tall trees, the blessed family's movements are curtailed slightly as they await the descent from the snow-covered hilltop. Even the faithful dog turns the viewer's attention toward the central figures. Ford did not rely upon the main characters for a total composition. The environmental landscape in and of itself is complete even before the inclusion of the holy family. However, the insertion fuses into the whole and becomes a natural part of the surroundings and subsequently projects a subjective experience.

Simeon Holding the Child, Jesus pictures Simeon being granted his plea to see the Savior before his own death occurs. Again the artist separated the two events with architectural devices. To the left of a vertical partition are Simeon, the child Jesus and the faithful dog, while to the right are Mary, Joseph and an unidentified old woman with a cane who mirrors death. Ford continued to allow the viewer to witness both the inside and outside simultaneously. The artist also identified sainthood by the traditional method of the halo.

A typical parlor scene is the site of the holy family in Nazareth. Gathered around a table covered with a knit cloth and anchored by a large kerosene lamp are Mary, Joseph and Jesus engaged in routine activities. Decorative wallpaper lines the background.

A seventh painting shows Christ sharing his ideas with the intellectuals of the day. The artist had split the canvas into three sections, each vertically triangular shape depicting a segment of the entire event. Christ and two observers occupy the middle plane and yet the three panels survive as one. Again, the inside and outside combination prevails.

The final of the eight paintings reveals Christ as a carpenter apprentice helping his father, Joseph, in the woodshed while Mary is seated inside the doorway watching the actions of the young Christ. In all paintings, Ford utilized the rectangular shape as an enclosure device along with employing the interpenetration technique. The artist never lost the panoramic vision, and although it is segmented in this series of paintings, one always senses a oneness, a vast extension into the future, a gathering together of all things into a 20th century adaptation of the life of Christ.

Discussed earlier in this chapter was a painting titled *The Vision at Dusk.* A panoramic view of the same vision was also painted and was titled *Vision of the Innocents.*[8] A circular composition made up of three-dimensional rectangular shapes in the forms of stone houses, it focuses on the communication between the children of the village of Pont Main and the image of the Blessed Mother. Each child in the painting looks heavenward toward the jeweled figure, while each adult, engaged in conversation, is oblivious to the phenomenom. Ford has banded together several residents of Pont Main in the lower right of the canvas, while others scurry toward the same destination.

Ford's spotting of individual characters throughout this painting is remarkable. In spite of the diminutive

nature of the characters, Ford has granted to them considerable care and diligence. The bristling painting is enhanced by the combination of strong stone residences and the delicately rendered stark trees and picket fences. Although the vision claimed that only children witnessed the appearance of the Blessed Mother, Ford felt the need to include the animal kingdom. Dogs of different sizes and shapes acknowledge Mary, the Virgin Mother, in typical animal curtsies. The humble gathering of villagers is reminiscent of Ford's painting *Bethlehem.*[9]

Other panoramic views expressed by Ford include the beautiful paintings titled *Hail Full of Grace,*[10] a renewal of spring, an extension of the resurrection. Her farmland of Connecticut is transformed into the promised land. The sheep and goats graze on the hilltops, the farmer tills his land, the plows and horses dig the furrows and the naked trees give evidence of blossoms. And in this humble setting, the artist has placed the scene of the Visitation. The Virgin Mary, Mother of God, dwells within the enclosed porch adjoining the weathered barn while the angel presents her message from God, which coincides with the painting's title, and which appears in the prayer "The Hail Mary," which goes as follows: "Hail Mary, full of grace, the Lord is with thee. Blessed art thou among women, and blessed is the fruit of thy womb, Jesus. Holy Mary, Mother of God, pray for us sinners, now and at the hour of our death. Amen."

A light, not unlike a strong spring sunlight, shines from the heavens onto the angel and the chosen Mother of Christ. And yet, as the light concentrates on the holy duet, the entire Connecticut landscape sparkles with a refreshing look of renewal.

Ford was not noted for her woodcuts, but an illustration appearing in the book *Saints for Now* proves her ability in the less direct medium.[11] It depicts the founder of the Benedictine order and a young monk huddled in contemplative quietude. It is titled *Saint Benedict and a Young Monk.* Unlike her panoramic, multiple compositions, this expression of intimacy between two adherents of God's kingdom illustrates the diligent portrayals of her figures when revealed at close range. The stark, bold simplicity of black and white reflects the humility of these two souls of Christ. They, indeed, could have been extracted from Ford's rendition of the *Resurrection,* and enlarged to form a dual composition. The lit candle acts as a compositional device separating, yet joining together, the two figures. It also serves as a source of light revealing the word of the Gospels. The open Bible is grasped by St. Benedict's left hand while his right hand gestures in a plea for the young novice to understand his teachings. The young monk looks intently at the meditative facial expression of this veteran saint. The black and white medium enhances the singularity of the duality. In addition to its tight overlap, the limited palette, so to speak, creates a oneness which would have been unattainable with a colored palette.

Ford's contribution to religious art was not widespread within the art circles. Rather, it appealed to the populace outside the art world. Her message was the birth of Christ, the joy—never the sorrow or the crucifixion. Her painting was a celebration of life. *Star of Bethlehem* or *The Vision*

at Dusk never rocked the American scene as did an Abraham Rattner or a Fred Nagler or a Clare Romano. And yet throughout the Depression, hers was the only voice (except for Nagler's) expounding the joys of the Christian world. It was not until the end of World War II that American artists began again to make reference to the Christian beliefs. Such artists as Rattner, William Congdon and Romano became the message bearers of Christian art.

In spite of Lauren Ford's consuming efforts, her religious voice was small, yet personal enough to attach itself to the viewer in an unforgettable manner. Ford's role players were lovable characters whose optimism conquered the doubtful, the fearful and the uncertain.

Perhaps one of Ford's most celebrated canvases is *The Country Doctor.* One delights in the endless parade of innocent activities which highlight the rural landscape. The visit of the country doctor was an event that occurred usually amidst the chores of the day. Ford chose the summer season to exploit the activities scattered throughout the farmland and its adjoining surroundings.[12] *The Country Doctor* is an objective panoramic view of a typical farm, but the charm it presents is due to the personal love the artist fuses into each brushstroke. Each recorded event had been an intimately rendered sketch before being introduced to the final composition. Thus, what appears to be a rambling countryside is in fact a carefully structured, exquisitely applied arrangement of a commonplace environment.[13]

Winter, one of Ford's non religious paintings, compares favorably with Doris Lee's *Winter in the Catskills.* Each utilized home surroundings, and each utilized the distant horizon to accommodate the winter enthusiast. Similar to her painting *The Country Doctor,* Ford's *Winter* reveals a panoramic view of the Connecticut countryside. It creates a real sense of winter, a sense of participation in nature's discoveries and delights. Just as *The Country Doctor* appeals to the warmth of summer activities, *Winter* recalls the thrill of activities designed for the snow-covered landscape. In spite of its objective approach, there exists a personal touch of familiarity and love that sets the Connecticut landscape apart from other similar themes seen for the first time.

The mixture of fantasy and realism has been evident in Ford's works throughout her career. In her painting *Little Boy Blue,* she has re-enacted the nursery rhyme, for "the sheep are in the meadow and the cows are in the corn." In addition, Ford presents an atmosphere of pastoral charm. Stillness prevails. Peace reigns. There exists a beauty not unlike her spiritual images. One senses the presence of the King of Peace. Visual perspective is enhanced by the sheltered framework in the near foreground, which incidentally recalls the manger of her several nativity scenes.[14]

Similarities between the works of Doris Lee and Lauren Ford emerge again in Ford's humorous painting titled *General Store.* The abundant activities of black children shooting craps and wheeling their bikes, and mothers mothering and simply sitting and listening inhabit the scene. There is the same joy and exhilaration as witnessed in *The Country Doctor* and her religious panoramic landscapes.

Lauren Ford. *The Country Doctor.* **Oil on canvas. Courtesy of the Canajoharie Library and Art Gallery, Canajoharie, New York.**

This 1944 painting is jammed with kids occupying the lower base while adults wash clothes, hang clothes and generally just "stand around."

The viewer is treated to a continuous display of playful activity, a recording of realism for which the artist made no plea or apology. Ford positioned her characters to the forefront of the picture plane. As one eyes the activities from left to right, one witnesses a happy playground in spite of environmental squalor. The spacing of her figures to avoid overlapping and to initiate separate activities aided the artist in her quest for compositional unity.[15]

Her painting titled *Milton Pond, Thanksgiving Day,* shows similarities with Doris Lee's rendition of skating,

Winter in the Catskills. Details flourish in both the distant landscape and the foreground, with groupings of children establishing several compositions within the whole. It is a holiday on ice picturing young talent and mischievous mishaps. Even the distant hills depict sledders whose inevitable destination is Milton Pond. Homes tucked amid drifts of snow, leafless trees piercing the stillness of the atmosphere and the abundant snow-covered hillsides contrast with the intense activity of the ice-borne youngsters.

As with her religious paintings of teeming activity, in *Milton Pond, Thanksgiving Day,* the action stems from all conceivable sources. In spite of a continuous flow of activity, spatial

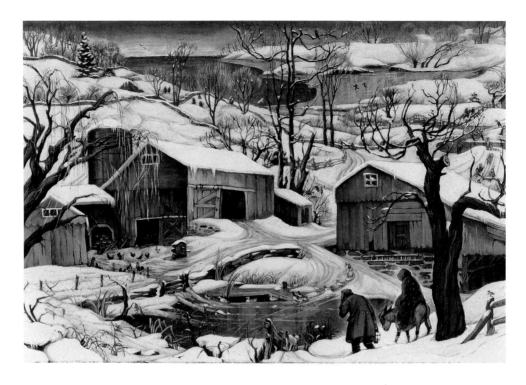

Lauren Ford. *Winter.* **Oil on wood panel, 11½″ × 17¾″, 1936. Photograph by Richard Stover. The Carnegie Museum of Art, Pittsburgh. Bequest of Charles J. Rosenbloom, 1974.**

dimensions allow for appropriate focus upon individual gestures. Her characters are innocent and untainted. Ford's approach is bustling with excitement and innocent of life's temptations. In this sense, she has followed the Christian message of the innocence of little children.[16]

The panoramic view of such famous works as *The Country Doctor, The Nativity* and *All Saints Day* is transformed into a single composition of overlapping figures in a 1934 work titled *Choir Practice.* The title is misleading, and the oil on panel lacks the spontaneity and enthusiasm of her expansive and complex landscapes. This is one of the few interiors

executed by Ford, and because of its objectivity and academic rendering of medium, it resembles a self-disciplined approach to life. *Choir Practice* is not an enjoyable scene. The children reluctantly obey the demands of the "choir" director.

Choir Practice is a complex painting diligently conceived and executed. Diagonals and verticals overlap in complete harmony. Details are carefully rendered. Intricately designed areas are balanced with muted tones of single hues. *Choir Practice* elicits a second cue to her future panoramic vistas. A second composition within *Choir Practice* is witnessed in the presence of the young girl playfully

Opposite, top: **Lauren Ford.** *Choir Practice.* **Oil on panel, 1934. In the Collection of The Corcoran Gallery of Art. Museum purchase, Abna E. Clark Fund.** *Bottom:* **Lauren Ford.** *La Grippe.* **Oil on canvas. Sacks Fine Art, New York, New York.**

seated in an overdressed armchair. Although playing a secondary role to the choir group, the girl's identity claims a segment of the whole, acting as a diversionary device.

The early Depression-era *Choir Practice* reflects the core of poverty. It may be fair to say that it identifies with her portrayals of Biblical events as illustrated in her book *Life of Christ*. The participants resemble posed figures brought together for a job at a commercial photographic studio. Executed when the artist was 25, *Choir Practice* reveals the obvious placement of figures and objects to assure a unified composition. And yet, there is a serene tone, a sacredness which prevails. A careful manipulation of figures to avoid routine and monotony are evidenced in the leg positions of the choir members. Equally significant is the selection of clothing worn by the participants. Earmarks of the Depression are witnessed in the unframed painting, the cracked plaster walls, the beamed ceiling, the decorative wall hanging and floor tapestry.

In spite of its title, *Choir Practice* lacks the excitement of scurrying figures so obvious in her panoramic paintings. This is an academic work, a study if you will, a base for future production.

In spite of the obvious objectivity of such paintings as *Country Doctor, Winter* and *Milton Pond,* Ford's compassion for life threads its way throughout each work. The degree of objectivity relies upon the number of objects or figures dotting the landscape. The compositional complexity of *Country Doctor,* for example, taxes viewer participation. And yet, instead of scanning the horizon for daily activities to share, one participates in delightful dialogue. And the continuity of events, the common cause initiating a togetherness that Ford insisted upon as part of a Christian tradition, assists in diminishing the objective viewpoint.

The Country Doctor is life at a distance, and in spite of the diminutive human forms, one senses an emotional exuberance in Ford's role players. It is the charm that Ford has brought to simple daily chores that delights the viewer.

Other examples of Ford's intimate objectivity are *Nativity, Epiphany* and *Resurrection.* In *Nativity,* it is not merely the birth of Christ, but the birth of the entire Christian world, and it is in this broad sense that one is compelled to decommercialize the obvious misrepresentation. For Ford, Christmas is the start of life, the celebration of eternal life (birth, death, rebirth) the everlasting cycle which Christmas symbolizes.

A segment of the cycle is further witnessed in *Resurrection,* the rebirth of man, the conclusion to God's promise of eternal life. Ford never revealed death in her expressions, perhaps because life was so bountiful. If death had ever been considered, the resurrection would have been nearby. And perhaps the reason for its omission from her life's work was that as a single event, it may have been assumed to be the end instead of the beginning of life.

Lauren Ford rejoiced in life and realized that the love of life should be expressed as a positive aspect of God's plan, and always in the spirit of good will. She skipped Good Friday and stayed with the joy of life upon earth and the rejuvenation of the resurrected life, the life after death, so that the emphasis was at all times placed upon life now and forever.

Lauren Ford. *Three Little Girls.* **Etching, 5″ × 4″ (plate), 10⅞″ × 7⅝″ (paper). The Dayton Art Institute. Gift of Mr. Frederic Newlin Price. (54.6.22)**

Notes

1. The painting *Epiphany in Bethlehem, Connecticut* was reproduced in *Life,* December 25, 1944.
2. The painting *Star of Bethlehem* was reproduced in *Life,* December 26, 1938.
3. The painting *No Room in the Inn* was reproduced in *Life,* July 4, 1938.
4. A description of *Resurrection* (complete title, *Resurrection at Monguyon*) follows, as written by the editor of *Liturgical Arts Magazine* in the November, 1943, issue: "In the church-yard at Monguyon, France, people of every sort, of every epoch, are rising from the grave. In the foreground are a knight of the crusades and his family, an eighteenth century poet, the curate's housekeeper. There are peasants — one family. Against the church is a hermit and through the roof the first Lord and Lady of the fief, and a holy priest known to the painter. Christ is reigning from the Cross in the sky. The prayer is 'Thy Kingdom Come' for the Resurrection of France."
5. The series of paintings beginning with *The First Communion Dress* and ending with *Saint Francis* appeared in reproduced form in *Life,* July 1, 1945.
6. Reproductions of the two etchings, namely *The Nativity* and *Adoration,* appeared in the April 21, 1947, issue of *Life.*
7. A series of eight scenes from Ford's life of Christ in paintings published by Dodd, Mead & Company are reproduced in the April 21, 1947, issue of *Life.*
8. A full description of *Vision of the Innocents* follows: "This painting represents the village of Pont Main, in Brittany, on the evening of January 17, 1871, during the Franco-Prussian War. The enemy was within a few miles of this village where for days the children had been praying to Mary Immaculate for their deliverance, for peace and the safe return of their soldier brothers. While two little boys were preparing fodder for their father's horses, Our Lady suddenly appeared above the rooftops. She was crowned in gold and dressed in the stars of the sky, and smiling. The boys made such a clamor that the whole village population was soon standing there in the snow. But Our Lady came only for the children. Every child in the village saw this starry vision and not a single adult, not even the holy priest nor the teaching sisters.

"Little babies, wrapped in their grandmothers' cloaks, waved their arms and called out. And our Lady's message was printed boldly in the sky for them. The children called out the message and the priest wrote it down: *Mais priez, mes enfants, Dieu vous exaucera en peu de temps* (But pray, my children, God will heed your prayers in a little while). On another line: *Mon fils se laisse toucher* (My son can be moved). Then the message was blotted out and 'the night rolled over the words.' Now the children see Our Lady aureoled with a blue band in which stand four candles. Now she leans over and picks up a red crucifix which appears at her feet and holds it out for the children to see, and she is very sad. When they all sing the *Ave Maria Stella* a star at her feet moves about the oval and lights the four candles while she raises her arms and moves her fingers slowly to the rhythm of the hymn. Finally two little white crosses are seen upright on her shoulder. Then, Our Lady is slowly enveloped in the night. At this hour the order was given to the Prussians to advance no further although they were within two kilometers of Laval. Within two weeks the armistice was signed and the soldier brothers all returned safely home. Petition: For France to-day, *Mais Priez, Mes Enfants.*" The above quotation appeared in *Liturgical Arts Magazine,* November, 1943, issue. The painting is in a private collection.
9. A full description of the painting *Bethlehem* appears in the November, 1943, issue of *Liturgical Arts,* as follows: "The scene is that of the Epiphany and it is laid in the village of Bethlehem, Connecticut, where the artist works and lives. All the familiar landmarks are shown: the church, the post office, the old inn, the village store. Miss Ford's farm is in the upper right of the painting. The Three Kings are at the door of the barn, having come a long way led by a star. Their servants are taking their luggage to the inn. In the right lower foreground the family of the artist come to adore the Holy Babe. Petition: for the countryside." The painting is now owned by the Art Association of Indianapolis.

10. The painting *Hail Full of Grace* was in the 1943 Carnegie Institute Exhibition. A reproduction appears in the November, 1943, issue of *Liturgical Arts.* A full description by its editor follows: "This is a picture of spring. The sky is very black, but light is shining through a rift in the clouds. The winter has been terribly cold and the spring very stormy, but there is a feeling that it will break soon and everything will be born anew and fresh. It is a picture of a promise. The angel is announcing a glorious fulfillment. Petition: For our country and our fold, that out of the chaos of war and after such trials as are asked of us we may be worthy of the Promise."

11. The illustration appears on page 56 of the book *Saints for Now,* edited by Clare Boothe Luce, Sheed and Ward, New York, 1952.

12. The painting titled *The Country Doctor* is owned by the Canajoharie Library and Art Gallery, and is reproduced in color in the book *Modern American Painting,* published by Dodd, Mead & Company in 1940.

13. Critic Margaret Breuning writes of Ford's painting *The Country Doctor,* in *Art Digest* (May 15, 1938, page 10), as follows: "The doctor, resembling so much the gentle and popular Dr. Dafoe, has stopped his horse and buggy before a pretty white house and is seen walking up the neat pathway to his patient. In an all-over patterned canvas, so often favored by Miss Ford, may be seen a little village with the inevitable steepled church and neighboring farms laid out compactly at harmonious angles. With the exception of definitely American touches the scene might easily have been a peasant village in Europe."

14. A reproduction of Ford's painting *Little Boy Blue* appears on page 10 of the May 15th, 1938, issue.

15. Reproduction of Ford's *General Store* appeared in the April 15, 1945, issue of *Art Digest.* It was first shown at the Feragil Gallery of New York City in 1944.

16. Thomas Craven writes of *Milton Pond, Thanksgiving Day,* the following in his book *A Treasury of American Prints,* published in 1939 by Simon & Schuster: "It is a work of exquisite fancy and finical detail. The scene is, to establish the realism of the setting beyond question, the Great Pond at Milton, Massachusetts, where the Indian sachem Chicataubot wept over his lost lands that the palefaces had stolen from him. Miss Ford has not depicted this unhappy moment, but has peopled the pond with some of the most delightful children in modern art. The etching deserves the closest attention, for a dozen tiny incidents and minute catastrophes are used within the confines of this nicely devised composition."

Bibliography

"Ageless Story." Review. *Liturgical Arts.* April, 1940.
Boswell, Peyton. "Epiphany in Bethlehem." *Life.* December 25, 1944.
_____. "Four Paintings by Lauren Ford." *Liturgical Arts.* November, 1943.
_____. "Lauren Ford's Saints." *Life.* July 1, 1945.
_____. *Modern American Painting.* New York: Dodd, Mead, 1940.
_____. "No Room in the Inn." *Life.* July 4, 1938.
_____. "A Star Is Born." *Life.* April 21, 1947.
_____. "Star of Bethlehem." *Life.* December 26, 1938.
_____. "Star of Bethlehem." *Liturgical Arts.* November, 1942.
Craven, Thomas. *A Treasury of American Prints.* New York: Simon & Schuster, 1939.
"Etched Beauty." Review of Feragil Show. *Art Digest.* April 15, 1945.
Exhibition Review. Feragil Gallery. *Art News.* December 21, 1935.
Exhibition Review. Feragil Gallery. *Art News.* May 14, 1938.
"Lauren Ford Reviews." *Art Digest.* April 15, 1930; May 1, 1932; December 15, 1933; June, 1934; November 15, 1934; June, 1936; March 15, 1938; May 15, 1938.
"Lauren Ford Reviews." *Art News.* April 5, 1930; March, 1946.

"Lauren Ford Reviews." *Arts.* April 7, 1930; December 21, 1935; May 14, 1938.

"Lauren Ford Reviews." *Parnassus.* May, 1935.

"Lauren Ford Reviews." *Studio.* January, 1937; May, 1931; May, 1930.

Luce, Clare Boothe. *Saints for Now.* New York: Sheed and Ward, 1952.

O'Connor, Jr., J. "Presenting Lauren Ford." *Carnegie.* May, 1939.

Proposed Benedictine Abbey in Connecticut. Drawings by Lauren Ford. Article by M. Lavanoux. *Liturgical Arts.* February, 1947.

Reproduction of *Bethlehem. Liturgical Arts.* November, 1943.

Reproduction of *Choir Practice. Parnassus.* May, 1935.

Reproduction of *Country Doctor. Art Digest.* March 15, 1938.

Reproduction of *Country Doctor. Art News.* October 29, 1938.

Reproduction of *Country Drive. American Artist.* October, 1949.

Reproduction of *Dinner's Ready. Art Digest.* November 15, 1934.

Reproduction of *Epiphany. Liturgical Arts.* February, 1939.

Reproduction of *General Store. London Studio.* January, 1937.

Reproduction of *Guardian Angel. Art News.* October 26, 1940.

Reproduction of *Hail, Full of Grace. Liturgical Arts.* November, 1943.

Reproduction of *Nativity. Carnegie Magazine.* December, 1949.

Reproduction of *Resurrection at Monguyon. Liturgical Arts.* November, 1943.

Reproduction of *Saint John. Atelier.* May 1, 1931.

Reproduction of *Star of Bethlehem. Liturgical Arts.* November, 1942.

Reproduction of *Vision of the Innocents. Art Digest.* June, 1934.

Reproduction of *Vision of the Innocents. Art Digest.* June, 1936.

Reproduction of *Vision of the Innocents. Liturgical Arts.* November, 1943.

Reproduction of *Winter. Art News.* March, 1946.

Stillson, B. "Bethlehem by Ford." John Herron Institute Bulletin. June, 1943.

Index

*Numbers in **boldface** refer to pages with illustrated works.*